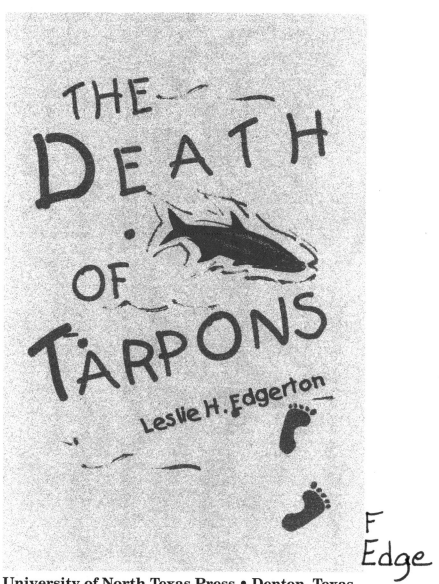

THE DEATH OF TARPONS

Leslie H. Edgerton

F
Edge

University of North Texas Press • Denton, Texas

8/96 *Brodart* *24.95*

10 9 8 7 6 5 4 3 2 1

Permissions
University of North Texas Press
P. O. Box 13856
Denton, Texas 76203

The paper used in this book meets the minimum
requirements of the American National Standard for
Permanence of Paper for Printed Library Materials,
Z39.48.1984. Binding materials have been
chosen for durability.

The author gratefully acknowledges support provided during
the writing of this book gained from his award of a
$2000 Associate Fellowship Grant in Literature **IIAC**
from the Indiana Arts Commission, which is
supported by the National Endowment for the Arts.

Library of Congress Cataloging-in-Publication Data

Edgerton, Leslie.
The death of Tarpons / Leslie H. Edgerton.
p. cm.
ISBN 1-57441-001-3
I. Title.
PS3555.D472D4 1996
813'.54—dc20 95-43090
CIP

ii

When working on a book, I am like many other writers—I have an ideal person in mind for whom I'm writing. I had two such readers in mind as I wrote *The Death of Tarpons*, my wife Mary and my good friend Patty Klingenberger, and it is to these two sensitive and caring individuals I would like to dedicate the effort you hold in your hands.

Contents

Back to Freeport / 1

Grandma's Drunk / 26

A Long-ago Fishing Trip / 42

The Sun Wins / 64

Rattlesnake! / 83

Some Things Become Clearer / 113

A Stab in the Toe and an Embarrassing
 Situation / 141

The Funeral / 167

Thief! / 194

The Death of Tarpons / 219

Acknowledgments

Although the author's is the name that appears on any book, publication of any work is the result of many others who sometimes are not properly recognized. Significant among those without whom this novel would not have been possible are the people at the University of North Texas Press, especially Fran Vick and Charlotte Wright, as well as Valerie Borgfield, Barbara Edmanson, Melanie Peirson and all the others at UNTP who had the faith that this was a book worth publishing. Thank you for that faith.

Next to his wife, a writer's best friend is usually his mailman. Thanks to a group of people who have made my life infinitely easier as a writer, namely my postman, Mike Grable, and the folks at my local Mail Boxes, Inc. office, Paul Lanning, Mary Roemer and Marilyn Roemer, who have time and time again gone above and beyond the requirements of their jobs in assisting me many, many times.

And appreciation to my kids, Britney, Sienna and Mike, and my wife Mary, for allowing me to sacrifice our time together so this book could be written.

Back to Freeport

Not long ago, I returned to the town of my youth, and made a disturbing discovery. It had weathered the intervening thirty years better than I had, at least physically, and that had the effect of giving me a bit of a jolt, as if the events of the last summer I spent there, the summer of my fourteenth year, hadn't been as cataclysmic as I'd imagined. Somehow, I'd labored under the notion that the town itself would be materially altered in some electrifying and obvious way, influenced, as it were, by the same momentous and epochal occurrences that had transformed my own then-tender psyche, but no, the downtown district, the park and business square, were not much changed from the last time these eyes had gazed upon it, that being the fall after Grandpa's fu-

neral; only it looked shabbier and tired-out, as if the buildings themselves suffered from emphysema or another of those creeping old-age diseases.

That was not a possible thing, I knew, but the immutability of it all made me feel as though the interval since I'd last stood on the sidewalk I now found myself on, peering myopically into the window of the family restaurant, or more correctly, the building that had formerly housed the family restaurant, now an empty, boarded, and shuttered hulk, had been aught but a dream, albeit a terribly long one of some three decades. Had I really survived that terrible fourteenth summer, had I later that fall gone up north to live with Aunt Pat and Uncle Charles, finished high school, gone to college, married and buried a wife, had children from that union, and held straining, squealing grandchildren on my knee even as late as last week? Staring at the weathered building, absorbing the Texas heat as it beat down, it scarcely seemed possible; I felt transported back to the time when I was fourteen years old and wincing at my father's constant rages, red-eyed fury, and fermentings against a world conspired against him, and presenting itself to him in my image, me, the son that failed him at every step, at every important juncture, in every single point that it was possible to fail him at.

My father! As his image came to mind, my eye helplessly flew to my watch, a reflex automatically triggered, useless as it may have been now, as he'd been

in the graveyard for years and years and certainly not concerned any longer with my punctuality, or lack of it. The knot I felt in my gut was unnecessary, but old bugaboos die hard, and this one was still chock-full of life. I stepped up to the glass door of the cafe and tried it, just in case, but of course it was locked. Dimly, I could see shapes inside, the long counter on the left, barstools, booths along the right wall and tables in the middle. Not a stick of furniture appeared different from the last time I'd gazed inside . . . except . . . something . . . there was something odd, different . . . missing. That was it—missing. What it was, I couldn't recall, and then as I went back in time, my memory dredging up old images, it came to me. Of course! What wasn't there that should have been was the Wurlitzer. Grandma's juke box! That was it. Someone had removed it. Hank Williams would never sing his plaintive laments inside these four walls again.

The Oyster Bar. The business that had sustained three generations, mine and my sister Doc's, my parents, and my grandparents. The business that, along with the taxi cab company, my grandmother had created and ruled as her own private fiefdom. Not with some metaphoric iron hand, but with a very real Navy Colt long-barreled .45 on the dash of her taxi as she nearsightedly navigated that humonguous boat of a Dodge about the town, ferrying drunks and career alcoholics over to Galveston Island for a bottle of whiskey unobtainable in our own dry county of Brazosport;

ruled with a sawed-off baseball bat, Stan Musial model, kept behind the bar in the restaurant itself, for those chilling moments in a seaport bar when the owner's authority was challenged by a sailor fresh off a Norwegian oil tanker who felt he had to disagree with the assessment of the degree of his public intoxication. She ruled absolutely and absolutely she ruled, in both businesses, and a tougher individual I couldn't imagine as a young boy, nor can I now, even at this more experienced date.

Ghosts of another age flickered in the shadows of the abandoned cafe as I stared through the smeared glass of the door—Dad, Destin Dean, the boat, Grandpa. Grandpa. Dad and Grandpa. Theirs were the memories I'd come here for, the ones I required for the crisis facing me, full a third of a century since I'd last walked these streets.

I don't know what it was I expected to happen as I poised there, staring into the place that had been at the center of my universe for so long, but whatever it might have been, it wasn't happening. Not here, not now anyway, not peering into this dark and abandoned room. Ancient memories stirred, but didn't flesh into life, at least not the particular memory I was after, the one I'd come a thousand miles for.

There were other places I needed to visit. Two more places.

I drove to the first, to the docks where the shrimpers tied up, and parked the car on the street side of

the levee, in deep saw grass. Oyster shells crunched heavily beneath my shoes as I walked up and over the hill and along the rows of warehouses and piers, past dozens and dozens of boats named mostly after women, both faithful and unfaithful members of the fairer sex, although a few were obvious optimistic paeans to better times ahead, like the one christened "The Merry Widow Chaser."

A small, insignificant shed is what I was searching for, the chances it still stood remote, but one never knows. Even if it had survived the years, the object it once housed and which was the purpose of this little stroll, had to be long gone, but still I went forward, not knowing if I would even be able to recognize the building.

But I did. Recognize it, that is. Almost instantly, and probably not too surprisingly, considering the hundreds of hours I'd spent inside its walls, laboring over what had been the most important undertaking of my fourteen years. More luck; it was open, a broken padlock lying in the weeds beside the door, sprung and slightly ajar. Momentarily, I flinched, wondering if it was the same padlock wrenched off in the white-hot heat of my father's anger that day so long ago in time, but too near in memory, but that was too ridiculous to even consider.

Inside, it appeared the shed hadn't been used in many years—nothing of value remained—junk; scraps of moldy wood, bits and pieces of rusted metal, a bro-

ken broom handle, crushed beer cans, old newspapers. It was evident no one had been inside the shed for years, except kids who needed a place to sneak a drink of flavored vodka, or to cop a puff or two of their father's purloined cigarettes. I knew it was useless, but I picked up a stick I saw lying on the floor and began poking through the piles of debris anyway, and sure enough, there was nothing there of any significance, save perhaps to a ragpicker. After a bit of this mucking about, I gave it up, turned to go, was almost through the door, when something caught my eye, something shiny under a pile of wood scraps, and I walked over, my heart beginning to thump against my ribs. I took hold of the end of the object I had spotted sticking out and tried to pry it loose, fumbling and struggling with the rubber tire on top, using my foot to push loose the scraps and sticks of wood and other clutter that imprisoned my find.

I had very nearly missed spotting it at all. Only a corner was showing, and only because of the time of day was that even visible, the tiniest splinter of sunshine slanting through the little window in back glinting off it for the briefest of seconds—ten minutes either way and I'd have passed without a second glance.

Even before I'd worked it loose and rubbed the dirt from the surface, I knew what it was. It was a miracle for it to still be here, although perhaps miracle wasn't the word to be used—curse seems a better choice of words. I took it outside, rubbing the last of the lubri-

cious grime away with my sleeve, not caring in the slightest how soiled my shirt became. The mahogany gleamed. It glistened. It should, was my thought; what with all the hours spent in polishing it, so very long ago. My legs all of a sudden felt rubbery. The air inside the shed must have been stale and low on oxygen, as I also felt suddenly nauseous. I sat down on the ground, cradling the treasure in my arms, and took deep breaths, counting until I reached twenty-five, and then I held the polished rectangle of wood away from me at arm's length and gazed at it. Dirt still filled the depressions of the letters, but it was clear as a billboard, the hyphenated word etched into the surface leaping out at me.

Bob-A-Long, it said.

I stood up, ignoring the catch in my throat, the sudden tearing in my eyes, and walked back to the car, laying the piece of mahogany on the front seat. I headed the car out to Bryan Beach, trusting I could remember the way. I'd never driven there myself, not having been old enough to pilot an automobile the last time I'd been there, always traveling by bicycle, unless an adult drove.

I found the beach as easily as if I'd just gone there the day before. I drove down the sand about two hundred yards, pulled the car up away from the reach of any early tide, and just sat there, my gaze fixed upon the rollers crashing into the shoreline, holding the piece of wood on my lap, waiting for the demons to materialize.

Nothing happened. The world didn't end; I didn't go mad; I didn't weep or even much feel like it. Nothing. I began to be aware of my surroundings, to notice there were other people on the beach and something was different about them. For long moments I tried to figure out what was strange about the scene, and then it occurred to me just what it was. There were blacks. Black people were out there, in the surf, walking along the beach, crouched over, looking for shells. It was funny . . . I'd never realized black people were interested in sea shells or tanning. The last time I'd been here, I'd been fourteen years old and this had been a "white" beach. Blacks weren't allowed; not only that— the word "blacks" hadn't yet been created. Black people were around then, only they were invisible to the white world. They had their own beach, and if we ever thought about it, we would have assumed it to be a beach not as nice as ours.

The town of my youth that hadn't changed, at least the town I'd thought hadn't changed, most certainly had, and so had I. The world of thirty years ago was gone, gone forever, and so was the small, frightened boy who had inhabited that vanished world. Or was he? I wasn't so sure. The man who sat in this car, clutching this poor piece of wood on his lap and staring out at the scene of what had been a great tragedy in his boyhood, was a stranger to that world which no longer existed and maybe never had, save in a memory.

I looked out at the waves crashing far out in the

surf, throwing raggedy lines of spume, and for an instant saw a small fishing boat and a young boy and an old man, out there in the boil of the surf, and there was something terribly wrong about the boat. The old man was standing up—that was foolhardy—but the boat itself somehow wasn't right. It was on a line parallel to the waves, not headed into them as it should have been. Didn't the old man know that?

I ran down to the edge of the frothy waterline and began screaming at the boat. A man came up and asked me what was wrong.

Out there, I said, agitated. *That boat. There's going to be an accident.*

There's no boat, the man said, looking at me oddly.

I narrowed my eyes and squinted. Nothing but waves from here to the horizon.

There isn't, is there? I said, and then I had to look away for the tears began to flow down my cheeks and I felt ashamed for the stranger to see me weep. *It's all right*, I said to him, concern and alarm both visible in his eyes. *It's really all right.*

And it was. The tears continued down my cheeks but they felt good. I walked back to the car and got in, turning on the engine and letting the air conditioner cool the interior.

I gazed out at the beach once more, and it had changed, forever, for me. It was just a beach. Sand, driftwood, waves, some people walking about, some swimming, but there was nothing frightening about it

any longer. I saw now what had really happened here, thirty long years ago; saw that none of it had been any of my doing; saw that I had merely been a young boy the world had used badly. No longer was I that helpless child, but an adult able to control his own destiny. Even if that destiny included an incurable disease.

This was a place I'd been afraid of my whole life, just as the shed I'd left a while before had held terrifying memories. There was nothing in either place to elicit fear; horrible reminders to be sure, but just that— mental recollections and nothing more.

Transformed, I put the car in gear and wheeled it around on the hard sand. It was time to go home. I could do that now. I topped a little hill and stopped the car for one last look at Bryan Beach. I could see the spot now where Grandpa had pitched out of the boat.

Good-bye, Grandpa, I said to myself, silently. *I remember now what it was you wanted me to know.*

I had gotten what I returned to my childhood for. I could see it was time to leave, put this behind me, go forward into my future, however scary and uncertain that future seemed. I was armed now, no, re-armed; no matter what happened I could handle what lay ahead.

I hit the button for the power window and when it was fully opened, I reached for the wooden nameplate on the seat beside me. When I hit fifty miles an hour, I let it fly into the hot Gulf air rushing in. The salt air felt good on my face.

I felt the past come up and wash over me, no longer threatening. As the telephone poles clicked by, the years melted away and I returned to a harsher time and place, but was not afraid to go there.

I turned the air conditioning as high as it would go and hit the window controls, sealing the inside of the car from the deadly Texas heat, visible in shimmering waves on the blacktop ahead.

Here I was, back at the last day of the eighth grade, eagerly anticipating summer vacation, which, to a four-teen- year-old boy on the Gulf coast of Texas, meant fishing, fishing, and more fishing, with a bit of swimming perhaps thrown in and a time or two going after rattlesnakes. But fishing, definitely. At that age, I lived to catch fish. That was an exciting prospect when you lived on the mouth of the Brazos River. You never knew what would hit your line when you threw in. It could be a panfish, a piggy or a croaker, or it could be a razor-toothed gar or eel, or if I went but a few miles from the house and angled off one of the jetties, it could be a redfish or even a sand shark. There was always the element of delicious anticipation and even danger when you threw your bait out.

Fishing was the catalyst of the forthcoming summer and the events that would transpire, although certainly at that particular time, I had no knowledge of that; if I had, perhaps I would have chosen another

passion to pursue, say, hunting alligators with stones.
There have been other summers, other winters, other
years; some with important consequences; after all, I
have been married, widowed, endowed with children,
had business successes and large and small failures,
but nothing has had the singular effect on my life than
the experience of that summer did, and nothing is likely
to again. Even now, as I contemplate what may be the
end of my days, that fearsome possibility ranks below
the emotional pain of those few months three decades
past, because it was then that I found that the world I
had thought to exist, never had, and what is there in
life more fearful than in discovering that you are all
alone, after all, and that the universe of safety nets
you assumed was, isn't, and if you want a world that
makes sense, it is up to you to create it or else learn to
live in the one you find yourself in.

*If he'd happened to be there expressly to spy on me,
or if it had only been an accident, his standing there, I
still don't know, but however it had come to pass, there
he stood, feet spread wide, hands spatulate on hips,
and I could see by the color of his eyes that were black
not brown as was their normal color when not enraged,
and everything slowed down in the universe at least
my personal universe so that it was like a movie and
what I remember most was his odor, a sexual smell I
can say now, but then I had no description for it, not*

*with words at any rate but now these thirty years hence
I can say with assurance that my father's smell was a
sexual one and a threatening one, not threatening as
you might think, not sexually, but in a purely physical,
dangerous way.*

*I had permission to be there; Grandpa himself had
given me the okay over the phone, even told me where
to look, but knowing this did no good to my inner peace
as I also knew that Dad would never believe me, not in
a million, trillion years, and that this was going to be
a trial that would be swiftly over, with a foregone con-
clusion by the judge, jury and hangman standing be-
fore me, my father.*

*"So," he said, and that was all he said for a mo-
ment. My heart pounded against my ribs and I knew
my face had caught fire and it was hard to breathe. I
had the sock in one hand, its weight suddenly much
heftier than before and I wished it invisible or at least
back in the closet where it had been five minutes ear-
lier. I wished it was five minutes earlier and Dad had
just walked in and asked me what I was doing in
Grandpa's room and there would have been the oppor-
tunity for a lie and not this, not this scene, me stand-
ing in front of Grandpa and Grandma's bed, Grandpa's
gray sock in my hand, half the contents spilled onto
the bed between my father and me and half still in the
sock I held.*

"Regular little Jesse James, aren't ya?"

"Grandpa said I could," I said, knowing even be-

*fore the words were out he wasn't going to believe them.
"Call him up and ask him," I said, a sudden idea strik-
ing me. If he talked to Grandpa, Grandpa'd tell him it
was okay and wouldn't tell him what it was for. As a
matter of fact, it would be impossible for Grandpa to
tell him what it was for as I hadn't told him nor had he
asked the use of the money.*

*"Toast is in Houston. In the hospital. He's sick. I'm
not going to call him up and tell him his grandson is
robbing him. He thinks the world of you. I'm not going
to make him sicker than he already is. If he's to get
well, he doesn't need to know about you. No, boy-o, this
is between you and me."*

*I tried to duck, but he was too fast, grabbing me by
the shirt and arm, pinching my bicep with his strong
fingers.*

*"Put the money back," he ordered. "Put it on the
bed. I'll take care of it later."*

*I did as he said. I emptied my pockets, piling the
money back on the bed, trying to think of a way out of
this. Every atom in my body was in fear. I had never
seen such a look on his face as there was now, not even
at his angriest. It was like the face of God Himself, the
face the fire and brimstone preacher Mom listened to,
conjured up, Sunday mornings.*

*We went downstairs and out through the kitchen,
him yanking and jerking me all the way. Out the back
door and down the path of stones set in the dirt, past
the yard I was supposed to have mowed but he had*

instead, and there was nothing I could do to save myself.

I couldn't; I just couldn't tell him the truth. What the money was for. I'd worked months for this. I couldn't show him until it was finished. I was going to get a whipping, I realized. I'd take it, but I still wouldn't tell him. I made up my mind. A beating was just physical. I'd get over it. It wasn't like I'd never had one. I wouldn't die.

I just had to endure what happened next. He'd realize what he'd done when I showed him the boat on his birthday and then he'd be sorry. It would just make things that much sweeter. I kept telling myself that.

"Bend over, boy."

I grabbed the edge of the work bench and did as he ordered. We had been here before.

Whomp! His belt laid across my back, whistling just before it struck. My back! I remembered the snake. My stomach rolled, then began to tighten up.

Crack! The skin broke, I could feel it give and knew I was bleeding, but oddly, there wasn't that much pain. I don't know why my eyes watered.

KaWhap!

"What were you going to use that money for?"

"Nothing."

Whap!

"I can keep this up all day. I will until you tell me, you little sneak."

Ssss-crack!

A different kind of fear came over me. There was no way out of the shed. He'd locked it behind us when we came in. He'd not done that before, in the past times of punishment.

I could feel the blood flowing down the small of my back into my pants.

Ketchup bottles.

Almost empty ketchup bottles.

That's what it was like; what I was reminded of.

Days and weeks and months, and in some ways years, I had waited for this moment. When that three o'clock bell clanged, I was going to be out of that door, flying like Jesse Owens for Olympic gold, for the restaurant, blasting across lawns, cutting through vacant lots, leaping over fences.

To go fishing.

With my dad.

For the first time since we had moved to Texas. Six years before. When I was eight years old and little. When things had been different.

Ketchup bottles with a bit of red in the bottom.

You're alone in the house, hungry as an orphan, and all there is to eat is a dried-out hunk of cold lunch meat with the corners turned up, and some bread, and the bottom inch of a ketchup bottle. You tip it over the bread and stand there. It doesn't move. No, it moves like a glacier. You shake it and smack the bottom with

the palm of your hand, but nothing will do except to wait until it creeps down, a tenth of an inch at a time, stretching itself out in a long red line. Then: it drips, separate little globs of blood, not the main body of the ketchup, just frustrating little teasers, not ever quite enough, so you go through the same thing all over again; two and three and four and more times, thinking about everything in the universe, but especially remembering all the times you had a full bottle of ketchup and didn't care; you wasted it, putting so much on your sandwich you had to scrape off the excess with your knife and rinse it in the sink, wishing you had that excess now: and then; at last you have your sandwich, all the ketchup you're going to get has come out.

That's how watching that damn clock was. The last inch of the ketchup bottle. I was hot to be out of there and the long hand of the clock knew I watched it, seizing up just when I expected it to drop to the next black marker, holding, holding, holding . . . making me crazy . . . and then . . . plink! It would fall, and the whole process started up all over again.

Four more ticks and school would be done for another year. Eighth grade would be history. Sweat poured down twenty-seven backs, and twenty-seven sets of lungs exhaled pent-up air each time the minute hand moved. Twenty-seven pairs of eyes were connected to that minute hand, even the eyes that belonged to the class grinds, Missy Gilbert and Duane Clinton Jones. Mrs. Clopys, Old Scratch, so named for

her incessant habit of reaching inside her blouse to adjust her bra, was talking, her hands waving, chopping down at the end of her sentences like she always did, like a butcher making hamburger out of verbs and nouns, but not a one of us was paying attention, not even the grinds; we were all willing that clock to go faster. Destin Dean punched me on the arm. And again. For the third time. I glared at him with little effect; he just grinned and did it again, and of course I hit back at him, meeting nothing but space and the icy glare of Old Scratch.

"You. Corey John. You'll stay after. Thirty minutes."

I groaned. Not aloud. I didn't want another half hour tacked on to my sentence. Dad wasn't going to wait. I knew he wouldn't wait. Not my father. Not three minutes, and certainly not thirty minutes. He was absolutely military about being on time.

Six years since we had gone fishing together. Six years since we had done anything that involved just the two of us. Oh, once we went dove hunting with a bunch of other people, and there were a couple of other things, but nothing really special. This wasn't anything all that great either, at least as far as great things went—it was just going after panfish, down at the dock, but what made it special was that it was going to be just him and me.

It wasn't his fault we didn't do things together. Not really. There was just always so much to do at work. Dad worked for Grandma, in both businesses, doing

whatever needed done, whether that meant waiting on customers in the restaurant, driving one of the cabs, fixing the air conditioner, picking up shrimp and flounder for the supper trade down at the docks, any of a hundred different tasks, and when he wasn't putting in fourteen and sixteen hours a day, six and seven days a week, he was just plain bushed.

So, no, I didn't blame him for not doing more things with me, but I wasn't any less disappointed. For two weeks I had waited for this day, and now Destin had ruined the whole thing. I wanted to hate him, even though he was my best friend, and for a minute I did, but I couldn't stay mad at him. I knew he hadn't meant to get me in trouble with Old Scratch. Trouble just seemed to come around wherever Destin was. I looked over at him with my maddest look, but he just stared down at his desk. I could see he felt terrible. Good.

Then, naturally, while I was engaged in thinking of ways in which to torture and eventually kill Destin, the clock hand snuck around and the bell rang and twenty-six bodies were launched from their seats toward the door, room 224 adding its contribution to the sea of lemmings I could see streaming by outside.

I'm dead, I thought. Dad'll be there at the restaurant, waiting for me, and I won't be there. He won't abide my lateness. That was his biggest single aversion. One of the biggest, anyway. He'd wait ten minutes, tops, and then he'd leave. Maybe I could get him to commit to another date in only three more years

instead of six next time. Maybe by the time I got out of high school. Damn Destin!

Briefly, I considered just getting up out of my seat and leaving, but I knew that was out of the question. It'd be even worse for me if Dad found out I'd defied my teacher. Not that I had any delusions about his finding out about this detention. Odds were ten to one Old Scratch would be burning up Ma Bell five seconds after I left the school. There was nothing to do but wait and hope that by some miracle he'd be late himself or would wait longer than I thought he would. Fat chance.

The first fifteen minutes of my sentence took hours to pass and then the rest flew by in only a second or so. I didn't care any more. Summer vacation had gone ahead and started without me, and Dad was already mad and gone, so there was plenty of time.

I stood up to go and Mrs. Clopys looked up, her hand busy inside her blouse rearranging her strap. She waited a full, fat second before awarding parole with a barely perceptible nod. I gave the same nod back, both of us as formal as penguins, turned militarily, and stalked out of the room.

"Bye, Mrs. Clopys," I said, in my best Little Lord Fauntelroy voice. "Have a fun summer."

And eat dog shit, I added, not out loud, as I made my way down the cool, dark hallway to the end of the building. Blast furnace temperatures smacked me when I stepped outside. East Texas heat, the kind not

available anywhere else; heat with sand and salt and chili peppers in it. A maroon Studebaker cruised by just then and I jumped, but it was a President. Ours was a Champion. Same color, though.

Destin was there, waiting for me on the sidewalk, too many teeth in his smile.

I glared at him a minute to make him sweat, and then said, "It doesn't matter," letting him off the hook. It wasn't his fault my dad was so strict.

"There's the whole summer. Maybe he won't be so mad," I added. Sure, and robins mate with bulldogs and pigs fly south in the winter. Destin knew how much I'd counted on this fishing trip, and how Dad had arranged to take off work for it, something he'd never done before. I knew Destin was feeling lower than a turtle's belly for getting me into trouble with Old Scratch, and it had taken lots of guts to wait for me, considering.

I shouldn't have let him off so easily. As soon as I did, his mouth turned up with the speed of light, forgetting his guilt, chattering and jumping around, punching the air with his fists. I got mad all over again, and then cooled down just as quickly. There was no way you could stay angry at Destin; he hadn't a truly mean stick in his frame. I watched him for a minute. He had a habit, a tic Mom called it, of blinking his eyes all the time, only not actually blinking them; he sort of slammed them down hard; that, plus his eyebrows were arched, like a girl's, which gave him a per-

manent surprised appearance. I stuffed back my grin
and began walking ahead of him, ignoring his antics.

We walked another half block without speaking,
and then Destin said, "Are you mad?"

"Naw."

I turned around, kicked at a rock, and it flew right
at him. He jumped and it missed.

"Not really. Dad's gonna kill me, though." I kept on
walking, staring at the ground ahead. I could feel his
eyes on me.

"I'm sorry, Corey." His voice came from behind
where he lagged, half a step to my rear. "Say," he
changed the subject in mid-sentence, "we're still going
tarpon fishing Saturday with your grandpa, aren't we?"

"Absolutely," I said. "Maybe." The tarpon trip had
slipped my mind, amazingly. Grandpa had promised
Destin and me tarpon fishing the first weekend of va-
cation. That promise and the excursion today, with
Dad, were all I'd thought about for weeks and weeks.
Now, half of the deal was down the toilet. Maybe the
other half, too. Dad could be so burned up he'd make
me stay home on Saturday too. Crap!

And I was crazy, absolutely bonkers to catch a tar-
pon. King Tarpon. That's what all the fishing and sport-
ing magazines referred to them as. There wasn't an
article printed on tarpon I hadn't read, and probably
more than once. There were plenty of the huge fish
around our area, just out in the Gulf, but I'd never had
the chance to go after one. I'd read and thought and

dreamed so much about catching one, however, that I knew exactly how it would feel to have one of the monsters trying to bust my South Bend salt-water rod.

I could feel him on my line—had felt him on my line, in my imagination. One hundred and twenty pounds of silver behemoth, jumping and twisting, blocking out the horizon, he was so colossal, tearing my arms out of their sockets. I dreamed about him at night; I dreamed about him in algebra class; I dreamed about him at the supper table. For months, most of my waking thoughts had been of my imaginary tarpon, leaping, slicing through the water in a silvery wake, sounding fathoms deep to throw my lure; I'd pictured him in every conceivable position and pose my mind could whip up. Months and months and months King Tarpon had preoccupied me. Years. Ever since the first glimpse of the first picture of one in *Sports Afield*, when I was eight years old and just moved to Texas. I knew every silver-dollar-sized scale on his body, knew just when he'd jump trying to throw my hook, and knew exactly what he'd look like doing it. I knew how long it'd take to land him: an hour and twenty minutes. I had already caught him a thousand times. I knew that fish!

My reply to Destin's question, therefore, was as much an attempt at reassuring myself as it was a truthful answer to what he wanted to know.

"I think so, Dest." His face looked like more of a question mark than usual. He wanted to go on the trip

nearly as much as I did, I could tell. "Dad might not let me go, for being late today." Destin shrugged and gave me another shot on the arm. He would be hugely disappointed if we didn't go, but still it wouldn't have the same significance for him. He'd already been tarpon fishing once. With his own father. On one of those rare times Mr. Dean had been sober.

We parted at the corner, east and west, me to the restaurant and Destin home to throw his shoes away for the summer. I already had mine off and under my arm. That was one of the nice things about going to school in Texas. You weren't required to wear shoes except for the first and last days of school. Until next year, that is. Ninth grade. In high school, you had to wear shoes every day.

Maybe Dad was still waiting for me. Maybe he had forgotten what time we were to meet. If he was still there, maybe I could make up some story about why I was late. We were just going fishing off the pier at the river for piggies and croakers, panfish. Maybe . . . maybe, he had gone after the bait and had to wait in line and was late himself. I considered all the possibilities and wished desperately for them to be true. I wanted to go fishing so much with my dad.

I hoped he wasn't mad.

I hoped he hadn't noticed the time.

I hoped we were still going, no matter what.

I started to run. It was useless, but then . . . anything might be possible on the first day of summer

vacation when you are fourteen years old and believe
in hope.

Grandma's Drunk

All the way downtown, I used lawns, head down, alert for nettles and stickers. When I had to cross a street, leave the coolness of grass, I ran faster, landing on different parts of the soles of my feet. First-day-of-summer-vacation-tootsies were too white and thin-skinned for concrete baked at ninety-plus degrees.

Then houses and lawns ended, and shops and sidewalks began, and I had to sit down in defeat, halfway up the first red-hot block, and put my leather shoes back on, my face as fiery as the sidewalk, as passersby stared at me sitting in the middle of the traffic stream. I walked, rather than ran, the rest of the way, stepping with long, stork strides.

Our restaurant—The Oyster Bar—sat directly

across City Park, a small square stretch of grass, pome-
granate and oleander bushes, and one huge, towering
palm tree that formed an island in the middle of City
Square, bounded by the Tarpon Hotel on one end, the
Brazos River behind that; another park, similar ex-
cept for the lack of a twin palm, on the other end, with
the two side streets that boxed in the park crowded
with small stores and shops, the Cafe being one of
them. I loved the park, even the mean old crow that
nested in the top of the palm and waited for me almost
daily. Waited until I was halfway across the park, fully
committed and equidistant from either side, and then
dive-bombed my head, trying to peck a hole in my skull
at kamikaze speed and attitude. I hated that crow, but
in a way it was fun to try and outwit him. I seldom
did.

I came around the corner of Broad Street and there
was the park. Across it I could see the cafe. There was
no use looking for Dad's car; it would be parked in back,
and I couldn't make out the numbers on the cabs at
this distance to see if number 401, the cab he ordi-
narily used, was there. I paused at the corner and just
stared across the park, a little to delay the confronta-
tion I knew was coming, but mostly just because I liked
the way the square looked. It was one of my favorite
places in town. It was the action part of our town, the
social center of the hive.

I drank in the panorama: Stick-shifted Hudsons,
burning four-gallons-for-your-dollar-gasoline, rolling

with arrogant indolence along the sun-cracked concrete
of the avenue, their headlamps, glassine and bug-eyed,
staring blankly ahead, gliding on fat balloon tires that
whispered and hissed in the crackling Texas sunshine,
round-shouldered Chevrolets and lime-green Studebakers
and the occasional DeSoto passing one another and
the people in them waving to each other. On the
sidewalks, bargain-mad housewives, sensible in their
white cotton Woolworth blouses, sloughed up and down
both streets of commerce, searching with fretting eyes
for sales on children's underwear and Buster Brown
shoes, or the best buy in men's khaki shirts, their pace
slowing an imperceptible beat whenever they chanced
to pass the open, beery doors of Red's Bar And Tap,
next door to our cafe, and the arctic blast of two tons of
Weatherking freoned air. Their heads would tilt like
suspicious rabbits as their ears were assaulted by the
gravelly roar of the Wurlitzer pounding out the rhythm
of Hank Williams age-old complaint against women,
". . . *yore che-e-atin' heart*," it went, heard by me clear
across the square, "*will ta-yull on y-ou.*"

I crossed the square, eyes nervous and alert, but
sure enough, halfway over, here he came.

"Yow!" I yelped, beating at the rush of black feath-
ers. He grazed my hair, lightly brushing it, before he
rose straight up in the air, and I was running as fast
as I could the remaining distance. Crows aren't hu-
man; they can't laugh, but this crow laughed, I swear
it. I cussed at him, raising my fist and shaking it, but

I knew the very next time I crossed the square, he'd be diving at me again. Someday, I was going to bring my pellet rifle to the square and take care of that bird.

My eyes briefly stopped at the sign on the window I'd seen thousands of times—"Oyster Bar—Jax Beer." I walked up the steps and pushed open the heavy glass door. Frosty air chilled the sweat on my forehead, and my ears twitched at the sound of Webb Pierce booming from our own Wurleitzer stuck up against the wall in the center of the room, between two booths. The stink of stale beer, cooking grease, and fried shrimp rose to my nostrils, and I drank it in, deep down, sucking in a smell I never got enough of. It was a grown-up, adult smell, exotic and mysterious and dangerous.

The door wheezed shut behind me, pushing back the heat and the honking of Packards and Studes, locking me into a vacuum of air-conditioned air, murmuring voices with a hint of East Texas twang, and the tinkle of cutlery on steak plates; the clink of long-necked beer bottles on glasses.

Smoke from a dozen cigarettes layered the air; the residue from a hundred thousand others covered the flowered wallpaper, once green, now greenish-yellow; and, under the aroma of nicotine and beer lay the faint scent of disinfectant. A dozen customers sat in pods of twos, threes, among the one or two solitary eaters and drinkers. The serious drinkers huddled in the back, the office workers on extended lunch breaks, flirting with the security of their jobs through mid-afternoon

dalliances, laughing with louder voices near the front. Some of the more regular customers waved at me as I stood there adjusting my outside eyes to the dim florescence of the bar. We, the family, referred to it as the restaurant, or the cafe, but in truth it was just a bar that happened to serve food. Booze was its raison d' etre. It was like a church for drinkers; Red Sovine, Patsy Cline, and Hank Williams provided the choir, courtesy the Wurleitzer; the communion was red beans and rice, hot enough to interest the Devil, and Grandma took the offering, after every serving of Pearl or Lone Star beer.

I stood there until my eyes became accustomed to the darkness, and then I looked about for my dad. I couldn't see him, but reasoned that he might be in the kitchen.

"Sugar Man!"

I squinted through the smoke haze to find her, and located her clear in the back, at the very last table. There was no mystery about who had yelled; only my grandmother called me "Sugar Man"; everyone else used my given name, Corey, except for upset or angry teachers or parents, and then it lengthened to "Corey John," and that's when I knew it was time to run, hide, or come up with a believable story.

Grandma was sitting facing me, at a table with Inez, the mammoth Negress who'd helped raise me and my sister Doc, and was now Grandma's cook in the restaurant and part-time maid at home, since Doc

and I were old enough not to require a nanny any longer. Inez's back was all I could see of her, but I knew that back and all its moods. It still inspired dread in me. Inez was The Law. Or had been, when I was little. She still seemed to be under the impression I was a baby. She was easy to recognize. Two hundred and fifty pounds of African royalty in a white cotton waitress uniform would stand out, even in the middle of the main aisle at the spring white sale at the J.C. Penney's down on Broad Street.

I walked back, detouring to behind the counter along the way, boosting a bottle of Dr. Pepper from the chrome-lidded cooler. At the table, I leaned down and gave first Inez a kiss and then went over to Grandma for her kiss and hug, sniffing her unique blend of cigarettes and perfume. And whiskey. That was a different ingredient to her normal fragrance, but I refrained from saying anything, plopping down in a chair and handing Inez my pop bottle. She took it without a word, stuck it in her mouth and twisted the cap off with her great white teeth, handing it back to me, opened. She bent the cap between her fingers and tossed it on the mound of dead cigarettes filling the ash tray. Grandma's cigarettes. The tray was overflowing with half-bent, used Pall Malls.

It was our ritual, mine and Inez's, a little ceremony I never tired of, and one which gave Grandma fits.

"Stop doing that, Inez," she ordered, like she did every time, and Inez ignored her like she did, every time.

Something was wrong with Grandma. Even aside from the fact that she had obviously taken a drink. Never had I known her to do that. Something was definitely wrong. I couldn't put my finger on it, but she didn't look right.

It wasn't her hair. It was up in its usual brown net. How long it was, only her and presumably Grandpa knew. If even he did. There was something about her appearance though, something in the way she was sitting. She always reminded me of an Old English bulldog, short and squat, no figure at all, just a chunk of a woman, solid and sturdy. She wore glasses, attached by a string that went around her neck for when she didn't need them. Another string held her cigarette holder. The holder must have been a good eight inches long by itself, and when she stuck a Pall Mall in it, everyone in her immediate vicinity stayed on their toes. Especially considering the way she liked to jerk her head around, talking to ten people at once and snapping her head in the direction of the subject she happened to be addressing. "Subject" was an excellent word; she ruled the restaurant and all its assortment of waitresses, bartenders, cooks, dishwashers and customers. And Dad. At least I was aware he felt that way. He was always crabbing about the partnership she had promised him which hadn't yet materialized, and, whenever they came into the same common area, it was like two prize-fighters had entered the room and were circling each other, testing the opponent, this

probably visible only to me as they used extreme politeness with each other at all times, and to an outsider the couple likely appeared to have an ideal relationship.

"Your dad left," she said, and whatever frail hope I'd held onto, fell to the floor in a pile of crystallized dust. She knew how much I'd counted on this trip, but one thing about Grandma—she never let a little pain get in the way of dishing out the truth. In a way I was grateful for that quality. It got the hurt in things out in the open quickly, and you knew where you stood. You never had to worry about bad news sneaking up on you around Grandma. She just kind of smacked you in the face with it.

"I figured."

"He did wait twenty minutes," she said. "Maybe twenty-five. I think he might have waited even longer, but Buster wanted to go over to Galveston and he took the chance to make some money."

I knew Buster. He was a regular at the cafe, a regular drunk, and made many such trips to Galveston, the closest town where you could get hard liquor. Brazosport was a dry county, and if a man wanted a bottle of whiskey or vodka, he needed to go to Houston or Galveston to get it. Grandma could serve beer and wine, but that was all, and all she actually stocked was beer, figuring wine was something only sissies and Yankees drank, sissies and Yankees being terms used for the same person, in her view.

Bitterness welled up, even though I'd known the
very second Mrs. Clopys had ordered me to stay be-
hind that Dad wouldn't wait, but that didn't lessen
the disappointment. A small fist twisted in the pit of
my stomach and my throat ached from holding back
tears. I was too old to cry, but I felt like it anyway.

"Maybe we can go some other time," I said, trying
to sound as if it didn't matter.

"Yeah, maybe," Grandma said, cocking her head to
the side and squinting as she took a drag on her ciga-
rette. She was on the second Pall Mall since I'd sat
down. I noticed the glass on the table beside her. She
reached down and took a healthy swig. The smell hit
me. It was whiskey. I'd never known my grandmother
to take a drink before. She was always swearing she'd
never touch the poison, not after thirty-some years of
observing what it did to the people she sold it to. That
was what was different. That, and her eyes. They were
all red, and looked smaller than usual. Tiny. I realized
then that she didn't have her eye goop on. Rather, it
was on, part of it, but it was smeared. It made her
eyes look about half their normal size. Crying and hav-
ing a drink. Something had happened. Something bad.
Immediately, for no reason, I wondered where Grandpa
was. I don't know why that crossed my mind just then;
there was no particular reason for him to be there.
Sometimes he was, this time of day—his shift at the
sulphur plant didn't start until four in the afternoon—
but it was just as normal for him not to be here before

he went to work. Maybe they had had an emergency at the plant. They were always calling him to come in and do something when somebody pulled the wrong switch, goofed up. He'd have to run out and take care of it before the town blew up. When he popped into my mind, my next thought was to wonder if Dad would let me go with Grandpa on Saturday on our tarpon expedition. The best strategy would be to not even mention to Dad where we were going and hope Grandpa didn't bring it up himself.

Grandma took another sip from her glass, and reached down for what I could see was a Wild Turkey bottle. She poured three fat fingers into the glass and set the bottle back down on the floor. She must have thought it wise to keep the bottle out of sight; some of the booze- hounds in here would cut a throat for a bottle of whiskey. Inez was drinking Dr. Pepper, same as me, which she held in her catcher's mitt of a hand, like she was the Queen of Holland, little finger extended just so. I noticed the contrast between the drinking styles. Grandma held her glass like a man did, all her fingers wrapped around the glass, a firm hold on it.

"Grandpa's sick, Sugar Man."

She must have been crying for a long time for her eyes to have gotten as red as they were. I felt that fist in my gut grow harder, bigger. I took a quick pull on my Dr. Pepper. It had gone flat.

She just went on looking at me, eyes blinking, and then laid her head down on the table, on her arms.

She didn't make a sound. At first, I thought she'd passed out, but I could tell she was weeping. I darted a glance at Inez, who shook her head at me and placed her huge brown hand on Grandma's head, patting it. She used to do the same to me when I was little and had fallen out of a tree or scraped my knee roller-skating.

For several moments, which seemed to hang suspended in air, we sat there like that, the three of us, me staring furiously at my knee which was jumping up and down with a mind of its own, Grandma crying silently, and Inez patting her head and stroking her brown hair in its net. I could see the white roots under the net, and realized for the first time that Grandma used hair color.

It was like we were frozen into some sort of tableau, and then, just like that, Grandma raised her head and it was all over. She reached into the pocket of her white uniform and extracted a small, wadded-up handkerchief and dabbed at her eyes. She kept it in her hand, in her lap, and looked up at me.

"Corey," she began. I knew it was going to be serious, weeping notwithstanding. She never, but never, called me Corey.

"Corey, your grandfather has cancer. Lung cancer."

Ugly words. Those were the ugliest words I had ever heard uttered. Lung cancer. "Lung" was an especially ugly word. I kept hearing her voice say the syllable over and over in my head.

Lung.

Lung.

Lung.

A blunt, squalid little turd of a word. I kept seeing our eighth-grade health book, the page with the artist's drawing of the insides of the human body, and I could see the lungs, and, for some reason, I saw it with worms crawling all through it. I was suddenly aware of my own lungs as I inhaled and exhaled. I could almost feel their shape and their obscene good health; their pinkness.

"Is he gonna be all right?" It was all I could find to say.

She opened her mouth, cleared her throat, coughed, and then got out, "Why, sure, Sugar Man. He's going to get chemotherapy. And radiation treatments. It's new, but they say they expect great results. It may even kill it all. The cancer."

It was the first time my grandmother had ever lied to me. I don't know how I knew she was lying, but I did. She was also lying to herself. That seemed even worse.

She took another gulp from her glass. Her strong, spatulate fingers were shaking. I didn't know how much she'd drunk already, but she didn't seem drunk, not exactly, although I had seen the bottle and more than a third of it was gone. Her words were clear and crisp; she might have been sipping Dr. Pepper, by the way she acted.

"He's in some pain. Shit, he's in a lot of pain! That's why he finally went to the doctor. He's felt pretty bad for over a year, now. Damn fool!" She paused, eyes blinking rapidly. "I told him months ago to go get a check-up." She sounded like I did around Dad when I had done something wrong. Guilty. I couldn't figure that one out.

She picked up her bottle and this time poured the glass so full it almost slopped over. She sat the bottle on the table before her and glared defiantly out at the room. I couldn't see, turned the way I was, but I knew no one would be foolish enough to stare back.

"The doctor says it may get worse. More pain." She wanted to tell me something, it seemed, but was having a difficult time getting around to it.

"He may die," she said at last, her voice so low that at first I didn't catch what she was saying. Then, like an echo, it hit my brain and penetrated.

"I don't think he's going to be up for your fishing trip this weekend."

I just sat there.

"He's going to get better though, Corey. We'll make him!" She said it with an angry tone to the words and knocked back a huge slug from her glass.

"It's okay, Grandma. About our trip. I just want Grandpa to get better."

We were even now. I was feeling low-down and mean. I was lying right back to her, just as she had to me a minute earlier. I had crazy, mixed-up feelings,

sinful, horrible feelings. One second I felt like blubbering my head off about Grandpa's illness, and the next I didn't care. All I could think of was that Dad and I hadn't gone fishing today and now Grandpa and I weren't going either. It wasn't fair! I'd counted on, dreamed about, planned on, both trips for weeks upon weeks. I hated Old Scratch for making me be late, and I hated Destin for getting me into trouble in the first place, and I hated Dad for not waiting, and I hated Grandpa for getting sick, and most of all, I hated myself for the way I was hating everyone.

I don't know why; I jumped up from the table, knocking over my pop. I didn't stop to pick it up, just ran out the back, through the kitchen, down the weedy path past Inez's trailer, across the alley to the vacant lot; only I didn't make it to the vacant lot. Blind with tears in my eyes, I ran smack into a fence post and went flying backwards, my chest on fire where I struck the post. I stepped back toward it and hit it as hard as I could, experiencing a severe pain in my knuckles that felt strangely good. And then, I just sort of sagged down beside the post, my mind raging, images of tarpons and Dad and baiting hooks, and . . . and . . . Grandpa.

Grandpa had cancer. Cancer. I had focused on the word "lung." Lung meant nothing. Lung was innocuous. The word that hadn't penetrated my thick skull was "cancer." "Lung" was just ugly; "cancer" was horrible, horrible, horrible. It was terrifyingly absolute. It was absolutely terrifying.

You died.

Cancer was final.

It began to dawn on me in stages, slowly, inexorably, and as it entered my awareness, the import of our little fishing jaunt began to diminish, fading away beside what was happening to Grandpa. Grandpa was going to die!

He couldn't die! He was the best friend I had in the world, better even than Destin. He knew me better than Dad or Mom. Hunting for tarpon shrank and moved away before the onslaught of this new information my brain was processing and filtering out to me.

I sat slumped, glazed eyes staring sightlessly at the ground, not even bothering to brush off the red ant that crawled up my leg, images of my grandfather filling me. Remembering. Things we'd done, trips we'd taken, the times we'd gone gigging for frogs, the crabbing forays, the dove hunt with him and Dad and Destin and Uncle Joe, the way his eyes had been when he'd given me my first cast net, the first sign that you were becoming a man in these parts. Always, I had imagined Grandpa immortal, indestructible, that always he would be there, tall and strong. That he might not be had never been a possibility. Not Grandpa. He was Gary Cooper in "High Noon," Alan Ladd in "Shane." He was the one who helped me to understand that Dad really did love me during those times I was sure he didn't.

I sat among the weeds, beside the post, aware but

not much caring about the wetness that seeped up from the ground into the seat of my pants, ignoring the car that rattled through the alley, stopping briefly beside me and then moving on. I sat there and let the tears flow—blinding, scalding-hot tears.

I cried for forever.

"Bend over, boy."

I grabbed the edge of the work bench and did as he said. I had no choice. He was my father.

A Long-ago Fishing Trip

Forever lasted around a half-hour. Thirty long sluicing minutes of waterworks I thought would never run out. I had no doubt I would dissolve into salt water. All the moisture would exit my body through my tear ducts and I would then blow gently away on the wind.

Every time I edged close to stopping, hiccuping and gasping, inhaling great gulps of air, I would catch another image of Grandpa and me doing something together, and start up all over again. I sat there, sobbing, wondering how long it would take before I died from grief. That picture of the ketchup bottle popped into focus again, dripping and inching forward ever so tantalizingly, and then I stopped, just like that; there were no more tears, and I knew I'd never cry again,

not like that. All the tears were used up.

I walked home unaware of my surroundings. I didn't hear anything, birds chirping, kids yelling, cars honking, nothing. I don't recall seeing anything either, but I must have since I arrived home okay, not having walked into any speeding cars.

I was in hopes no one would be at the home, but that was unlikely as we all lived with Grandma and Grandpa in their house. It was huge, five bedrooms, but sometimes became very small, like when Dad was yelling at me from downstairs. I was in luck. The house was empty.

It wasn't that I was thinking of anything in particular, not even Grandpa. My mind was a blackboard with no writing whatsoever on it. I went into the house and up to my room and changed clothes, putting my brown corduroys and orange dress shirt away till next fall, and probably forever, at the rate I was putting on pounds and inches. My shoes, I threw as far back into the closet as I could. I didn't want to even think about high school and losing my barefoot freedom. There was still the rest of the summer to enjoy. The first day had started out about as badly as it could have, but there was a long way to go until the fall and such onerous realities as having to wear shoes, and thinking that brought up a picture in my mind, and a smile to boot.

The boat! I remembered my project. It was just the ticket to get my mind off Grandpa, Dad, the day's events thus far.

The boat was pure inspiration, a flash of pure genius. The idea had come to me over a year ago, but I hadn't begun taking it seriously, implementing it, believing I could carry it off, until two months ago. Once started, though, every minute I could spare went into the project.

All of my life, or so it seemed, my father and I had been at odds with each other. I tried my best to please him; I wanted to please him, desperately wanted to please him. I wanted him to smile when he saw me, tossle my hair and throw me up on his shoulder when I was younger; now, I'd settle for just an arm flung around my shoulder and a hug once in awhile. But it never happened, no matter what I did. Before we moved to Texas, I think it was different. We had done things, father and son things, but that had started changing six years ago when we came south to live with Grandma and Grandpa.

In some way I couldn't fathom, I had become a big disappointment to him. I just didn't seem to fit, anymore, his idea of what his son should be. I liked to read, a vice he despised; only sissies or girls read books. I abhorred things mechanical, things a "real" boy should enjoy, if he was any kind of boy at all. In Dad's view, that is. I guess in a lot of people's views. But other people's opinions didn't matter. His did.

There was this one incident that happened when I was about eight, right after we'd moved south. He came up to my room with this fierce scowl on his face and

wanted to know what I was doing. It was evident what I was doing; I had the book right in front of me on the bed where I was stretched out prone.

"I'm reading *Robinson Crusoe*," I said. "It's about this man that . . ." I started to say, but never got to finish.

"I know what the hell it's about," he snapped. "I'd just appreciate a little help when I'm working on your bicycle."

It wasn't much of a row, probably nothing to get too excited about, but that seemed to stick in my mind as being about the time things began changing. I mean, he didn't beat me up or anything like that, but it was the first time I can remember a sense of deep-down disappointment from him. I could just tell, somehow, that he thought my reading that book was the worst thing I could be doing, that it was something *his* boy shouldn't be at, and I guess it was the first time either of us realized I was going to be interested in things that he wasn't.

People did things with their hands, that's what impressed him. Me, I couldn't remember the difference between a Phillips and a flathead screwdriver until I was almost eleven, and even then I'd forget. That's why I was so proud of what I was attempting to do for him— build a boat from start to finish. It would have been much easier to make something else—an end table, for instance—but building a boat! If I could bring that off, he'd be amazed, although probably not any more

than I would!

It seemed the harder I tried to be the kind of boy I thought he wanted, the worse it would get. For example, I'd go out and tear my bike apart, carefully timing it so I knew he'd come by and see me all greasy and dirty and with a tool in my hand, and what would take place instead of the scenario I'd dreamed up, would be I'd get the damn thing in pieces and then wouldn't have the foggiest how to resurrect it, and would have to go find him to help me. Disgust would fill his face; he'd rant and rave and carry on about how no other kid he'd ever known in his life could create such a mess. Always, there would be an important and vital part missing. I could never figure out how it happened, but inevitably there would be a nut or a bolt or a cog-thing that vanished, and then we'd have to make a silent, jaw-muscle twitching run to a hardware to find a replacement, and what had been intended as a step toward making him like me, would end up as a fiasco that drove us even further apart.

Then, last year, I got this fantastic idea to do something totally on my own, in secret, that would show him once and for all I could do something mechanical. Manly. Then, he would love me and be proud of me and put his arm around me.

I decided to build a boat.

For him.

A fishing boat.

Nothing fancy; just a step beyond a john-boat, but

it was taking more skill and determination that I would have ever guessed I possessed. There were moments when I could have used help from someone, but I was bound to do it all myself. I got the plans from the library, and I'd been constructing it in an old shed down at the docks. I knew everyone down there from years of fishing off the piers, and the old guy who owned the shed agreed to let me use it, being as it was pretty much abandoned anyway, and all I had to do for the use of it was keep it neat and clean and locked up.

I snuck tools from home and borrowed others. And rented still others. It took over a month and a half just to get the frame done. I learned to use a lathe, a sander, power saws. I talked my way into the use of the workshop at Sandy's, one of the smaller dry-docks, by cleaning up the rest of the place in exchange for the use of their machines.

I collected pop bottles and mowed lawns for the money I needed. I collected a lot of two-cent pop bottles! Plus all that I had saved over the last couple of years. Over two hundred dollars.

I bought the best redwood you could get for the main planking. With hard-earned dimes and quarters I purchased the most expensive glues and caulking compounds, and spent precious funds for the finest varnishes. Twenty dollars alone went for just the nameboard. I chose mahogany, sanding and polishing it to a mirror finish, etching the name in Old English lettering, from a stencil specially ordered. It shone like

amber, and every time I came to the shed to do some more work, it was the first thing I looked at.

The "Bob-A-Long."

That's what I named it, what the nameboard read. Dad's name is Robert. I figured he'd get a kick out of it.

I rented a spreader and learned how to use it by basic trial and error, ruining over thirty dollars of redwood until I could get the right tension. Mister Sandy himself let me use his lathe to groove the headboard, nearly slicing off my thumb once, and I washed cars in the neighborhood to earn enough money for the special brass screws I wanted to use.

Every day, I checked the slots in every parking meter in town for coins that hadn't been eaten by the machine.

On Saturdays, I carried the huge reels of film up to the projectionist booth at the movie house next door to the cafe, for ten cents a reel. The reels seemed to be about as tall as I was and I think they weighed more.

I did anything I could think of to earn money for that boat.

And no one knew what I was doing. Not even Destin. Not even Grandpa. No one. It was all finished except the seats and oar-locks. I wanted it completed by Dad's birthday, in two weeks. Only there was a hitch. I was at the end of my funds, flat busted, and still needed almost twenty bucks for the rest of the material.

Thinking of the boat took my mind off Grandpa, at least. It was my chance to fix things up with Dad. Once he saw the boat, I thought, everything would be perfect between us. And, I realized, although not for the first time, the thought recurring; he'd have to take me fishing in it. He wouldn't be able to wait any more than I would. That boat was just the most important thing in my life. It was the answer to everything that was wrong between Dad and me. And, I was finding out something about myself as well. Something surprising.

Doing mechanical things wasn't all that bad once you got into them. Though even this close to finishing, there were times I had to drag myself down to the shed to work on it. I'd have much rather gone fishing or curled up with a good book. But I didn't mind the work on it half as much as I'd thought I would. There was a kind of warm feeling watching the boat take shape and knowing that I was doing this all by myself. More than a warm feeling; it gave me a terrific feeling, one of power and accomplishment.

It was funny. I was doing the sort of activity Dad would be proud of, which was the whole reason I had set out on this project to begin with, and yes, looking at the boat take shape, knowing it was doing so only because of my efforts and no one else's, understanding all this did give me a tremendous sense of pride and accomplishment.

The phone rang in the living room. I ran down-

stairs.

"Sugar Man, are you all right?"

It was Grandma.

"Yes ma'am. I'm sorry I ran out."

"I understand, sweetie. I do. It's all right, baby. Only you left before I could tell you what your father said."

I waited.

"I know it's the first day of summer vacation and it's not been very good so far for you, with the fishing expedition cancelled with Robert and the news about Grandpa, but I'm afraid there's even more good news!" She laughed, but it was plainly a forced effort.

"You have to mow the lawn. Your dad left word that it had better be done before he gets back from Galveston tonight. I'm sorry, Corey."

"It's okay, Grandma. It sorta fits the day. 'Sides, it won't take long."

"I guess. Okay, then. How are you?"

"I'm fine, Grandma."

"I mean about your grandfather. Are you all right?"

She knew how close Grandpa and I were. It was just like Grandma to be concerned about others, even when she was upset and worried sick herself.

"I think so, Grandma."

"Sugar Man, I didn't mean to scare you. But you deserve to know the truth." Her words had a kind of slushy sound to them I couldn't figure out until I remembered the whiskey.

"Uh huh."

"Maybe I painted too bleak a picture for you. The doctor seems to think he's got a good chance, with radiation and chemotherapy. They'll know more next weekend. He starts treatment and they're going to do some more tests. They know a lot more about cancer nowadays. A lot more than they used to. After all, this is nineteen fifty-five!"

She hesitated, searching for words. That must have been the extent of her good news.

"It's okay, Grandma. I'm okay. I understand. He's going to be all right." I felt like bawling all over again, but I was all out of tears.

"Well, okay then, Corey. Mow that lawn now. And do the trim. You know how upset your father gets if he sees grass along the fence."

"Yes, ma'am. I will. I'll get on it right now."

Only I didn't. I started to, even going so far as to get the mower out of the shed and cutting an outline around the edge of the backyard, but the watermelon smell of the cut grass made me crazy. I felt like the old plantation hands must have felt every single cursed day of their existence. I was mad at Dad, too. Mad that my first day of vacation was ruined and mad because we just had an old hand mower, not one of the new gasoline ones some of my friends' dads had. My dad thought they were sissified.

"Can't even raise an honest sweat with those damned things," he was always complaining. "All people want to do anymore is avoid work."

Meaning me. He was right. I was all for avoiding work—or at least making it easier.

The more I thought about everything, the more I had to get out of there. Unlike the field hands, I could. I grabbed my tackle box and fishing rod and cut out on my bike. I'd come back before dark and finish the grass. If Dad was on a Galveston run, it'd be hours before he'd return.

I had ten cents, enough for a quarter-pound of shrimp for bait. The price of shrimp, jumbos, had just gone up to twenty-five cents a pound, but instead of being able to buy a quarter-pound for six or seven cents, they made you pay a dime. Only a few weeks before, you could get a quarter-pound for a nickle. Like everything else that seemed to be going on in my life at present, it wasn't fair!

I made the lady put the shrimp in a double bag so it wouldn't come apart and let the bait leak out. Cut up, they would be more than I'd need for bait; all I really needed to do was catch one fish and cut it up and I'd have bait forever. One time when I was completely broke, I'd begged for just one shrimp from a guy fishing off the dock, and he hadn't even given me that much, just tore one of his shrimp in thirds and gave me a third of that shrimp. I caught a little croaker on that, cut it up, and ended up catching thirty-six fish, mostly piggies and croakers, but also two gars and an eel. I could make a piece of bait go a long way.

I'd already caught five or six piggies and a croaker

when here came Destin, wheeling his bike up on the
dock where I sat, my feet dangling over. He had his
fishing pole and the cloth sack he used for a tackle
box.

"Whatcha got?" he said, plunking down beside me
and taking one of my shrimp without asking. I watched
him tear it into three pieces and jab his hook into one
of them, threading it securely. He had it cast just in
front of a shrimp boat with the unlikely name "The
Brown Camel" before I could say anything. He was
bottom-fishing, same as me. I watched it sink into the
greasy Brazos and said, "That'll be a nickel."

He looked at me. "A nickel!" he hooted. "I wouldn't
pay a nickel to watch a monkey fug a football!" We had
just discovered what we laughingly called "the inter-
course word" that year, and tried it out in a lot of silly
ways. Only we never said the actual word, just "fug."
Both of us had logged a lot of church time, and I think
Destin had the same secret fear that I did, that if we
used the actual word we'd go straight to Hell.

I smiled back. "Okay, then. I get half of what you
catch."

"Sure." He looked back to where his bait had gone
done. "You get the heads and tails. No problem."

I hit him on the arm, flicking my knuckles to give
him a frog. We settled back, both leaning on one arm
and waiting for our rods to twitch. In the space of an
hour, we had more than twenty fish flopping in the
burlap sack I'd brought, hung down into the water,

suspended by a long piece of kite twine. Every now and then, one of us would haul it up to see if crabs or turtles or a gar had chewed their way through the sack. It was all right.

"Didjer Dad leave?"

"We didn't go." He knew Dad had cancelled out; he had to rub it in.

"He waited quite a while, though. He's not like your dad, Destin—he has a job."

As soon as I said that, I knew we were close to a fight. It was up to him. He kept quiet, which was a way of saying he was sorry. I had to apologize too, if I wanted to even things up. I decided I didn't want to. A fight was fine with me.

"Saturday's probably off, too," I said, breaking the silence.

"What! Your dad won't let you go?"

"No, that's not it." I had him now. I had the perfect squelcher, but it was cheap to use it. "My Grandpa can't go. He has cancer. He might die." I felt like crud, using Grandpa's illness that way, to win like that. "He'll probably be okay, though," I added quickly, making up for what I had just done, oddly enough, feeling worse about that, like I was showing weakness or something. "He's going to get radiated. It's a miracle cure."

Destin didn't respond, and suddenly I didn't feel like talking either. It had been dirty, saying that about his father, but I knew we'd be all right by tomorrow. And he knew how I felt about Dad. He wouldn't forget,

but he'd realize I was upset. We'd had discussions about our fathers before. He knew people took things Dad did the wrong way. I wouldn't trade him for a million dads like Destin's, even if he took me fishing ten times a week. At least he didn't get drunk and beat up my mom like Destin's dad did. Once a week, like Monday wash, only it happened on Saturday nights.

And no one worked harder than my dad. Heck, he never worked less than a ten-hour day and it was usually more like twelve or fourteen hours. When the oil tankers came into port, and the cab business was going full throttle, he even put in twenty hour days. Six and seven days a week.

"Your dad home now?" I don't know why I asked that question, just my mean streak coming out, I guess. Destin's dad went out to sea, looking for shrimp, for two week periods, and then he'd be home for a week. If he got on a really good binge, he'd skip going back out when it was time, instead, he'd lay around the house drinking, taking turns beating Destin's mom and Destin, whoever was closest when he got the mood to smack somebody.

"Yeah. He's home. I'm here aren't I?"

I reeled in a piggy that was on the smallish side, hesitated a minute and then threw it in the bag. A shrimper went by and Destin waved. He knew all the shrimpers. His dad had worked for or been fired by most of them at one time or another.

"You can have the fish," I said, getting up and tak-

ing my stuff to my bike. "I'll see you tomorrow, probly."
I swung up on my bike and sat there a minute.

"I'm sorry, Corey." He had his back to me but I heard
him perfectly. It surprised me, and worse; it meant I
couldn't be mad at him.

"About your grandfather, I mean. I hope he gets
well."

"Yeah, well, he's probly gonna die. For real." I
pushed off. "See ya."

That was cruel, but I didn't care. Destin knew bet-
ter than to crack on my dad, especially with the dad
he had. A drunk. His dad didn't have one tenth the
moral character my dad did. That's what made me mad.
I hardly ever said anything about Destin's father, and
here he was, smarting off about mine, pretending like
he didn't know we hadn't gone fishing. Not being open,
but sneaky. At the top of the levee, I looked back. Destin
was reeling something in and I could see by the way
his rod was bent that it was good-sized. Just a stupid
gar, I bet myself, and kept on pedaling over the hill,
my tires crunching through the oyster shells. I kept
my eyes open for nails. I couldn't afford a flat just now,
not with Dad's birthday in two weeks and still twenty
bucks short of finishing the boat. I felt a twinge of guilt
at the dime I'd spent on bait, but shook it off.

I smelt the fish on my hands as I rode. Something
kind of clicked in my head and an old memory sur-
faced.

I was eight. We were still living in Indiana and it
was summertime. We, our family, Mom and Dad and
Doc who was just a baby then, were on vacation. Some
lake in Michigan. It was chock-full of bloodsuckers,
but I went swimming every day anyway, pulling them
off of my legs and arms and even my scrotum once. We
had rented a cottage.

I hadn't thought about this in years and years. Odd,
that I should remember it now. It was probably the
smell on my hands. I was just a screwy little kid then.
It all came flooding back, just like it was the day be-
fore yesterday.

It was early, early morning, the sun just pushing
up over the horizon. We were the only two people alive,
my father and I, as we pushed off our boat from the
dock. One solitary bird flew by and scooped something
from the lake, a minnow or something, and the ripples
looked like they would go clear across the lake, it was
so calm.

Nothing else moved. Not at that early hour. It
wasn't as if the world had died; it was more like it had
never lived yet, like the first day of creation maybe,
but not like that either. It was like any other morning,
ordinary and magical, special because I was with my
father.

We undid the boat from its mooring and climbed
in, myself last, for my duty was to shove us off. Nei-
ther of us said much. We didn't want to wake the people

sleeping. We whispered when we talked, which was only when absolutely necessary. I don't remember it being necessary, so we must not have even whispered. I certainly wouldn't have said anything unless my father had first.

Behind us, the campground was quiet as an abandoned cooking fire, and we moved as if we were in a sickroom. The self-imposed stillness was an omen I didn't recognize, but still respected. I felt I was doing adult things, mysterious things, sacred things.

My father was rowing and each squeak of oars sounded very clear and jarringly loud. We looked around at each chirrup in the same way a child does when his mother has told him to be quiet and he hasn't been, and he expects to hear her chiding voice. Our mothers weren't there, but they might have been. We felt that they were.

It wasn't a long distance to the spot, a secret spot my dad knew about, but it took us an extraordinarily long time to reach it, and I could tell he was tired from rowing and holding his breath. There was a motor but we hadn't used it for fear of the noise.

There were anchors, I remember, on each end of the boat, and we let them down cautiously, inching them through our fingers until they reached the lake bottom. Then, they were down, and we picked up our fishing rods and baited the hooks. We were using redworms and a slip bobber.

The sun was coming up now and neither of us had

felt a nibble since we'd arrived. We felt we could talk now because there were esses of smoke curling back at the campground and the recurring sounds of a car honking. Mostly, we talked about the lack of bites and wondered if we should change bait or fish deeper. We did neither; we kept on the way we were, and after a time my father caught one. A bluegill. Nine or ten inches long. He caught three more, all more or less the same size, before my own bobber went down for the first time, making my heart sing and start, and then I was taking off a bluegill and it was bleeding on my hands and then on my pants where I wiped my hands. On my blue jeans you couldn't even tell it was blood; it was just a dark, damp stain that might have been water.

I caught a little one then and laughed. It looked just like Jimmy Porter, my best friend, with his pop-eyes and oval mouth. Jimmy was always opening his mouth and not saying anything either, just like this fish. I showed him to Dad and asked him if he could guess who the fish looked like and he said Jimmy Porter and we both laughed. Jimmy and I were great pals. I put him back in the water and he swam away crookedly. He swam with Jimmy's walk.

Don't throw those back anymore, my father said. Kill 'em, there's too many little ones and they're starving out the big ones. It's called practicing conservation, he said. He had a little one in his hand as he said that, and he laid it on the seat beside him to illustrate

his point. Taking his big fishing knife, he stabbed down into its head and drew the knife nearly the length of its body. Then, he made another cut, crossways. Makes 'em flop around before they die, he said. Might draw some bass our way, they hear the noise. That's some good action there, bass. He threw it overboard. Now, next time you get one that size, kill 'em, he ordered. I nodded.

There were some other boats on the water now, and waves. Like pariahs, we floated apart from all. None of the other boats would have anything to do with us. The sun was bright and you could see a perfect ball in the water, even the color, red with white all around it. I turned for a minute, and when I turned back I lost my father in the sun and felt a mild panic. By twisting my head slightly, I could see him again. The sun turned white and put a glare on everything, but it wasn't hot, and a brief breeze scuttled over the water, ruffling the tops of tiny beginnings of waves.

His bobber was going down as quickly as it hit the water now, and the stringer was more than half-filled. I wasn't fishing anymore, and hoped my father didn't notice. My line was out, but there was no worm on it. Several small bluegills floated belly-up in the water near the boat, dead from fish-knife wounds in their sides. They wouldn't be starving out the big ones any longer or going hungry themselves, I thought.

He didn't even notice I had stopped casting. There were more floating near the boat than before; there

seemed to be dozens and dozens, and some were still alive. The live ones would play dead on their sides, and then all of a sudden begin jerking in circles, flip-flopping sideways, and then play possum again. After awhile, the flopping would cease and their bellies would turn up, white, and they weren't pretending any more.

The stringer was finally full. It seemed to take forever, but then, I wasn't helping. I was so afraid he'd say something, but he never seemed to notice. We made lots of noise now as we hauled the anchors. Going back, we didn't row; we used the motor and it didn't seem loud.

The campground looked like an anthill someone had stepped on, people and kids crawling and running about everywhere. Some of the smallest kids were splashing around in the water and their mothers were yelling at them to come up and eat breakfast, which they all seemed to ignore.

Some men came down to the dock when they saw us come in. There was a regular gang of them, seven or eight. How they bitin', said one. Pretty good, said my father back to him. Too many of those darn little ones but the big ones are there too. He held up the stringer and some other people saw it and came up too. I wasn't in the conversation. They were all grown-ups.

My father was feeling good now because he was smiling and laughing at just about everything he said. He laid the stringer down on the seat of the boat for

everyone to admire. They looked just like those smaller
ones that were floating back in the lake, but some of
them were still jerking. They were shiny and the ones
that were still alive kept opening and shutting their
mouths. I reached over the side of the boat and splashed
some water over them.

I looked at the fish and then at the gang of men on
the dock and then I looked for Jimmy Porter, my best
friend. I couldn't see him and I got the same mild feel-
ing of panic as when I'd lost my father in the sun. Then,
the heat or something got to me and I couldn't breathe,
and I was scared and sick to my stomach, all at once,
and I was letting go with my lunch, except it couldn't
be lunch or breakfast either, as my last meal had been
last night's supper, but whatever it was, I lost it. I hal-
lucinated; that's what Dad said; the fishes caught on
fire, it seemed, and then I shook my head and they
were just fish again.

Someone grabbed my belt, my dad I guess, and I
was done throwing up. I still felt sick and suffocating
and my dad said to somebody that I probably had a
fever and my mother was going to kill him if he didn't
get me up to the camp.

He climbed out of the boat and held out his hand
to help me up on the dock. I tried to get up without his
help but I was too little and had to take his hand. Then,
he reached down and grabbed the stringer of fish.

It's the sun, he said to a man. We walked through
the people standing on the dock, my father, me, and

the bluegills, all hand-in-hand and walking together.

The only other thing I remember about that vacation was a big argument my folks had about whether my father should be a flyer, an airplane pilot dusting crops, or if they should move to Texas where Mom's folks lived. It was not long after that that we moved south, and now the vacation seemed like something I'd imagined or dreamed. The smell of fish on my hands had brought back the memory, and I realized something as I made my bike go faster, standing up on the pedals.

Salt-water fish smelled the same as fresh-water fish when they were dead.

I pushed my bike faster. The sun was going down and I needed to beat it home and finish mowing the grass.

The Sun
Wins

"*T*ake off your shirt."

"What?"

"I said, take off your shirt. We're not leaving here without the truth. I won't have a lying thief for a son. I'd rather have a dead son than one that lies or steals. Take it off. If I have to beat you half to death then I'll do it, by God."

I took off the shirt. It was already stuck to my back. I wanted to say something, something that would get me out of this nightmare, but the words caught in my throat and I was speechless. I did the only thing I was capable of. I turned back around and put my hands back on the edge of the work bench.

I won the battle but lost the war. I won the race home by at least twenty minutes. But Dad was already there and out in the yard, strong-arming our old hand mower across the yard, horsing it so that it lifted up when he turned the corner. The square I'd begun had shrunk to half its size.

I leaned my bike up against the shed and took my fishing gear inside and stowed it away, rinsing the reel under the cold water tap first. If I'd known Dad was going to already be there, I'd have thrown my gear away before I got there. And, I would have come in the front way instead of through the alley.

Shoot, I might have just run away. Become a Canadian.

I walked out of the shed and over to him, stopping about four feet away.

"Hi, Dad," I said. "I can finish that."

He kept on mowing past me, turned at the far end and stopped, his back to me. He had his shirt off and the sweat was running down his back. He reached inside his back pocket and brought out his handkerchief and mopped his face. He turned and looked at me. I saw his jaw muscles and looked away, then back, but he was already pushing the mower, water pouring down his face as if he had never wiped it.

I stood there a minute and then walked toward the house. I tried to walk without putting any weight down, and I went slowly, hoping but not hoping that he'd call me back. He didn't, even though I hesitated a long sec-

ond when I opened the screen door, before stepping up
and in. I held my hand on the door as it closed, so it
wouldn't slam. I went to the sink and turned the wa-
ter on full blast and hunted up a glass and had a cold
drink. Then, I went upstairs to my room.

If I looked out, I knew I could see him from my
bedroom. There was a screened-in window the size of
a door that looked out into the back yard, but I didn't
go near it. I could hear him though. I knew each time
he turned a corner, the mower slowing but not stop-
ping, and the time got shorter between each pass. It
got quiet then, and right after, I heard him taking the
mower back to the shed. He'd turned it around and I
could hear the squeak of the wheels. I could even hear
the hose as he turned it on. He'd wash it till it was
sterile. He took care of his tools. He loved his tools.

Downstairs, the front door opened and my mother
was saying hello to my sister. Mom must have been in
the front room when I'd come upstairs. I hadn't no-
ticed her, but it was dark. She sat in the dark a lot,
meditating and praying.

The next sound was the back door slamming shut,
and then I heard Mom talking to Dad. It sounded like
they were under a blanket from where I lay on the
bed. I wanted to hear what they were saying, but
couldn't. I went over to my bookshelf and picked up a
book without seeing what it was. Three or four pages
into it, I realized it was *Treasure Island*. I kept turn-
ing the pages, aware of the noises downstairs. The

shower turned on and I could hear pans being put on the stove. Plates were slammed down on the dining room table and that told me my sister Doc was setting the table. She hated the chore but usually got it.

Just then, my door opened up and there was Mom, framed in the doorway, her yellow apron on, wiping her hands on the dish towel.

"Hi," I said. I wondered what she was doing. Mom and I hardly ever talked anymore. She was always reading her Bible or on the phone to whatever preacher she believed in at the moment. Since we'd moved to Texas, it seemed as if my old mom had stayed behind in Indiana and I'd gotten a new one here. She didn't talk much to any of us except to let us know when we were sinning. Which, come to think of it, in my case anyway, was pretty much a regular occurence.

"Corey," she said. "Mind if I sit and talk to you a minute?"

What could I say?

"Sure," I said, moving my body so she could sit on the bed. She went over and picked up the chair by my desk instead and lugged it over beside the bed and sat down.

"Corey, your father's very upset."

No kidding!

"I know, Mom. I'm sorry. I meant to finish mowing. I just got back a little late, that's all."

"It's not just the yard, Corey. You know he took off work today especially to take you fishing and you didn't

show up. That was very rude. You know how much Grandma needs him in the shop and how hard it was for him to get off work. He's very hurt over it."

He's hurt! What about me? That was the thought that went through my mind, but I kept my mouth shut.

"Corey, you know your father is working very hard to build the business up, and that he can't spend time with you like some other fathers can. That's why it was so thoughtless of you not to show up on time."

"I got kept after school." I sort of mumbled the words.

"What? Oh, yes. We know that, Corey. Mrs. Clopys phoned. That's another thing we're not too happy about."

Another thing? It's the same thing! It's why I was late! I started to say that, but she went on talking.

"I just wanted to have this little talk with you, Corey. You know that God has appointed your Dad to be the head of our household. This means we are commanded by the Lord to obey and please him." She was wringing her dishcloth as she spoke. "That's God's Plan, and as His Children, we must do as it says in the Bible."

She got up, still wringing the cloth. "There. I'm glad we had this little talk. I know you'll try harder. You see, Corey, when we're children, sometimes we don't see the grand design God has mapped out for us. That's why He gave you parents—to guide you until you attain the age of reason and wisdom. Believe me, it's not easy being a parent sometimes." With that, she left

the room, still twisting the dishcloth in her hands.

Man! Talk about the Sermon on the Mount! I felt like I imagined Catholics to feel after going to confession. Wrung out and guilty, although I was starting to get mad the more I thought about what she'd said, the mad beginning to override the guilt.

Dad didn't work hard to "build the business"—he just didn't want to be around us, and he was just plain mad at the world for the situation he was in. Couldn't she see that? Her and Grandma were always going on about this "partnership" Dad was supposed to get some-day—although Grandma barely mentioned it any more. Supposedly, that was the reason Mom had talked Dad into moving to Texas in the first place, but that had been six years ago and he was no closer to the promised parnership than the day we'd arrived. Maybe Mom really believed that it would come to pass some day. Ha! Fat chance! Didn't she know that Grandma hated all Yankees and especially the one that had married her daughter? Even I knew that! It was the only thing that kept Grandma and I from being really close. I knew exactly how she felt about Dad. I had even seen her throw Yankees out of the restaurant, refuse to serve them, just because they were from the North. Let a Yankee become her partner? When elephants play harps!

Just in the past few months I had begun to understand some of the things that were going on with our family.

Mom's obsession with religion was making me crazy, for one. According to her, you could dump all over your kids because that was God's "Grand Plan." I knew I wasn't being exactly fair, the way I was thinking, but it just seemed like everyone was against me. Here it was the first day of summer vacation and it had turned into one of the worst days of my life.

I tried to see their point of view. It was kind of nice, Mom's coming up to talk to me. She hadn't done anything like that in months. Thinking back over the years we had been in Freeport, I could see where she had gradually been withdrawing into a tighter and tighter shell, excluding everything and everyone that didn't have a connection to her religion. Maybe her coming up to my room was a good sign. Maybe she was going to start being normal again, like she had in Indiana. I tried to remember the last time she had even hugged me, but I couldn't.

That made my throat ache. I picked up my book and tried reading again.

The smell of frying chicken wafted up. I tried to ignore it, but my stomach betrayed me with its growling. Fried chicken meant mashed potatoes and homemade gravy with chunks of the liver and gizzard and heart. My stomach was touching the back of my spine, but there was no way I was going to go downstairs unless someone called for me to come and eat.

I couldn't hear anything for a little while and then the sound of chatter rose from the dining room. Mom

must have said the blessing, I thought, and then realized they must be eating. No one was going to yell for me. I was being punished. If I wanted to eat, I'd have to go down on my own. Dad was going to make me walk that mile of fire. I considered it and decided I wasn't that hungry. I turned book pages, concentrating on concentrating, the words Chinese.

"Corey!"

It was Doc. "Brat" was a more descriptive name.

"Corey, Dad says for you to come and eat. Right now! He says, 'what're you waiting for, an engraved invitation?'"

My appetite, ravenous seconds before, vanished.

"I'm not very hungry."

"What?"

"I'm not hungry," I said, louder.

"'You'd better get your butt down here,' Dad says."

"Doc!" That was my mother. "Butt" was a cuss word to her. I had to go down now. It would be worse if I didn't. If he felt like he had to come up after me, I'd wish I'd been adopted by Eskimos. I got up, not hurrying, but not dawdling much either. I made noise as I clumped down the stairs.

At the bottom, I stood for a minute, unwilling to open the door and enter the living room. If there had been a back way out of the house, and a nearby recruiting booth of the French Foreign Legion, I would have taken the opportunity. I knew that when I reached the dining room and sat down across from Doc and

sandwiched between Dad and Mom, I'd pay. I'd pay for every single blade of grass my father had mowed, for every minute I'd been late for our fishing trip. I'd even pay for the lousy tip Buster had probably left my dad after his Galveston run. I for sure didn't want to go in and sit at that table, but the alternative was even bleaker. If I ran from that confrontation, there surely would be another, only much worse.

"Hi, Mom, Dad," I said brightly, feigning a cheefulness I certainly didn't possess, and sitting down at my place before a plate already fixed. "Doc, you could raise the dead the way you yell." The grin on my face was the only one at the table.

I picked up a piece of breast meat and chewed. Doc must have fixed my plate for me, getting devilish delight in doing so. She knew all I ate were drumsticks and thighs. I hated white meat. And I knew it was no accident that potatoes had been sloped on part of the chicken.

"Great chicken, Mom," I said. It probably was, too, even though at the moment I couldn't tell. It could have been seagull for all I could taste. Usually, we ate at the restaurant or Inez would come down and cook for us. It was supposed to be a treat when Mom cooked; mostly, it was an ordeal. She could do chicken better than anyone, though.

No one responded to my chatter except Doc, who smirked at me when she thought Mom and Dad weren't watching. She loved it when I was in trouble, just as I

enjoyed the relatively few instances she fell from her normal state of grace. Doc had slightly larger front top teeth than the bottom ones, and at this moment I felt like taking my fist and bringing them more in line with the back ones, but under the circumstances, all I could manage was a good glare in her direction.

Mom sat there picking at her food blindly—I doubt she even knew what she put in her mouth—her attention riveted on a small book she held down below the table on her lap. One of her religious tracts, I assumed. I didn't dare look at Dad, but I could see out of the corner of my eye he was digging in like Henry the Eighth, glowering at the food as he shoveled it into his mouth. He ate his whole meal in silence, at last laying down knife and fork and reaching for the pack of Camels sitting to the right of his plate. He struck a match and held the flame to the end of the cigarette and puffed, twice, sending a huge cloud of smoke over the table. Doc made a face, careful not to let him see her, and Mom just kept reading, head down.

"Can my little darlin' get me some coffee?" he said, and Doc jumped up and skipped into the kitchen, returning with a steaming cup which she placed proudly beside his plate. She picked up his empty plate and took it back to the kitchen. I heard her put it in the sink and then she was back, anxious, I was sure, not to miss any of the show.

He took a sip of the coffee, squinting, and suddenly he seemed to realize that I was there.

"Lose your watch?" he began, in a voice and manner an outsider would have called gentle and quizzical. So this was the way it was going to go, I saw. Chronological order. First things first.

"No sir," I answered, making sure my mouth was empty. I didn't want to give him something else to yell about. My table manners had come up for discussion more than once. "I don't have one."

That was true. I had never owned a watch and he was aware of that.

"Oh, I see. I forgot you were a reader. You take things literally, don't you?"

"No sir. I'm sorry. I would have been there on time, but I had to stay after school."

"For disrupting the class, I hear."

Goddamn Mrs. Clopys. I knew she'd call.

"And he didn't mow the grass, either, Dad."

That was Doc. Dad ignored her this time, but I knew it was going to come up again. He went ahead with the same line of questioning.

"You didn't disrupt the class? Mrs. Clopys lied?"

I didn't want to snitch on Destin, not that he'd get in any trouble or that I especially cared if he did, I just hated tattletales. So did Dad. Or so he said. I had noticed that whenever Doc would reveal some wrongdoing of mine, she'd get a pat on the head. It was all right for girls to snitch, I guess. I didn't say anything, just looked down at the floor.

"Whose fault was it, then?"

"No one's." I said this real low, my head down, eyes on my half-finished chicken breast. A little piece of stringy gristle was exposed. I felt queasy. I could see Mom intent upon her book out of the side of my vision. I knew what Doc was doing. Smirking.

"Who? I didn't hear you."

"No one's. Sir."

"Do you know what I did?"

"You took off work. Sir." Again, my voice was low. I couldn't seem to get it any louder and it made me mad at myself.

"You're damned right I took off work. I arranged to take the whole rest of the day off. To go fishing with you. I went in early to make up some of the difference. I was up at four this morning, working, while you were sacked out. You begged and cried so much about going fishing, I took a day off work. Do you know how much money I lost because of that?"

"No sir." I didn't know, but didn't think it had been much. He had only waited for me a half an hour before he took Buster to Galveston, so it couldn't have been much. I didn't remember begging and crying for him to go fishing, either. I asked him, once or twice, weeks ago, and hadn't said anything much since, just an occasional reminder so he wouldn't forget was all. I decided not to bring this up, though.

"A half-day's work is what. More than half a day. More like three-quarter's of a day. Do you think money grows on trees?"

"Not in our yard." As soon as I said that, I wanted
to pull it back, but it was too late. In a way though, I
was glad I had said it; it was the response I'd wanted
to give a couple of hundred times to that question. It
was one of his favorites.

"Not in our yard!" He mimicked the words in a high
falsetto, I suppose in an imitation of me. "Not in our
yard!" This was in his normal, I'm-mad-as-hell-and-
you're-gonna-pay voice. "You've got a real smart mouth,
don't you, Mister?"

I just shook my head. Suddenly, I needed to go to
the bathroom in the worst way. I squeezed my legs
together but it didn't help. I hated the way my hands
started sweating at times like these.

"Goddammit!" He stood all the way up, pushing
his chair back. He stubbed his cigarette into his coffee
saucer and sparks flew. I watched, mesmerized as a
large one landed on the white tablecloth and began to
grow. He didn't see it, but Doc did. Her eyes widened
and she smiled. She knew I would get in trouble for
that, too, if the tablecloth caught on fire. Even Mom
glanced up for a second. I couldn't see her because the
rule was I was supposed to give my father my undi-
vided attention, but from past experience I knew she
had looked up, not knowing what was going on, and
had then gone back to what she was reading. She
hadn't heard him curse or she would have spoken.

"Why'd you start mowing the lawn and then leave
the mower out where it could get rained on? Or sto-

len?"

"I didn't, sir. I mean, I did. I started to mow. I was going to finish. That's what I was doing when I came home. I left early to get it done."

"Left early? Left what early? Let me give it a guess—you left fishing early, is that it?"

I should have answered, but I was unable to. I just shook my head, fighting to maintain composure. That's what he was after, what he was pushing for, for me to cry. It was a battle we often waged and always he won. Not this time. I wouldn't cry.

"Let's see. I give up a half-day's work, no; make that three-quarter's of a day's work, to go fishing with my son the troublemaker at school, and then he stands me up. Then, by way of repayment for this effort, he goes ahead and goes fishing on his own instead of doing his own work. Then, he smarts off to me and leaves the mower out where any nigger can steal it. Is that about it? Is that the way you see it?"

Again, I couldn't choke out anything. I just shook my head. Nothing I could say was going to affect whatever it was he was going to do. I just wanted to get it over with. I had to go to the bathroom so bad it was beginning to get painful.

Then, the cavalry rode in. From out of nowhere, Grandpa materialized, standing just inside the back door. I don't know how long he'd been there.

"You never got in dutch when you were a kid, Robert?" he said, his voice soft and his eyes smiling. "Boy,

oh boy, you were a lucky kid! Myself, I think every time I turned around I was in trouble. You know though—occurs to me that I'd rather have a son has a little orneriness in him than one who was a perfect angel." He winked at Dad but I saw he included me as well.

"I was you, I'd kind of like a boy wasn't a namby-pamby, don't you think?"

Grandpa was slick. Smart, too. I could see the bile and anger start to settle down inside Dad. His pride had been salved when Mom took up his part, and now Grandpa was working on him. He kept talking, his voice low and modulated. I could see even Doc paying attention, her eyes never leaving off watching him. I snuck a peek around. Mom was reading again. I guess she thought the storm was over and her prayers had been answered. Dad had left off cussing, which was all that seemed to have caught her ear.

"Kids are different nowadays, Robert," Grandpa was saying. "It isn't like it used to be. It isn't the Depression anymore."

I saw Dad's eyes blaze up and thought, uh-oh, Grandpa screwed up; now Dad was angry at Grandpa and had forgotten me. The situation for me was defused; I was off the hook, for the time being anyway, but now Grandpa had made an enemy. No one spoke ill of the Depression to my father. He revered the Depression like it was the Golden Age of All Time, as I'd noticed a lot of people who'd gone through it had. I

tried to understand, but it wasn't easy. We'd had hard times too, but I wasn't bitter about them. I hadn't had to quit school in the eighth grade and go to work, selling fruit at a roadside stand either. It was just one more puzzle piece that made up my father. Someday, it would all come together and I would know why he was like he was, and then I could help him to understand why I was like I was. I wanted that more than anything.

"Oh, t'hell with it! Go on and get out of here, Corey. Get your ass up to bed. Right now. Tomorrow morning I want to see your butt out there and paint that shed. Two coats and all the trim. And don't be bugging me about any more fishing trips, you hear?"

I left on swift, quiet feet, happy with my punishment, even though I already knew that when the morning sun arrived and I was standing there with a paint brush in my hand while everyone else in the world was going swimming or fishing, I'd view things differently. I felt bad for Grandpa, though. I didn't want to leave him there with Dad, but what could I do? He must have sensed what was going on in my mind; just as I left he glanced at me for the first time, met my eyes and gave me an almost imperceptible nod. I let him see my thanks in my eyes and then I left the room, stopping by the bathroom to relieve my tortured kidneys.

Once up in my room, I fiddled around awhile doing nothing. I opened and shut the drawers on the dresser,

my mind blank. O. Henry's book of short stories was on the floor just sticking out from under my bed, so I went over and picked it up and flopped down on the bed and tried to read it, only I couldn't concentrate. Finally, after about ten minutes of this, I went over to the heat register and opened it, wincing when it squeaked.

Peering down, I could tell none of them had heard it open. They were all busy talking. I could see all of them except Doc. She must have gone outside or to her room. It wasn't the first time I'd used the register to eavesdrop.

"So how bad is it really?" my dad was saying. I didn't know who he was talking to at first, until Grandpa replied.

"Pretty bad, Robert."

"Oh Dad!" That was Mom. I saw her put her hand on Grandpa's brown, weathered paw. He was sitting in my place, my plate still in front of him. I was surprised to see that Mom had put her book away and was looking intently at Grandpa. For a moment I couldn't figure out what they were talking about and then it hit me. The cancer! I couldn't believe I had forgotten! I listened even more intently.

"They've come a long way, Toast. There's people all the time licking it now." It was Dad, and his voice was different, more softened than it usually was. I knew

he held a lot of respect for Grandpa, even though he and Grandma often clashed. In fact, tonight was the first I'd ever seen them argue about anything.

"Yes, Dad. Mrs. Vincent at church was cured. She had the same thing, chemotherapy, and it's been almost two years and she's fine. Not a trace of it."

I noticed none of them would come right out and say the word. Cancer.

"Maybe you're right, Mary," Grandpa said. Sometimes it was difficult to imagine them being related, much less father and daughter. Mom wasn't like Grandpa or Grandma. She wasn't like anybody. "Maybe I'll live another sixty years and drive your mother crazy." He laughed but neither of my parents even smiled.

"Lucille didn't tell us much," said Dad. "What's the prognosis?"

"They give me . . ." I didn't hear the end of the sentence. I didn't want to hear the end of the sentence. I jumped up, softly of course, so they couldn't hear me, and went over to my bed. From there, I could hear the murmur of voices but nothing distinguishable. All of a sudden I was exhausted.

I don't remember even getting into bed or under the covers. The next thing I was aware of, the sun was shining in the window, hurting my eyes, and what I'd thought to be a nightmare about two cats fighting turned out to be real; two toms were duking it out in my sister's sandbox, next to the shed I was supposed

to paint. I got up to get my pellet rifle to plug them with, but then thought better of it. If Dad was still around the house, I didn't want to draw attention to myself.

I got up and put on the same jeans I'd worn yesterday. They were at the foot of the bed so I must have taken them off.

I didn't remember taking them off, though.

Rattlesnake!

The first coat was half-way done, and I was working on the east side, slapping bright, white paint over yellowed white paint, when I heard a noise and looked up. How long he'd been sitting there, staring at me, I don't know.

"Grandpa!" I yelped, delighted. "What're you doing?

"Hey, Corey. Just thought I'd stop by and visit awhile. Makes me feel like Tom Sawyer watching Huck paint that ol' fence." I chuckled along with him. Grandpa had been the one to give me my first Mark Twain book, as well as volumes by Dos Passos, Steinbeck, and even Kafka and Camus, for birthdays, Christmas presents, or just because he thought it was time I had a new book. I was probably the only four-

teen-year-old in town who read Celine, and it was only because I was lucky enough to have a literary grandfather. It was he who first made me aware of the heady world of ideas, and he even gave me works by people he disagreed with, like Sartre and Ayn Rand, people who lived, as he said, "in a world far away from East Texas, and I ain't talkin' geography!" Read anything and everything, he said; it's the only half-ass way to find out the truth about things.

"This the first coat?"

I nodded my head, making a grimace. He snorted. "Well, I didn't hear your dad saying anything about not accepting a helping hand, did you?"

"No," I answered, suddenly nervous. He hadn't said I couldn't accept help, but I was fairly sure he'd be sore if I didn't do the whole job by myself.

Grandpa stood up from where he'd been crouching and ambled over, picking up a paintbrush from the empty paint can where we kept them. He dipped it in the paint and began stroking bold swipes over the old paint.

"I wouldn't normally let you trick me into this, Tom," he said, continuing the Twain joke, "but for two reasons. One, it's a hot day and I hear the fish are goin' crazy waitin' for you to come down and feed them; and, two," here he winked at me and dipped his brush into the can for another load, "your dad just got a fare to Houston. Saw him leave myself, just a half hour ago. We should be done long before he gets back."

This was the first time Grandpa had ever defied
Dad. We both knew what my father would say if he
knew Grandpa was helping me escape any part of my
punishment. I sensed a turning point in our family
and it made me edgy. I painted faster.

We swabbed paint on in silence for awhile. As much
as I detested this particular chore, I loved the smell of
the paint itself. I also liked the smell of gasoline, so
my sense of smell was not in line with most people's.

When the first coat was on, I went into the house
and got a glass of iced tea for me and a can of Pearl for
Grandpa. We sat on the sandbox seat and admired our
work. I had to admit it was a big improvement. The
old paint had been peeling badly. That made me think.
I turned around and looked at the house. It had been
painted at the same time as the shed. I groaned. I had
no doubt my father would see the difference too. There
went the rest of my summer.

"You heard about my problem, I guess."

I knew what he was talking about, but I pretended
not to.

"What problem?"

"My cancer. You can say it, Corey. It's not a bad
word or anything. It's just a noun. Like 'bird,' or 'house,'
or," he looked at the sweating can of beer in his hand,
"like 'Pearl.'" Course, I have to admit, I sure wish the
doc had told me I had a 'Pearl' 'stead of what he did."
His smile was thin, but it was a smile, all the same.

"Does it hurt, Grandpa?" Immediately, I wished I

had the question back.

"Sometimes, Corey. Sometimes it hurts a hell of a lot. I've got a good chance, though. That's what the doc says anyway, and what choice do I have but to believe him?"

Then,

"I didn't bring it up for your sympathy, buddy-boy. Just wanted to be sure you knew about it so you'd understand why we can't go after tarpon on Saturday."

"I know, Grandpa. I understand."

"I knew you would, boy, knew you would. I got some good news howsomever. We're still gonna go. Pretty soon. First weekend I feel enough pep. I shouldn't think that'd be too far off. This week's definitely out, though. I got to go to Houston for some treatments. They pretend I'm Hiroshima and drop bombs on me. Metaphorically, you understand." He laughed through his nose, snorting, and when he did I caught his wince of pain.

"Don't worry about it, Grandpa. It's not that big a deal. We can always go. End of the summer, maybe. When you're better."

"You're not a good liar, son," he said, "but don't you worry. We'll go before then."

We finished the second coat and then he told me he had to get to work. I wondered about that—it was only noon and he didn't have to be there till four, but I didn't comment. I thought, if I was Grandpa, I'd never go to work again. Just drop a line in the water and worry about keeping bait on my hook.

"Want to go fishing with me this afternoon, Grandpa?"

He looked for a minute like he might take me up on the invitation, but then his face darkened and he said, no, he'd best not. When I saw his face get like that, I realized he was in pain and I realized something else. He had been doing that ever since when, last fall? Why hadn't I noticed it before? Maybe I had, but was just too full of my own puny problems to realize he had bad times too.

I went over to Destin's house after I cleaned up the paintbrushes. He was outside on his porch. I could hear his mother and father inside. His father, mostly. They were fighting. No surprise there.

Destin's father was a sometime shrimper and full-time lush. I had seen him plenty of times at the cafe, although that wasn't his usual hangout. Red's Tap was where he usually got drunk. Falling-down drunk. Grandma would allow a customer to drink, even drink a lot, but when you got to the falling-down stage, she made you leave. Red, the one-armed proprietor of the bar that bore his name, catered to falling-down drunks. Grandma said he stole from his customers and that's why he preferred them soused. She said never to say that to anyone—she had to coexist since they were business neighbors—but for a fact she couldn't stand Red.

He was a mean drunk, was Destin's dad. Destin's mother Delores was kind of strange, quiet mostly and

kept to herself, huddling inside the house reading her Bible whenever her husband, Fembo, was home, and hitting the bars, raising hell till morning light at road-houses full of good ol' boys and shrimper friends of her husband's, whenever he was away chasing brown shrimp, south off the Mexican coast. I never said any-thing to Destin, but his mother didn't seem too smart. If she wanted to chase around, seems like it would have been better if she'd gone somewhere other than places where everyone was acquainted with her husband.

Once a week, regular as red beans and rice, Fembo got drunk as a bachelor party, begin calling Delores a whore and worse, and commence bouncing her off vari-ous walls in the house, while she yelled out to God to save her. Destin would get smacked around too, some-times, especially when he tried to intercede on his mother's behalf. That done, Fembo would slink away to sober up on a boat called "The Merry Widower," and take out after shrimp and Mexican senioritas. Delores would shovel pancake makeup on her black eye, stash her Bible in a bureau drawer, and be transformed into "Dee Dee." The makeup was wasted effort for the dark joints she frequented, skulking coquettishly in dim corners nursing her cherry coke—no sinful booze for her, thank you very much—and try her best to collect reasons for Fembo to bash her around the following week. It was a looney-bin house Destin lived in, and I had just discovered the term "Madonna-whore com-plex" and knew that was his mom, to a T. She was

both rolled into one, and according to what I could fig-
ure out, the author of the book I read that in was say-
ing this was a woman a lot of men wanted, though
why wasn't clear to me. I guess she was perfect for
Fembo. Maybe that was why they stayed together so
long.

The sounds coming from the house told me Fembo
was warming up for the Saturday night fights early,
and being as it was only Tuesday meant Destin's first
week of summer vacation was off to as fast a start as
mine. He looked like a little old man sitting on the
stoop, all slumped over. I could tell he had been bawl-
ing.

"You goddamned bitch! The more I make, the more
you spend!"

Their fights were boringly the same. Destin tried
to act like he didn't care, for my benefit, making a joke
about what we'd just heard, but I could tell his stom-
ach was churning and he was wishing he was bigger
and stronger so he could throw his old man out. I knew
he was waiting until the physical part started and then
he'd go inside and do something, even though he was
terrified. His face was white and his jaw muscles were
working. In his way, I think, Destin was the bravest
person I've ever known.

"Let's go fishing," I said, knowing he wanted to
get out of there in the worst way, but his pride wouldn't
let him, not without a good excuse.

"No," he said, wildness in his eyes, a look I hadn't

seen in him before. "Let's go rattlesnaking."

I shrugged and agreed. We hadn't done that in awhile, because of the weather. It had been too overcast, and they were harder to find. We got on our bikes and headed south, out of town, toward Byron Beach. There was a piece of property Dow Chemical owned that was restricted and fenced in, but we knew plenty of places to crawl through and the place was thick with snakes. Thirty minutes later, we were squirming under the chain link fence. The first thing we did was hunt up sticks, looking for just the right size and for ones that had a branch at the end we could break off into a fork.

Destin spotted the first one. Yelling, he pinned the head down with his stick and then reached down, just like that, and picked it up, holding it just behind the head. We had both done that before, but usually it was with a lot of daring and double-daring on both sides. He must be mad, I thought, and then I remembered Fembo. I guess I'd pick one up too, if I felt like he does, was what went through my mind. He put the snake on the ground, his hand holding the head firm against the hard sand, and then he put his bare foot on it and took his hand away. The reptile writhed and coiled and uncoiled, slithering every which way, but Destin kept his foot hard on its head.

"Jesus Almighty, Destin. Don't do that. Kill it." I was so scared I was close to a bowel movement. He laughed.

"C'mere, Corey."

Like hell, I thought, but I went anyway, prepared to jump back in an instant.

"Grab his tail."

I looked at him and I know my eyes were two full moons.

"You got to be joking!"

"Naw. I mean it. Hand me his tail. I'm gonna whip him."

I knew what he was talking about. We had heard tall tales of people grabbing a rattler by the tail and snapping them like a whip. Supposedly, it snapped their heads off. Only the craziest or bravest men could do it, the legend went. Many times we had talked about doing it, trying it, but never had either of us had the nerve to actually try it with a real live rattlesnake. Once, with a garter snake, but the results had been inconclusive. I had been the one to try it, but when I went back to snap it, the snake just flew out of my hand. I think my hand had been sweaty, but whatever the reason, we had gotten interested in something else and hadn't bothered chasing it down and trying again. Besides, I had felt guilty about hurting something as innocent as a garter snake, and oddly, felt the same thing about the reptile Destin had now, even though it could kill. If we had left it alone, it wouldn't have bothered anyone. I was starting to get funny ideas about animals, the older I got.

But, here was Destin, with this three-foot for-real

rattlesnake, about to try a stunt we had only previously attempted with an eight-inch garter snake.

I started to refuse him until I saw his eyes. They were yellow, crazy-like, like a dog I'd seen once, a dog they'd hunted down and shot, swearing it had rabies.

"Okay," I said, the word sounding small and faraway in my own ears. There wasn't a drop of blood in my face, I was sure, as I took a step forward and bent over the tail swishing back and forth in slow, even esses. This had to be handled like a dive into cold water—you didn't dare think about it too long or you'd never do it. Just take a deep breath, blank out your mind, and do it. And that's what I did. As soon as I felt Destin's hand close on the tail, I jumped back and kept stepping back. Fast. He stood there for a long second, and then he moved so fast he was hard to follow. All in one fluid motion, he jumped off the snake's head and brought his arm up, the one holding the tail, straight out in front of him, fast, and in a heartbeat, snapped the best imitation of Lash LaRue I'd ever seen outside of a movie theater. I saw the snake . . . and then I didn't see it.

It was just gone, vanished into somewhere. I was concerned about just where exactly the snake had gone to, and the first place I looked was in a circle around myself.

"Damn," Destin said, and then, "damn, damn, damn!" I guess I'd closed my eyes for a second or two. I looked at Destin and he just stood there, staring at

something in his hand. I stepped toward him, looking over the intervening ground between us first to be certain it was snake-free, and he opened up his hand and I saw what he had. It was the snake's rattles. They'd snapped clean off.

"Where's that snake!" I shouted, more anxious about the answer than I'd been about any other information in a long time. "Where is he?"

"Over there," he pointed. A good ten feet from us lay the serpent. It looked mad to me, its head lifted off the ground, tongue whistling in and out, tasting the air, and gazing directly at us. I looked around for a big enough rock and saw one inches from my feet. I picked it up and started to draw back, when I thought better of it. I handed the rock to Destin. He took it and hefted it in his hand and then took two quick steps right at the rattler, drew back and fired. It was a perfect throw. Thank God. Right between the eyes, just the way it would have been done in the movies with a six-shooter. It's the way Alan Ladd would have done it in *Shane*. It crushed the snake's head like a beer can. Its body didn't know it was dead yet, but that didn't stop Destin. He walked right up to it and put his foot down on the crushed head and grabbed the snake's body and yanked, tearing the head off. Then, he looked at me and grinned. I grinned back. His eyes were normal, now. We put it in the sack Destin had brought. His mom would fry it. Rattlesnake was better than rabbit, cooked right. Barbequed was the best way.

We chased around the rest of the afternoon, killing two more and missing at least ten. He didn't try to whip any more, thank God, but stuck to rocks or trying to pin them down with his stick. Then, we found a big one and stoned it with at least seven or eight stones until we saw it wasn't a rattlesnake at all, only a king snake.

"Hey, these are good snakes," I said, grabbing Destin's arm before he administered the coup de grace. "They kill rattlesnakes. He'll be a good pet."

We argued over killing the snake for awhile and I won.

"Let's take it to Jerry." Jerry was Jerry Greenlaw, our old Scoutmaster and janitor at the high school. "He'll know what to do with it." The snake was bleeding, dripping all over me as I held it.

At Jerry's house, we got lucky and found him at home. He was taking a long lunch break. Once we'd shown him the snake and explained how we'd come by it and he'd chastized us for hunting rattlesnakes, he went into his bathroom and emerged with bandages and tape. Half an hour later, the snake was bandaged neatly in seven or eight places and snug inside a shoe box which Jerry dug up. Already, I had decided on the name "George" for my new pet; why, I don't know except that for some reason all my pets were named George at first and then later, for some of them, the ones that lived or weren't released, they were given other, different names. He just looked like a George. I

guess all animals looked like that should be their name, at first, to me. Maybe I was just a weird kid with a total lack of imagination as far as names went.

Destin, figuring the fireworks at home were over, decided to head for his house and something to eat, and I lit out for my place, George tucked under my arm in his box. When I arrived there, I gently flipped the box over and dumped George out in the back yard. He promptly crawled away, leaving eight round, white bandages in a perfect S-pattern to show where he'd started from. So much for first aid, I noted, and ran and picked him up, holding him behind the head like Destin had held the rattler.

I took him over to the house and released him, guiding him with my foot until he took the hint and wriggled under the foundation. Where there were mice and centipedes and roaches and all sorts of other good and tasty snake-meals to eat. I felt good about George being there; it meant we would be safe from rattlesnakes. And scorpions. King snakes were supposed to be immune from any such poisons, and were said to especially hate rattlesnakes, killing any found in their territory.

I got a jar lid from the shed and filled it with water from the hose, setting it just inside the ground under the house. Now George would have water along with plenty of bugs and mice to eat. The perfect home for him.

It was by now late afternoon and I wondered what

to do to kill the rest of the day. Just then, Inez came out of the house, a basket full of wet, soppy, white sheets and pillow cases in her arms. This was her day to clean and wash. I went over and took the basket from her and carried it out to the clothesline. We talked about nothing in particular for a minute and then I went into the house to check out the refrigerator. I didn't mention George.

There was nothing worth eating but some cold hot dogs, so I grabbed three of them and went out the front door, no particular destination or plan in mind. Maybe I'd scout up some pop bottles, sell them. I needed money to finish the boat and it was too late in the day to hunt up lawn-mowing jobs.

An hour later, after finding only three bottles in the weeds along the levee, a whole six cents worth, I trudged back home. I went around to the back to put the bottles with others I'd already collected, in the shed. I walked around the corner of the house and my heart popped up in my throat. It was Dad and he was mad. I could see it in the way his jaw was jumping and by the color of his face. Inez was beside him, arms folded, one huge forearm pointing toward the edge of the house. Beneath it, rather, as I soon discovered.

"Corey John!"

I was in massive trouble. "Corey John" was always, but always a harbinger of bad news.

"Yessir?"

"Is that your snake?"

"What snake?"

"That snake!" An angry forefinger pointed toward the house. Down, at the crawl space. I walked over and there was George, casually lying there as if he was the King of England, except the King of England didn't have multiple cuts on him, probably.

"Yessir, he's mine. He kills rattlesnakes."

"Goddammit!" He took a step toward me, arm upraised, and then lowered it to his side. It seemed to take an effort. "Inez, go and get in the car. I'll take you back to the shop in a minute." She turned obediently, and walked to where one of the cabs was parked, in the alley. He came over and stood in front of me. My hands were as wet as a cave wall and twice as cold.

"I don't give a good goddamn if that snake kills polar bears. Get rid of it. Do you know what that damned thing did?" He didn't wait for my guess. "It crawled between Inez's legs when she was hanging up the sheets. Right between her feet!" I got a picture of that, and, scared as I was, couldn't stop the smile that spread over my face.

He raised his arm and I knew he was going to hit me. I flinched, but didn't look away. When his arm was drawn all the way back, he didn't something totally unexpected. He started to grin himself and then burst into outright laughter. He lowered his hand and just stood there laughing and then so was I, and just like that, it was over, the tension gone out of the air.

"You little shithead," he said, his voice mock-stern

but with a trace of mirth in it. "I ought to whip your butt right here and now, dammit." He smiled again, unable to prevent it, and said, "But I won't. It is kind of funny to imagine that big ol' black woman jumping like that, isn't it?" For a brief moment, warmth crept into his eyes as he looked at me and we shared the vision neither of us had seen, but both were imagining, probably in the same way. The softness in his eyes lasted only a second more and then he turned and said curtly, "Inez is so scared she says she won't hang up any more wash. She had to call me at work to come home. I had to turn down a fare to Velasco to come here. Do you realize how hard it is to get a good maid? Do you know how much money I'm losing by having to come here?"

I didn't have any of the answers to any of his questions. I wanted to ask him why he just thought of Inez as a hard-to-get maid, when she had practically raised me from the age of eight, had been more of a mother than my real mother had been, but I decided this was not the time to bring that up. I said nothing for a second, and then,

"I'm sorry, Dad. He won't hurt anyone. He kills rattlesnakes. I thought . . ."

He stepped toward me, not raising his arm this time, but it had the same effect on me as if he had. I stopped in the middle of my sentence. I was just going to explain that I had felt putting George under the house was a good thing, that he would protect us

against rattlers and scorpions and stuff like that.

"I don't care what you thought, Corey John. You just get your butt in gear and get rid of that snake. Right this minute. You're getting worse and worse. I don't know what to do with you anymore." He whipped around and stalked toward his cab and Inez, who I could see in the back seat, peering out. Part way there, he turned again.

"You didn't finish the shed like you were supposed to, either. I told you a second coat everywhere. You only gave the trim one coat."

I waited until the car was gone before I moved. I couldn't see at first, because of the tears that had come from out of nowhere. It was a stupid time to cry. He hadn't hit me and we'd even shared a laugh together. I told myself it was dumb to be bawling like that, but I couldn't stop. It seemed like that's all I did anymore, bawl like a big baby.

After a minute, I rubbed my face with the heels of my hands, and went to look for George. He was still in the same place, catching the fading sun's heat. He was easy to catch.

I was going toward the alley, when for some reason I glanced back. I saw Mom at the window, curtain parted. When she saw me looking, the curtains whipped closed and she disappeared.

Ka'rack!
"Save your bawlin."
Whap!
"What were you stealing for?"
Whap.
"For you."
He stopped. I was standing still, but it took every bit of strength I possessed. I felt my shirt on my back sticking to my skin. It was funny—when he quit, it didn't hurt that much.

"You chickenshit." Wramp. "You sniveling brat. I knew you were a little queer. You and your faggot friend. Now, you're gonna get a good whippin'. If you hadn't lied to me that woulda been it." I tried to turn, slow, because it hurt to move. He had his arm raised for the next lash. I could see the brown leather glisten and realized it was my blood that made it shine so.

"It's the truth, Daddy." I was trying to talk between snot running down my nose and tears blinding me. I wiped my sleeve across my face which only smeared it more. I despised myself for my weakness, for what I was about to do.

I walked around town, edging slowly toward the outskirts with the best of intentions. To let George go. I made a mistake, then. I started talking to him. That gave him a personality, and once that happened there was no way I could release him. Not with stone bruises

and cuts and lacerations all over his body. He was in no condition to go back into the wild. Some rattler would finish him off in no time. Or a hawk or a gator. So I did something I hadn't done in a long time. Something I knew was going to backfire. Something I knew I was going to be sorry for doing. Something that gave me a cramp in my stomach and made my hands sweat, but something I just had to do.

I disobeyed my dad.

I took George back home.

Only this time, I didn't release him beneath the house. I let him go under the shed this time. It wasn't on pilings like the house, but various animals, cats, possums, maybe a raccoon or two, had dug holes under it for their lairs, and that's where I released him.

And forgot about him until the next day.

I even started painting the trim right away. I hadn't been painting five minutes when Dad's cab pulled up, in the driveway alongside the house. Uh-oh, I thought. What'd I do now? Maybe he was coming back to yell at me some more about the snake. Guiltily, I looked about for George, but didn't spot him. Please stay under the shed, I prayed.

"Corey."

"Dad."

"Corey, I got to thinking." He stood before me, hands on his hips, looking down, and he got quiet for a minute.

"I've been kind of hard on you, son." I couldn't help it. This was not the time for it, but I was powerless.

Tears welled up and I turned away, hoping with all my might he didn't see how weak I was. I stared at the ground and made my mind go blank, fighting back the tears until I got myself under control.

"It's okay, Dad," I said, finally. I dipped my brush into the paint can and painted over the spot I'd just finished, just to keep my mind and hands busy. To my utter surprise, Dad came over and picked up one of the brushes in the turpentine can and wiped it on the grass. He began painting with me.

Nothing was said by either of us for awhile; we just slapped on the paint, side by side, and then,

"Your mom's sick."

"Huh?" I stopped painting, brush in mid-air.

"Your mom's sick. She may have to go to the hospital for awhile."

I laid down my brush and stared at him. He kept on painting, not looking at me.

"It's nothing physical, Corey. It's . . . it's emotional. We think she's having a nervous breakdown. All this religion."

I was stunned, flabbergasted. Sure, Mom was extra-religious, maybe even a little fanatical, but sick? Emotional?

What he meant was crazy, insane. Why didn't he say that? It wasn't true. She wasn't crazy. She was just . . . religious.

"Dad . . ."

"If she gets much worse, we might have to take her

to Houston. She might have to stay awhile." He looked sideways at me but his eyes were on my face, not meeting my eyes. "I wish to hell we'd never moved here!"

I wanted to say something, but what? He began talking again, at the same time painting over and over the same spot, dipping his brush in the can from time to time, but painting the same exact piece of trim. I could tell by his voice that he was somewhere else in his mind, another world I couldn't know about. I think he'd forgotten I was there.

"We were fine at first. Had fun—boy!—did we have fun! Did you know your mother was one fine dancer?" It wasn't a question that required an answer. In fact, I don't know if he knew I was there, listening, even though he was addressing me. He was somewhere deep, somewhere I couldn't go, and it was all coming up out of him. I was embarrassed. I couldn't go and I didn't want to stay there and listen, but I had no choice. I started painting again, doing my best not to listen, not very successfully.

". . . she'd have a drink or two sometimes, too. Never get bombed or anything, except that one time, but man-oh-man, we had us some times!

"And she was all for the idea of me flying. Even had this idea we could get our own plane eventually and then some more, hire others, build a business. Then, she starts reading that damn Bible!" The venom in his voice was alarming. I painted faster.

"It was her goddamned mother that got her the

bug to come back to Texas. Move to this hellhole."

"Dad." It was difficult to open my mouth and speak, but I didn't want to hear any more about Mom. Or Grandma.

"Dad, do you want to try and go fishing this Saturday?"

I couldn't see his eyes, but I saw his shoulders tense up and knew I'd angered him.

"No."

I got reckless.

"Why not? I won't be late this time, Dad. I know a place where we could catch a hundred piggies and croakers. Heck, maybe even two hundred." I was lying. We might catch twenty-five, thirty. Still, that was a lot.

"Corey, I already took off work once this week to go fishing with you and what happened?"

"Dad, I won't be late this time. I'm not in school now. Ol' Scratch can't keep me in." As soon as I said "Ol' Scratch" I wished I hadn't. Dad was very big on respecting teachers. I went ahead, real fast. "'Sides, you need a day off—you've been working too hard."

"I don't think so, Corey. If your mom has to go to Houston, we'll need even more money. Insurance doesn't cover mental . . ."

"I know a place where you could go fly fishing."

I was playing dirty pool. I knew Dad loved fly fishing more than anything in the world. He was always putting down local fishermen for not using lightweight

tackle. More than once he'd sneered at my bait casting reel. He didn't seem to realize trout and panfish gear weren't suitable for the fish down here. He was still in Indiana someplace, fishing for what people down here would call "little bitty bait fish." I knew I'd hooked him when he hesitated.

"Well, I don't think so, Corey. I . . ."

"I know a place where the river makes a bend and backs up where there's pools so deep and still the water never moves. It's perfect for fly casting. Lots of mullet." I must have been desperate. I wouldn't let a mullet get on my line, in case I'd lose my standing as a fisherman. You couldn't eat mullet. They were top feeders. Some said the colored people ate them, smoked them or something, but no one I knew would consider it. Sometimes for kicks we'd catch them on doughballs. They weren't bad bait, cut up. But Dad was a Yankee, through and through. He didn't even know the local prejudice against them. Indeed, he admired the way they looked. Kind of like a trout, he'd say, and trout fishing with a dry fly was his avocation.

I got him!

"Well . . . maybe we can go sometime."

"This week. Saturday. Please, Dad?"

"Maybe. Let me think about it."

We kept on painting. At least he'd quit talking about Mom. And then,

"Okay, Corey. We might be able to go Saturday. I don't think any tankers are due in. I'll check the list."

He meant the list in the dispatcher's office at the taxi company, next to the restaurant. They kept a list of all the oil tankers scheduled to dock. If tankers were in, no one got off. The cabs were shooting all over the place then, taking sailors off to Galveston or Houston to buy a bottle or a woman.

We finished the trim and cleaned the brushes and I thanked Dad for helping. It felt so good to be doing something with him. It was hard to remember the last time we had done anything together. I wished the moment could go on forever. He was just about the best dad a son could have, I was thinking, and just as I thought that, he said the perfect thing.

"What th' hell. Let's go fishing. Six o'clock sharp, Saturday. You better be up and ready to go."

"Oh, wow! Don't worry, Dad. I'll be ready at five! I'll have to get some bait the night before so we don't have to waste time." Then I remembered he wanted to fly cast. "I'll get bait for me I'll get all the gear and your fly rod out Friday night, too."

He grunted and said he had to get back to work. We stood there a moment, admiring our paint job, and he put his hand on my shoulder. Outwardly, I appeared very calm, but inside I was a Mexican jumping bean with delight and joy. Just this was all I had ever wanted with my father. Maybe things were changing.

I was waving at him as he backed out of the driveway and all of a sudden I felt something on my foot. George! He had crawled out from beneath the shed. I

lifted him with my foot and flipped him in the direc-
tion of the shed where his hole was, and he must have
felt my anger for he slithered right into it. It was only
the purest of luck that he hadn't appeared when Dad
had been here, or not only wouldn't there have not been
a fishing trip Saturday, I wouldn't be doing much sit-
ting either! I should have gotten rid of the snake right
then, but my brain wasn't working right.

The next day, around ten in the morning, the glow
from the previous day still on, I finally awoke, mad at
myself for oversleeping on a vacation day, loud voices
from the back yard penetrating my foggy mind. Why I
didn't look out my window to see what the commotion
was, I don't know. Maybe I knew what it was and was
just afraid to look out.

I reached the downstairs just as my father was com-
ing in, through the kitchen. I could see Inez through
the window, standing in the yard. Two or three sheets
were whipping about in the breeze, the rest still in the
basket which I could see was piled high. She wasn't by
them though. She was standing clear back by the shed.
Just beyond her, in the alley, was Dad's cab.

I turned to run up the stairs, but he was too quick.
Just as I reached the bedroom door, he grabbed me by
the hair and yanked me backwards. I thought my neck
was broken. Then, I was on the floor, my elbows dig-
ging into the hardwood and he was striking me. Not
with his hand, not even with his belt. With George.

He was whipping me with my snake.

Over and over and then it struck my neck and
whipped around it, choking me. I could feel the cool-
ness of his body and feel pieces of his entrails on my
cheek and I clawed at him to tear him loose to get air
in my lungs and instead of oxygen filling my lungs I
began to vomit and that began to choke me as well. In
absolute terror, I tore at the thing that was around my
neck, screaming and crying and choking on my vomit,
and then, somehow, I got it off, flinging it across the
room. I doubled up into a tight ball, trying to compress
into as small an area as I could, shaking violently, as
if suddenly overcome with a severe tropical fever. I felt
his boot thump into my ribs, but I couldn't feel any
pain. My shaking was so intense I doubt if I could have
felt anything. And then, he must have left; I heard a
car door slam and the sound of gravel being strewn up
against the shed and then everything was still.

Where was Mom, I kept thinking. I knew she must
be out, probably down at the church, and I hated the
fact I wanted her, like some big baby. That's what Dad
would think, but at that point I didn't care what he
would say. I just wanted my mother in the worst way.

For the longest time, I couldn't bring myself to
move. When I did, finally, the first thing I did was go
over and pick up George. He was a bloody piece of rope,
the blood already turning black. I went into the bath-
room and turned on the shower and walked in, the
dead snake in my hands, and I stood there, clothes on
and all, for what seemed hours, but in reality was no

more than several minutes, I suppose. I took off my clothes with the water still beating down on me, laying what was left of George down in the tub while I did so, and, naked, picked him up and went upstairs to my room, not bothering to dry off. I put on new jeans and a white t-shirt, no shoes, and went back downstairs. I went back into the bathroom and picked up my clothes, wringing them out in the tub as much as I could, and took them out to the kitchen, to the little laundry room off it, and placed them in the hamper. Back upstairs, I got George from where I'd lain him on the floor, and went back downstairs and outside, holding him like he was still alive and just hurt.

I took him over to the vacant lot behind our alley and buried him, digging with my fingers. When I covered him over, I saw that my fingers were bleeding from the tips, under the nails.

I went back into the house. I must have been a little crazy because of what I did next. For some reason, I didn't go up to my own room, but walked into my parent's bedroom and into their closet. Their closet was huge. Grandpa had converted the little sitting room that adjoined the bedroom, hanging poles for all of Grandma's clothes and shoes and junk. I crawled to the far end, in the corner, behind large paper sacks of old shoes, and sat down, my head hidden in my arms, like some wounded animal, which, in a way, I guess I was. Spiritually, at least; I don't think I was actually hurt physically all that much. I don't know how they

got there or why I had them, but I realized I was holding a pair of my mother's old deck shoes.

Just then, the front door opened and I could hear my grandfather and grandmother talking as they entered. It was so still in the house, that even where I was, I could hear them plainly.

"I don't think he's here, Lucille." They were opening and shutting doors. Who were they looking for? Me? I didn't come out.

"I guess you're right, Toast. What're we going to do?"

"Well, she's our daughter, but she's his wife. We can talk to him, but this time I'm not sure that he's not right. A little religion's all right, but she's gone past that point."

"I know." It got quiet. It sounded like they were standing in the middle of the living room. I knew who they were talking about.

"I've never seen Robert like that."

"I know. He was in an absolute rage. Might just be guilt from making the decision."

Decision? What decision? Then, I knew exactly what they were talking about. Dad was sending Mom to the hospital in Houston. He had decided to have her committed! I started to rise, but changed my mind.

"He looked like the insane one when he left," Grandpa was saying. "I hope Corey wasn't home when he got here. He looked like he could have killed someone. What a time for Inez to call!"

"Well, I don't like snakes either. Corey should have done what he was supposed to." I felt like hating Grandma for sticking up for Dad, and then I realized she had no idea what he'd done.

"Corey's probably somewhere fishing. Let's go. I think I know where Robert went. If we can just talk to him, maybe we can talk him out of sending Mary away. We've got to try. Maybe you ought to try talking to Mary again. Not that she's ever listened to you! Remember when she was in high school and wanted to go on that trip to Dallas and you said . . ." Their voices faded away and I heard the front door open and close. They were gone.

I sat there awhile, trying to sort things out in my head, and then I just fell asleep.

I must have been tired.

I was dreaming and I knew it. It was one of those dreams where you are fully aware that you're in that state and you also know you can choose to wake up if you like or continue with the dream. I decided to continue with the dream a little while. I was reliving the time my father had taken me fishing and had shown me how to cut crosses in the fish that were too little and throw them back. The little ones were starving out the big ones and we needed to cull them, he said. He showed me how to cut them so that they didn't die right away, but would swim noisily, possibly attract-

ing bass. I was remembering all this in the dream, but that part was only kind of background stuff. I was at the part of my memory where the sun was bright, bright, bright; so bright it was as if it had exploded and this was the first flash, kind of like those photos of atom bombs exploding.

The sun was bright, like I was saying, and you could see a perfect ball in the water, even the color, red, with white all around it. I turned for a minute, and when I turned back, I lost my father in the sun and felt a mild panic. I twisted my head, knowing this would bring him back into view, but this time it didn't work. This time he had disappeared, completely. He was nowhere to be seen. Somehow, he had disappeared into the sun.

I was terribly afraid and tried very hard to remember that this was just a dream and therefore I could awaken whenever I chose.

Some Things Become Clearer

When I awoke, it was later, much later, though I had no way of knowing how long I'd been in the closet. I barely remembered having a bad dream. I must have slept forever.

The first thing I noticed when the cobwebs began to blow away was that I was ravenous, the second that I hurt all over, and the third, realized but a split second behind the other two realizations, was that there was someone in my parents' bedroom, talking.

It was my parents. They were arguing.

There was no way of telling what time of the day or even night it was. The closet seemed darker, but it was hard to tell the time from that since the doors were shut. It just seemed darker. I wanted to be out of there, terrified at being in that place and that close to

my father, but there was no way I was going to move until the room was clear. Part of me wanted to hear what my parents were talking about; part of me felt shame for eavesdropping and wanted to be far, far away. I didn't have much choice in the matter.

"It's been six goddamned weeks!"

That was my father. He was mad, but trying to keep his voice low, it sounded like. There must be others in the house, probably Doc, maybe Grandpa and Grandma, although Grandma usually worked until one or two in the morning, and Grandpa's shift didn't end until midnight, and sometimes longer if there was a problem at the plant. So on second thought, Doc must be who he was trying to be quiet for. Her bedroom was next to theirs.

"Do you think I'm a eunuch? A man has rights, you know."

They were arguing about sex again. There had been too many slurs and half-hidden hints and innuendos for too long a time, for me to be in the dark about the subject of this discussion.

My mother said something, but I couldn't hear it; her voice was too low. It sounded like she was crying.

"No, of course that's not why we're sending you to Houston. You're sick, Mary. This is just part of it. You just aren't Mary. You aren't the woman I married. It's this blankety-blank religion." He actually said blankety-blank—even in the heat of argument, he respected or feared her prohibition against profanity.

Most of the time.

"Where in the goddamned Bible does it say we can't have sex? How do you think all those people got there? By osmosis?" So much for keeping profanity out of his speech.

"Robert!"

I heard her this time, loud and clear. He should have stuck with "blankety-blank." All of this sex talk was making me nervous. What would I do if they actually decided to "do it"? I didn't have an answer for that.

"Robert, my Aunt Fanny. It's been six weeks this time and more than two months before that. You tell me, is that what you call normal? Is that 'God's Plan'?" The sneer was plain in his words. I remained as still as possible. I was terrified I'd sneeze or something and they'd discover I was hiding in the closet. I was covered with perspiration and my chest hurt from holding my breath in. I was certain they could hear me breathe.

Mom said something but again I couldn't hear it.

"You haven't felt good since we got back here. You haven't felt good for six damn years. Ever since you got tied up in that church."

She said something of which I caught only scattered words. "God," "damnation," "I love you." How it all fit together, I hadn't a clue.

"I love you too, baby." His voice was huskier and I heard the bedsprings squeak, so I guessed he'd been standing and had sat down on the bed.

"All I ever wanted to do was fly." His voice had taken on another quality, not exactly pleading but something akin to that. "You wanted the same thing once. At least you said you did. We could have been set by now, if we'd stayed in Indiana. I might even be flying for an airline. At least I'd be flying, even if it was only crop-dusting. I'd be doing something I wanted to do, not driving a damn cab for a woman who promises part-nerships and never delivers. And you'd still be a wife. We might even have a decent marriage." His tone had changed again, become sarcastic. He slipped into a falsetto, mimicking voice.

"I'm tired, I'm praying, I'm reading now." It was a mean, loud voice.

"Even your mother agrees that you need to be com-mitted. If we'd stayed in Indiana like I wanted, we'd be all right. You wouldn't be such a fucking fanatic and I'd be doing something I enjoyed, instead of being your mother's head nigger." I had heard my father cuss many times before, but never had I heard him employ the language he did now, and rarely did he use the word "nigger." He was proud of the fact that he was a Yankee and not prejudiced like everyone else down here. He talked about it all the time, and the one thing guaranteed to make him see red was for either of us kids to say anything bad about colored people. He must really be boiling.

It surprised me that Mom didn't respond, at least not that I could detect. I suspected she was weeping

silently into a handerchief.

The bedsprings creaked again. It sounded like he had gotten up. His voice changed once more, and I felt the perspiration on my skin chill. There was absolutely no emotion in the words he spoke. He might have been reciting the Gettysburg Address for a class assignment.

"This is just about it, Mary. I'm just tired of the whole thing. Even your goddamned son is turning out like you. Kid reads all the fucking time, doesn't know a gasket from a cantaloupe, and goes around saving stupid animals like St. Francis of Assisi, just like you used to. He's going to end up just like you, a goddamned religious faggot."

I didn't want to hear this. I put my hands over my ears, then just as quickly took them off. I couldn't stand hearing his muffled voice and not knowing what he was saying. He had a point, I guess. I read constantly, and stuff that would be considered adult. I'd tried books like the Hardy Boys series and was bored stiff. Reading as much as I did got me in trouble sometimes with kids my age. It made my vocabulary different and sometimes I would forget to talk like everybody else and they'd look at me funny, like they thought I was putting on airs. I wasn't, it was just the language I thought with, but I knew it was a peculiar language for most boys my age. And Dad hated it. I tried not to talk to him in my "high-falutin'" tone, as he called it.

Actually, I thought of myself as possessing several "foreign languages." Depending on the situation and

who I was talking to, I'd found the need to use different diction, different words. When I was with the kids at school I talked one way, and when I was with adults, certain kinds of adults, I used another "language." I learned to do this very early on, but sometimes I slipped and used the wrong words. But, after all, I was just a kid. Kids make mistakes. Dad was going on.

"Ha!" he said. "You think that's normal! A boy doesn't act like he does. Girls act like that, not boys. Makes me want to puke, it does! If I'd been like him when I was his age, my dad would have busted my ass. Hell, six more years he's gonna have t'make a living, and how's he think he's gonna do that? Can't even change a flat tire. Who'd hire him?"

Dad, Dad, I pleaded in my mind. Don't say those things. Just love me. Please. I'll be what you want. You'll see. Wait till you see what I'm building for you. You'll change your mind. You'll see I'm the kind of boy you want. I'll quit reading.

I hated my books at that moment. If I'd been in my room right then, I would have ripped them all to shreds. I'd do anything to make him love me. I thought about the boat. I wanted to rush out, tell him about it, take him to it, show him the completed vessel, have him put his arm around me like he had yesterday, say he was sorry he'd thought I was a sissy when it was obvious only a real boy could have built such a thing. But I couldn't. I had to sit there in the closet, remain quiet. Three weeks, I kept thinking, holding on to the thought

like a life buoy. In three weeks, he'll change his mind, once he sees the boat. Everything will be all right then.

". . . nothing wrong with Corey." My mom was speaking and I could hear her better. "He'll go to college, become a teacher or maybe a lawyer or doctor. You'll be proud of him."

"And wear a suit and never do a damn day's work in his life. That what you want?" Dad hated suits on men. He felt that anyone who wore a suit was soft, didn't do any "real" work. Work was something you did with your hands.

"Be a teacher? That'd be perfect! He can sit around in the teachers' lounge with the rest of the ladies, sipping tea with them. Little Lord Fauntleroy! Great kid you've raised, Mary. I'm sick of it, and I'm sick of him, and I'm for sure sick of you! You'd just better get ready for a trip to Houston. I've had it. You'd just better start packing your bags. Oh, and don't forget your Bible. Not that you would." There was silence, as if Dad were waiting for a response, and then I heard him walking toward me, toward the closet, and my body froze in terror. The smell of my arm-pits rose up and struck my nostrils and my hands were slippery with icy sweat. He knew I was in here! I shrank back, pinching myself into the corner with the shoes, trying to melt into the wall, and the door flew open, flooding the space with light. He stood there, towering above me, right on top of me or so it seemed, and I swore he looked directly at me.

But he must not have been focused, or had other matters occupying his mind, for he reached his hand forward, for me, I was certain, and I cowered, about to scream, my eyes closing in anticipation, and then I heard the metallic rattle of a clothes hanger and the door slammed and I was back in the dark once more. I squinted open my eyes, with trepidation, making sure that, indeed, the door was closed. Almost. A tiny sliver of light peeped through where it stood slightly ajar, pearlized light, from the lamp on the nightstand, I imagine, but appearing to my dazed state as a light emanating from Heaven itself. Or possibly Hell.

He had merely grabbed a jacket. I could hear him zipping it up.

"I'll be back when I'm back."

There was a slam and then silence. With the door ajar I could hear better now, and it was clear my mother was crying. This lasted a long time, and then I heard her blow her nose, and the bed squeaked a bit, and I began to hear pages being rustled as they were turned. She was into her Bible, I knew.

I was still trapped. There was no way out. I had to wait until she grew tired and went to sleep. I hoped that would happen before Dad returned. I had a feeling it would.

It turned out to be one of her marathon reading sessions. Once or twice, I heard sniffles and she blew her nose a couple of times and I could imagine the scene. I had time to think about all the times I had

gone into her room before going to my own bed and found her sitting up, Bible in hand, tissues strewn from one end of the bed to the other. Now, I had an idea what had spawned them.

As I waited, my mind was busy enough, filled with a kaleidoscope of images. Something my father said bothered me—something?—everything!—but something in particular, and at first I couldn't figure out what it was, and then it came to me. He had said something about how Mom had started changing when we moved back to Texas six years before, how she had started getting tied up in her church and had gotten more and more religious and withdrawn. Something to that effect. I began to realize something. Not only Mom had changed then, but Dad also. Memories came flooding back as I sat in the darkness and waited for my mother to cry and read herself to sleep.

I remembered Dad before we had come to Texas. He had been a pilot in World War II, flew B-17's, and talked incessantly about the joy of flying. He had always worked as a mechanic in various garages and gas stations, but would rent Piper Cubs and other small craft from time to time, and take us, Mom and me, aloft with him. I could even remember him handing me the controls when I was only six or seven and letting me "fly the plane"! I hadn't, of course; he had the ultimate control, I'm sure, but it was exciting nonetheless. And I recalled how proud of me he'd been, bragging to Mom how I'd taken to flying right away,

exhibiting a fearless and brave attitude. Pieces and
snatches of recollections came flooding back. It had
been so long ago. I'd forgotten that Dad and I had once
been great pals. All I had been remembering was the
last few years, when more and more, we clashed openly
and fought. There had been a time when such wasn't
the case at all; when we were happy and loving to-
ward each other, me and Dad and Mom and my new
baby sister Doc, when she came on the scene. Before
we had moved. What had changed?

It had to be the move to Texas. What was it about
moving here? It was six years ago; I was only eight.
Something began to emerge in my memory. An argu-
ment. That was it. An argument that went on forever,
for days, weeks. Dad had a chance at a job with a crop-
dusting service. It was low pay, I think; I think that
was one of the reasons Mom didn't want him to take
it. It was dangerous, too. Now I remembered most of
it. Mom cried and cried, saying she could just see him
crashing into a power line or the side of a barn some-
where. Then, one of the pilots for the company did just
that, crashed his plane after hitting some telephone
poles. Mom was beside herself.

There was a choice. Mom's mom, Grandma, had
written and called, asking us to move to Texas to help
her with her businesses. With the restaurant and cab
company. Dad resisted, didn't want to go, wanted the
flying job. It could build into a partnership. Where at
one time Mom had gone along with the idea, even act-

ing excited over Dad's dream, now she began crying and carrying on, for days on end. She was homesick. She hated the weather in Indiana, the winter snow and sleet, the "coldness" she claimed Northerners had, the food, bland and tasteless.

Then, Grandma phoned, offering Dad a partnership with her in the businesses. That was easy to remember. The partnership had never materialized, and Dad fumed about it often and vocally. I'd overheard remarks he'd made to Mom, and she'd always say, "You don't need anything in writing. When she dies or retires, it'll be yours. You'll see." And he'd counter with "that wasn't the deal; there was to be a partnership right away"; he hadn't wanted any of it to begin with, but at least she should keep her end of the bargain. I knew he hated not being able to see the books, never knowing how much profit or loss the business generated, having to live on the salary she doled out to him, working seventy, eighty hours a week, six and seven days most weeks. I had heard those complaints and more, many, many times over the past six years.

My thoughts were leading me into new waters. I began to realize some things about our family relationships. Like Grandma always calling me "Sugar Man" and fussing over me, spoiling me, giving me anything I wanted. She always did it more when Dad was around. I had never thought of that before, but now I saw it clearly as could be. She would fuss over me, but then forget to pay Dad on payday, claiming to have

forgotten to have made out the check, keeping him waiting all day sometimes until she "found time," acting angry, like he was keeping her from something more important. Then, two minutes later, she would be jumping up to go fetch me a doughnut I hadn't asked for or make me an ice cream cone.

As soon as we'd arrived in Texas, Mom had begun attending church. We had never gone up North. I seemed to remember she had started going only to see old schoolmates, people she had grown up with, and then she started to actually listen to the sermons, the hell and brimstone tirades the Baptist minister regularly delivered, yelling and screaming and hopping about. They had scared the bejesus out of me when I'd been forced to go, so that I felt guilty at every action I took, even going to the toilet, knowing somehow that even taking a leak was sinful.

At first, she only went Sunday mornings and then we had to go Sunday evenings as well, and pretty soon Wednesday prayer meetings were added to the schedule and it was only natural after that for her to join a Bible fellowship group that met at members' homes on Tuesdays. By the time we had been in Texas a year, she was in church half the week, and immersed in her Bible and religious books the balance of the time.

That was when Dad changed! This realization struck me like a thunderclap! He didn't hate me; he hated the life he was forced to lead. I felt a warmth flow over me with this insight, and my first instinct

was to leap up, fling open the closet door and yell at Mom, "Mom, it's your fault, yours and Grandma's. Don't you see? Get out of that religion, let Dad take us back to Indiana, let him do what he wants," but I knew that would be a mistake. No, that wasn't the answer. There were forces in motion I could never go up against and succeed in thwarting. The answer was to understand Dad, try to help him as much as I could, show him I loved him, forget it when he yelled at me or hit me. I was only adding to his frustrations.

I felt intense shame. All I had done was give Dad grief. When the whole world was against him, I had done things to disappoint him further. I thought of the times when he would want to work on the car, in his few minutes of spare time, and I would conveniently disappear instead of acting interested and helping him, handing him tools, learning the things he could teach me, wanted to teach me.

I had hated everything to do with cars and the like. I'd rather read or go fishing or even just sit and think. I could see now what a major disappointment I'd been. It would have been so much easier on him if I had just pretended to like the same things and hung around at times like that, handing him screwdrivers, asking him questions, taking an interest. I had been utterly self-ish, wanting to do only those things I enjoyed doing. No wonder he despised me. I'd despise such a son as I'd been too, probably.

I made a vow. A solemn oath. From this day for-

ward, I'd be more understanding, more tolerant. Go out of my way to do things with my Dad, things he liked, even mechanical things.

The boat! I remembered the boat and excitement overcame me, all over again, just as it had when I'd first conceived the idea. When he saw that boat, he'd know beyond any doubt that I loved him, was the perfect son. I saw it all so clearly. I saw the light go on in his eyes as he realized I was, indeed, the very son he'd always wanted.

Just then the light in the bedroom went off. Mom had finally decided to go to sleep! I waited for what seemed another hour, listening to her toss and turn, before she settled down. After long moments of dead silence, I figured she had finally fallen asleep. Taking extreme care to be quiet, I inched along the floor and opened the door. Peeking outside, I could just see her form outlined in the bed, her back to me, the room dully illuminated by the phosphorous light of the clock radio on the nightstand.

I was almost to the door when I heard a gasp behind me and the light flared on.

"Corey John!"

Oh, man, I was in deep trouble!

"Yes ma'am?"

"What are you doing in here?"

I was in luck. I didn't think she knew I'd been in the closet. I decided to play it that way, act as if I'd just entered the room.

"Nothing, Mom. I was just looking for my blue shirt. I thought it might be in the basket." Sometimes when Mom did the ironing instead of Inez, she kept the basket in her room.

"It's already in your drawer. You didn't look good enough."

"Oh. Okay, Mom. I'll look again." I put my hand on the doorknob. "Well, goodnight. See you tomorrow."

"Wait a minute."

Oh, Jeez, I thought.

"Yes'm?"

"Come over here. Here." She indicated she wanted me to sit down on the foot of the bed. I obeyed, wanting nothing more than to escape. Especially before Dad came back.

I sat there, neither of speaking at first, and then she said, "Corey, I've been meaning to talk to you for awhile now, but there never seems to be a good time. I might have to go away."

I knew what she was talking about, but I played dumb.

"Go away? Where? On vacation? You and Dad?" I couldn't look her in the eye, but stared at the bed. It was littered with yellow tissues.

"No. It won't be a vacation. Your father . . . and Grandma . . . think I might be . . . ill. They think I need to see a doctor. They're wrong, but I have to obey your father. He's the head of the house and God says I must obey him, in every way. Even if I feel he's wrong.

God has a plan for me."

Some plan. Lock her up in a loony bin, dope her up, take her away from her kids. I could have thought up a better "plan" in about five seconds and it would have had a better ending.

I couldn't stand it when she started on about "God's plans." According to her, if Dad told her to take a chain saw and wipe out the neighborhood, she had to do it. Well, it wasn't quite like that. She was supposed to obey Dad at all costs, unless he asked her to sin. That was the one thing she could disobey him on. It was too much for me. It made her some sort of sub-human, living in a fascist regime. I knew better than to argue with her, though.

"This hasn't been a good year for you, has it?"

Her question surprised me. It hadn't occurred to me for a second that she noticed anything about me, or what was going on in my world. Then, I remembered her face at the window the other day. Maybe she saw more than she let on. Still, the question just knocked me out.

"No, Mom," I said, and before I could stop myself, I was in her arms and she was patting my head and I was blubbering like a baby.

"Mom, I . . . I can't seem to do anything right. Dad hates me. Grandpa's got cancer and they're gonna send you to the crazyhouse, and . . ." I was crying and hiccuping and the words tumbled out in a rush, with no thought behind them, just things that were on my

mind, hurting me, and I knew as I said them I shouldn't.

"There, Corey, there, there." She was patting me and smoothing my hair and there were tears in her voice and I couldn't help it; I just bawled and bawled. The tears I'd thought forever dry when I'd found out Grandpa had cancer, returned, and I plain couldn't help it. We both lay there together, sobbing, not saying a word, and I knew I'd missed this, missed not the crying in my mother's arms, but just having a mother, one that would comfort me and take my side.

And then, just as quickly, the tears dried up and I felt an intense resentment, both at her and at myself. At her for not being there for me before this and at myself for being so weak. This was just the kind of kid I'd become and I could see Dad was right. I didn't say any of this, didn't even move from where I was laying, but just stopped crying and waited.

When I felt her stop also, I lay there a minute, a feeling of embarrassment enveloping me. I sat up and moved away, back to the foot of the bed.

"Sorry, Mom," I said, staring down at the floor. All I wanted was to leave.

"Son, I know you and your father have a problem. But, he loves you." I looked up and saw she was staring at the far wall, but I knew she wasn't seeing it.

"You should have seen your father when you were born. He used to sit and hold you for hour after hour and just talk to you. He'd tell you about all the plans

he had for you. He was going to teach you how to fly."
She started crying again, dabbing at her eyes with an
ever-ready tissue.

"He hates it when you read so much, Corey. That's
because of me. It's my fault. I read to you too much
when you were little. I don't know . . . I thought I was
doing the right thing. I guess it's my fault. I'm not the
right kind of wife to him and I've changed you from
the kind of son he wanted."

This was too much. What she was saying was prob-
ably true. It just hurt too much to hear it. She was
reaffirming what I'd discovered. We'd both delivered
nothing but grief to Dad. Well, if she wasn't going to
change, maybe she couldn't, but I could. I'd make Dad
proud of me.

I got up and walked to the door. Opening it, I
glanced back. She didn't even know I had left, lost in
some reverie or other. Quietly, I slipped out.

*"It's the truth, Daddy." I was trying to talk between
snot running down my nose and tears blinding me. I
wiped my sleeve across my face, which only smeared it.*

*We rode there in his cab. I felt like an old man, my
body bent and bruised and bleeding. When he drove
past the docks, I lowered my head. I knew most of the
men who worked there. I didn't know how bad I was
bleeding, but my whole shirt was starting to stick to
my back, and I had to lean forward during the ride. I*

hated having to ride in front with him, that close.

We got to the shed and he parked in front, the car facing the door. I got the key out of my wallet, my fingers stiff and shaking, and fumbled with the lock. At last, I got it open.

I started to take the padlock off, when he shoved me aside and did it himself. He threw the lock on the ground and tore open the door, going in ahead of me. This was not the way I'd imagined this, I thought, and then I followed him in. I think there was still some kind of hope burning inside me. A tiny flicker.

I'd set my alarm to go off at five so I could catch Dad before he left for work. He must have come in some time during the night while I was sleeping, but it had to have been late—I tossed and turned until way past midnight before I fell asleep. The sun wasn't up yet, but was close enough that there was a gray half-light outside my window. It was going to be that kind of rainy day that felt like a sweet depression—like a slight toothache—it itched more than it hurt, but you didn't want to get rid of it. Great fishing weather. Fish took the bait quicker on a day like today than on any other. Maybe they were eating to keep from being morose.

I got right up and went downstairs. He was just going out the door.

"Dad! Dad!" I yelled at him, and he stopped and

closed the door. I saw he had a scowl on and ignored it. If I was going to change for him, I had to be brave about it.

"Dad, I'm . . . I'm sorry about yesterday. About the snake and all. Sometimes I don't think."

"S'all right," he muttered, his eyes avoiding mine. He didn't smile, but his scowl went away. "Sorry I lost it. You're not hurt, are you? Lot of pressure right now. Things . . ." He turned without finishing whatever it was he was saying, and went out the door and was gone. I felt funny. It hadn't gone the way I'd pictured it.

Suddenly, unexpectedly, the door flew open, and he stuck his foot up on the top step and leaned in.

"How about going floundering? Tonight? Yes?"

I could only nod, my eyes bright, a grin splitting my face in two.

"All right then. Seven o'clock." He stepped down, his hand still on the door and then turned back. "And if your friend Destin wants to go, it's all right."

"Wow! Thanks, Dad. Seven bells."

"Yeah." He looked as if there was something else he wanted to add, but didn't know what. "Well," he said, finally, "don't be late," and then he was gone and I heard the door of his cab slam shut.

I didn't jump up or down or anything juvenile, at least not externally, but I skipped breakfast and fled like a posse over to Destin's house.

"Destin!" I yelled as I ran up his walk, forgetting it

was only six-thirty in the morning. "Destin!"

He came around the corner, from his back yard, quick, holding his hand up to shush me. He was already dressed, but it looked like he'd just gotten up by the way his eyes looked, puffy and red. Then I realized he'd done what he did a lot of times—slept on the back porch. His eyes weren't puffy from just getting up; his father was on a tear and had hit him. It wasn't the first time. Our fathers were one of the reasons we got along so well; it gave us something in common. In several ways, they were much alike. I remembered the first time I'd known that Destin's father beat him. Even though I felt sorry for him, I felt good about the knowledge, in a funny kind of way. There was finally someone I could talk to about my own father. He felt the same way, I know. Sometimes, we both felt like we were the only kids in the world that had been struck by our dads.

I lowered my voice to a loud whisper. "Say, pard, I've got some great news. How'd you like to go floundering? Tonight?"

His eyes lit up, but not as much as they would have ordinarily.

"Sure. Who with? Your Grandpa?"

"Naw." I acted nonchalant. "With Dad. He said you could come. It was his suggestion, even." I said the last fast; Destin was nervous around my father, at least at first, until he had been around him a few minutes and then they warmed up to each other. It was strange

though; every time Destin and my dad got around each other, it was like they'd just that minute been introduced, both awkward and strained until ten or twenty minutes went by, and then it was like they had known each other a hundred years.

Another thing that was strange; Destin really liked my dad, and my dad seemed to like him, too. He was always kidding around with him, and I guess at times I felt a little jealous. And then, I liked Destin's dad too, at least when he was sober, which truthfully, wasn't all that often. Fembo had taken us fishing and crabbing lots of times, and we always had a good time. Except at the very end of whatever expedition we were on. He drank beer the whole time we were out on the Brazos, or the Gulf, or a bayou, and was fine, until at the end of a long day fishing, when he'd drunk nine or ten beers, and then he got nasty. Then it was time to walk softly, be careful with your words. It didn't happen like that all the time, but lots of times. It was when he got home that he got really bad, but I was never around then. I made myself scarce. I just heard about it from Destin. About how he walloped his mother around. Destin, too, sometimes.

"Your dad!"

"Yeah, smart-ass, my dad. My dad takes me fishing, you know."

"Yeah, like every other leap-year." He must have realized he was going too far, because he added, "I'm sorry, Corey. I didn't mean it like that. Hey! It sounds

like a ball! When we goin'?"

I told him. "And don't be late, buddy."

"Ha! You kiddin'?" We both laughed, remembering the last time Dad was going to take me fishing.

"Your old man drunk?" We were good enough friends I could ask.

"Yeah." He got an awful look on his face. "He hit Mom last night. Me too. Didn't hurt, though. He can't punch when he's drunk. Just thinks he can." I could see Destin's eye better now. We were walking around to the back yard and the sun made it look shinier.

"Just a love tap, huh?" We both laughed, though neither one with a great deal of mirth.

"Yeah. Someday . . ." He let his sentence trail off.

"Hey kid!"

It was Fembo. We were just ready to turn the corner of the back of the house. It sounded like Fembo was either standing on the back porch yelling or was just inside the door. Destin put his arm on me and pushed me back. Like I was going to walk around and have a chat with his dad!

"Let's get out of here," he whispered, his voice tight. "He's been at it all night. Probably drank close to a fifth of whiskey."

We went back the way we'd come, around the sidewalk, moving fast, trying not to let our bare feet slap on the concrete. We stopped at the edge of the house, and Destin peeked around. We heard Fembo yell again from the back door, so we cut across the front lawn

like we were Pancho Villa and Billy the Kid going across the border. We ran as hard as we could, illogically, for two blocks, and then we stopped, collapsing on somebody's front yard, wheezing and laughing, getting all wet from the dew still on the grass.

"Damn! I'm sure glad to be out of there!" Destin giggled. "I've 'bout had it being a punching bag for a week!"

"Good thing he can't hit good drunk, Dest. I'd be throwin' dirt on your coffin!"

He laughed, and I saw his eyes had changed color. He had the weirdest eyes; you could always tell his mood just by the color. His eyes had been almost black at his house. Now, they were just a muddy brown, almost the color of my own, which never changed, no matter what.

"I got something to show you." I don't know why I said that. I hadn't meant to.

"What?"

"Come on."

It took us ten, maybe fifteen minutes, to walk to the levee, and another five to get to the shed. I made him hurry, almost as if I was afraid of changing my mind. I took the key out of my wallet where I kept it, and unlocked the padlock. I took it out of the hasp and yanked open the door. Stepping in, I reached out and snapped on the light. Even in the pitch black, I felt it by memory. The light clicked on.

"Jeez!"

I just stood there, but his exclamation put a grin on my face. I was suddenly very glad I'd brought him here.

"It's a boat! Neat!"

Then,

"Whose is it? Not yours!"

I kept smiling and walked over to it. I ran my hand down the surface of the name board, feeling the indentation of the letters. Bob-A-Long.

"It's yours? Where'd you get it? This must have cost a fortune. Hey! It's not done! Where's the rest of it?"

"I'm building it for my dad. By myself. The whole thing."

"You built this? You can't even drive a nail straight. You don't even know what a nail looks like! Gimme a break!"

"For real. I did every bit of it. It's for Dad's birthday. In three weeks. Ya think he'll like it?"

He was walking around the boat, feeling it with his hands, looking it over.

"Man-oh-man! Like it? He'll love it! Who wouldn't?"

He gave me a suspicious look. "You did this? Honest? How come you never told me? I'da helped."

"I didn't want anyone to know. Or help. No one knows about this, not even Grandpa. You're the only one. You've got to promise not to say anything to anybody. Promise."

"I promise, Corey. Scout's Honor and all that baloney. I mean it. I won't tell. What a super neat thing!

Man! Your dad doesn't want this, I'll take it!"

He continued to walk around it, inspecting it, feeling the boards, cupping his hand around where it curved on the sides. "Jeez. This is something. How come it's not done?"

"Money," I answered. "I ran out of money. I just need to do the seats. I'm gonna use pine. The rest is redwood, except the nameboard—that's mahogany. The rest is gonna run me about twenty bucks. And a couple two or three for the varnish." Everything but the missing seats was already varnished. Six coats. Hand-rubbed. It was shining like a beautiful piece of amber in the lightbulb's glare. It was gorgeous. At this moment, I was the proudest person in the world. And this was just a preview of how I'd feel when Dad saw it. I couldn't wait.

"Mahogany. So that's what mahogany looks like. That's expensive stuff. Like platinum."

"Let's go," I said, finally. "I can't make any money standing around here. I'm gonna go look for pop bottles."

We went outside and I put the padlock back on. I tested it twice to be sure it was secure.

"I'll help ya," said Destin.

"Thanks, buddy," I said back. "But no. This is something I got to do all by myself."

He shot me a queer little stare and then grinned. "I gotcha. No prob, bud. Hey!" His face lit up again. "I'll see ya later. I'm gonna go swimming. Down at the

barge. You get done, come on down."

He didn't stand on ceremony but took off, walking fast, then trotting. I guessed he was a little miffed that I was excluding him from my project, but I knew he understood, or would, once he'd mulled it over. It was really the first time since we'd started hanging around together that one of us had done something without the other. I'd hurt his feelings some. But he'd get over it.

"Seven o'clock!" I yelled at his departing back, suddenly remembering.

"Six-thirty. I'll be there. Don't worry." He disappeared over the top of the levee, heat waves making his body shimmer like some ghostly apparition.

I went home to get a sack to put bottles in. It was only about seven in the morning. Twelve hours to find bottles, make some cash.

Something else occurred to me. Dad had said we could go fishing on Saturday. I'd assumed that was off after the beating with George. Could it be it was on again? I decided to screw up my courage and just ask him. I'd wait until he'd speared a big flounder and was happy with himself and then I'd just casually mention it.

"Oh, by the way, Dad. What time are we going fishing Saturday?"

But first I had to go make some money. There wasn't much time left to finish the boat in.

What if I'd just held on a bit more? Surely, he wouldn't have gone on beating me much longer. Looking back, it was hard to say. At the time, I felt he'd never stop, not until I was unconscious, or dead, and probably the latter. He probably would have stopped, but I couldn't know that.

Standing there, my wallet in my hand, my fingers on the key, I thought about defying him, maybe running away, except I was too stiff from the whipping to move fast enough to elude him. I got the key out of my wallet, my fingers stiff and shaking, and fumbled with the lock, all the while trying desperately to think. I should have run away before we ever got to the shed in the first place. I could have escaped, laid low until Grandpa returned, let him clear things up, tell Dad he'd given me permission to take the money. The surprise could have still worked. I wondered if there was still time to get away, but no; it was too late. If I ran now, we were already here. All he had to do was kick the door in.

At last, I got the door open. I started to take the padlock off, but I must have been moving too slowly for him, for he shoved me aside and did it himself. He threw the lock on the ground beside me and opened the door.

This wasn't the way I'd pictured it.

A Stab in the Toe and an Embarrassing Situation

I hurried up and cashed in the bottles I'd found, at the Piggly-Wiggly Supermarket. I hadn't been able to find even half a burlap bag full. Two dollars and fourteen cents. That was it. I needed at the very least, fifteen more dollars; actually, I needed closer to twenty still. In two and a half weeks. Less; I needed at least two days to cut and fit the seats and varnish them. At least two coats and preferably six, like the rest of the boat, and each coat would need time to dry before applying the next. I needed to find some real money fast.

I got home in plenty of time. I ran upstairs and changed jeans, digging out my oldest and most ripped. I found my Marine camouflage jacket and threw it on the bed, and then decided to take it out to the shed with me. I was going to have everything ready for when Dad arrived. I located three lanterns, one for each of us, and filled them with kerosene, and got out the gigs, two of them. We used the single tine kind, just a basic spear. Destin's was fancier—he liked the trident type—I teased him about having such bad aim at frogs and flounder that he needed three times the payload I did.

I couldn't locate the fish bucket and went into a bit of a panic, until I saw it peeking out from beneath a piece of old tarp in the corner. I took everything out and put it on Doc's sandbox, on the seat. There was still time to make a peanut-butter sandwich, so I went back in the house and made two. There was one Dr. Pepper left in the fridge, so I grabbed it and went back out to the shed, sitting down beside the lanterns and gear and ate my snack.

Destin got there first, lugging his gig behind him like a battle-weary Zulu warrior. He had a sailor hat on, two sizes too big. Probably one of his dad's old ones from when he was in the Coast Guard.

"Hey, Sheena, Queen of the Jungle." There was a serial that had been playing the last four Saturdays at the movie house next to the restaurant, by that name. I was referring to the natives in the movie, with their spears. Destin caught on.

"Hey, foreign pig." I guessed he meant the same movie, but I think he had it mixed up with another one. He grabbed one of my sandwiches and took a huge bite out of it.

"Hey, you're the pig! And you're not foreign." He just laughed.

"Where's your dad?" he asked, chewing.

"Not here yet. He's still at work."

Destin could never get over the weird hours our family kept. The only one who had hours with any regularity of any sort was Grandpa, with the three to eleven shift at the sulphur plant. And Mom, I guess. She just put in a steady twenty-four hours a day with God, either at church, with a church group, or huddled in her bedroom reading her Bible or one of John Bunyan's works.

Dad and Grandma worked all hours. The restaurant opened at six in the morning and closed at two, but the cabs ran twenty-four hours, three hundred and sixty-five days a year, and since they both drove on a regular shift, while working in the restaurant as well, and also took over when a regular driver was sick or hung over or when tankers were in port and it was especially busy, they were liable to be working at any time of the day or night. We all lived together, but it was rare that everyone was at home at the same time. Indeed, it was seldom either Dad or Grandma would be home at all, except for a stop for a clothes change and a quick shower or for a few hours sleep. Cab driv-

ers, at least the ones Grandma employed, seemed to be notorious drunks, and it was normal for one or both of them to have to take up the slack when someone failed to report for work.

"Your dad works some long hours," was all Destin said, and just then Dad pulled up in his cab, parking behind the shed in the alley.

"Hi boys," he said. "Everything ready, Corey?"

He saw the lanterns and gigs on the sandbox seat. "Good. Give me a minute to change." Then, for some odd reason, he laughed. He strode over and picked up one of the lanterns and looked at it like he'd never seen such a thing before. Destin and I looked at each other and his eyebrows raised.

"The last time I used these lanterns was when we first moved here," he said. He chuckled. "Toast took us on our first frogging trip."

I had gone frogging several times with Grandpa. You used either gigs like for flounder or .22 rifles. It was fun, and frogs were delicious the way Grandma cooked them. You skinned them like a catfish and ate the whole thing, not just the legs like Yankees did. The best meat was on the back, but Grandma said the reason Yankees didn't eat that part was that the frogs you got up north were too small.

Dad was telling us about his first frogging experience. "My Uncle Whitey was down on a visit. This must have been the first month or so after we'd moved here. We were all out here at the shed getting ready, fixing

the lanterns and stuff, and just as we were about ready to go, Toast goes over to the back of the shed and starts pulling out lengths of stovepipe and handing them to us."

I knew what was coming now.

"Toast hands Uncle Whitey two pieces of stove pipe and Uncle Whitey laughs and says, 'What's this for, Toast?', and your grandfather says to him, 'Why, it's for the snakes, Whitey.' 'Snakes?' says Whitey, this concerned look on his kisser. 'Sure, snakes,' says Toast. 'What snakes?' asks Uncle Whitey again and it's pretty obvious he's really concerned now. So Toast proceeds to tell him how you go about hunting frogs.

"'We wade the bayou and push our piroque along in front and shine the lanterns in the frog's eyes. Then, we gig 'em.'

"'I got that part,' Uncle Whitey says. 'I'm just not clear on the stovepipe part. Or the snakes. It's the snakes I'm especially interested in.'

"'Oh,' says Toast. 'That. Well, in the bayous are lots of snakes, rattlers, water moccasins, you-name-it. The stovepipe is to put on your lower leg and then you put your waders on. Lots of folks that don't know any better think a snake can strike a long distance, but they really can't. They can only strike upward a few inches, a foot at most, and that's what the stovepipe's for. Ordinarily, a snake can't get much higher than that, happen he decide to get mad. It's just protection. Works good, too. You'll feel 'em hitting every once in awhile

and sometimes even hear 'em, but there's nothing to worry about, long as you got your stovepipe on.'

"Well," Dad says. "Uncle Whitey doesn't say a word, just starts pulling his gear off and throwing it on the bench, and then he's gone, out the door, and we don't see him until the next morning, at breakfast. Wouldn't eat none of the frogs we caught, either."

We all had a laugh, Dad, me, and Destin, and then Dad said to load up the car, he'd be out in a minute, soon as he got his work clothes off. I was heady with anticipation of the good time we were going to have, buoyed up by the mood Dad was in.

Thirty minutes later, we were driving onto the hard sand of Bryan Beach. Dad parked the car way off the beach proper. The tide was already beginning to come in. We all laughed at two cars, parked close to the water's edge, maybe twenty yards from the waves.

"Tourists," said Dad.

"Yankees," said Destin.

"They'll be sending a tow truck in the morning for them," I said. We all laughed and Dad went down to warn the owners of the vehicles.

There was perhaps half an hour before sunset, so to kill time, Dad fiddled with the lanterns, adjusting them and checking the fuel. Destin and I raced along the edge of the water with our gigs, looking for sand fiddlers to stab.

Going floundering was one of my favorite activities, not to mention the flounder being my favorite fish to eat. Until they are about two inches long, they are like other fish, swimming upright. At that length, for some weird fish reason, they flip over and begin swimming on their sides. Their eyes eventually grow together on the down side of their heads; rather, one eye moves around until they are both side by side. They are bottom feeders, and at night, when the tide comes in, they will swim up into shallow water to find food the waves churn up.

Being a flat fish and swimming on their sides meant they could go into very shallow water, which is exactly what they did. It was possible to catch a flounder on a hook and line, but it was a tenacious undertaking, as their mouths were too small for but the tiniest hook, so the practical way to catch them was to wade the shallows of the Gulf with a lantern, and when you spotted one, stab and pin it to the bottom with a gig. Once you pinned them, you reached down and grabbed them like you would any other fish, and threw them into whatever you were keeping your catch in.

Dad and I had single tine gigs, barbless, just simple spears. Ours took a little more skill to use than the trident kind Destin had, but I was glad I had the one I did and not one like Destin's with what took place next.

I was after a sand fiddler that kept eluding me, until I had chased him for maybe five yards, stabbing at him five or six times and getting only sand. Then,

he was right beside my foot and I thrust down my gig, hard, with all my might. I missed the sand fiddler once more, but speared something all right. My big toe. Right through the middle of the toenail, all the way through the flesh of the toe. The spear tip was bigger than a pencil in diameter, pointed and round and sharp, and it had gone completely through my toe and was stuck in the sand, pinning my toe the same way you'd pin a flounder. Now I knew what a flounder felt like. Except it didn't hurt. I didn't feel anything. Not right away.

"Destin!" He came running, smiling until he saw what the problem was.

"Jeez-a-lordy!" he said, grasping the situation at once. I pulled up on the gig, trying to pull it out of my toe. My toe came up with the gig but it wouldn't come loose. I thought for a second about Destin's gig and was glad mine didn't have a barb. We would have had to get a hacksaw and cut off the tine, if that had been the case. All I had to do was pull it out of my foot. I got a better grip and yanked again. It was stuck, but good, didn't budge a quarter of an inch.

"You pull, Destin," I said. It still didn't hurt. There was no feeling at all, but I was starting to feel sick to my stomach anyway.

Destin tried, using both hands, with no better results. All that happened was that he about tore my toe off my foot. That hurt!

"Ouch!" I said. "Dad! Hey, Dad!" He was down the

beach a ways, bent over the lanterns still. He'd already lit one. The sun was dropping fast. He got up slowly and I could see him squinting in our direction. It was plain he couldn't see what the problem was.

"Corey stabbed his foot!"

He stood up then, and began toward us, not running exactly, but walking at a brisk pace. When he got to us, he looked at my foot, and must have seen that while it was serious, it wasn't life-threatening.

"Damn, boy," he said. "How the hell'd you do that?"

He laughed, and for some reason, his laugh made me feel good. It was like he was accepting me as a man or something. I hadn't cried, wasn't even close to crying. For some reason it just didn't hurt. The only thing that had hurt was Destin's tearing my toe almost off, but that had nothing to do with the gig stuck through it.

"Pull it out," he said.

"I can't." I pulled on it, hard, to show him. My toe popped up, just as before. "Destin tried too. He couldn't get it out, either."

"Here." He took the handle from me in both hands, and put his foot over mine. A sharp pull and it was free. Now it hurt. And how. As soon as air hit the wound, the hole, it began smarting. The blood began to flow as soon as the gig came out. A river of blood. Dad reached into his back pocket for his handkerchief and bent and wrapped it around my toe to staunch the flow. It didn't seem to do much. In seconds, his handkerchief was

crimson. My toe was throbbing now, the pain deep, but nothing I couldn't stand.

"Can you walk?" he asked. I heard the concern in his voice and thrilled. No way I was going to be anything but a man about this.

"Sure, Dad. It's not bad."

"Well, see if you can walk. Here. Hold on to me." He stepped to my side and put my arm around his neck. I was surprised to see that we were almost the same height. I was only an inch or two shorter. When had I grown that much?

We began limping to the car, me hobbling on the heel of my wounded foot, and Dad trying to match my pace, stumbling himself, as we lurched toward the cab.

"Go get the lanterns and stuff, Destin. We've got to take Corey back to town. To the doctor."

I tried to protest, argue that I was all right, we could still go floundering once the bleeding stopped, but he wouldn't hear of it. Once again, my heart warmed and overflowed with love at his concern.

On the way back to town, I sat in front with Dad. He cranked the radio up full blast and kept sneaking glances over at me, at my foot and then at me. To see how I was taking it, I guess. I could see the speedometer from where I sat. Once or twice, on the straightaways, it reached eighty, eighty-five. I couldn't be sure from my angle.

"Aren't you afraid of getting a ticket?" asked Destin from the back seat. We were really flying, dust thick

behind us. Dad just grunted. "The sheriff comes in the shop," I explained, proud of our special status.

"Does it hurt?" I could see Destin and he had a big grin on. Except for my possible discomfiture, he was having a blast, speeding down the road.

"Not too bad," I lied. It was really throbbing now, and so was my head, in unison. I began to worry about dying from loss of blood. As if he were reading my mind, Dad spoke just then. "Don't worry," he said. "You won't bleed to death. No one ever bled to death from a toe before, I'm pretty sure." If that was calculated to assure me, it didn't work. I could feel the blood draining from my body.

When we got to the hospital and the nurse took the handkerchief off, clucking her tongue, I saw that my fears of bleeding to death were groundless. It had already stopped bleeding and was turning black. She began cleaning it with alcohol or something, gasoline maybe; it burned. Each swab of her cloth made me grit my teeth so hard I thought they'd break, but I didn't make a sound. The cleaning done, she excused herself.

"I'll be right back. He has to have a tetanus shot."

Tetanus shot? I'd rather not.

"It's all right," I said, calling after her. "I don't need one." She didn't listen, coming back with the longest needle they had in stock. I went kinda nuts, I guess. All I remember about the next few minutes is that I got up, "shot up," according to Dad's later testimony,

and tore away from her and that needle. It seems they both, the nurse and Dad, had to chase me around the office, finally cornering me, him grabbing and holding me down while she stabbed me. I kind of remember Destin holding his stomach while he laughed. I know I finally made a sound, yelling and screeching, and I remember hating myself for that and hating Destin for his smirk, but unable to prevent caterwauling. I hated shots worse than poison.

We left the hospital and went to the restaurant. To get some ice cream Dad said, since it was too late to return to the beach and I was a sick puppy. He kept chuckling the whole way over, four blocks through the sticky Texas night. You could hardly see the street lights for the June bugs and stuff.

When we walked in, the place was chock full of people drinking and playing the juke box. We went to the back table where Grandma sat. Inez was sitting there and some shrimper. I recognized him as being one of the guys Fembo worked with on the Merry Widower. Destin didn't say anything when the man said hi, so I didn't either.

"What happened to my Sugar Man!" Grandma saw the huge white bandage on my big toe.

"We went floundering and Corey got the biggest one," my dad said, laughing. "Inez, go heat up the grill and let's broil this flounder." He was talking about my toe. They all wanted to hear what happened.

He told them about the nurse chasing me around

the emergency room and how he had to grab me so she could give me the shot. I felt like sinking into the floor, and Destin didn't help matters.

"Yeah, you should have heard him yell when she stuck the needle in!" I gave him my dirtiest look but he ignored it.

"I think Corey needs glasses," said Dad. "He thought his toe looked like a sand fiddler." They all began laughing at the scene he created, even Grandma, and at first I was angry at the way he was making fun of me and then I realized he wasn't making fun at my expense; he was teasing me in a good-hearted, good-natured way, and when I realized that, a warm feeling swept over me so that I felt almost giddy, and I entered the kidding myself.

"Well, if you have to broil it," I piped up, meaning my toe, "then let Inez do it because if Grandma cooks it it'll be charcoal," and that got a huge laugh, seeing as how Grandma was not known for her gourmet cooking, all of us preferring she stay out of the kitchen and not go within fifty feet of it.

We had another Dr. Pepper, Destin and me, and Dad even let me have a pull on the beer he was drinking. I knew he had a beer once in awhile although it was a relatively rare occurrence, but this was the first time I had seen him drink more than one or two at a sitting. Before we had been at the restaurant an hour he'd already downed three and had the fourth in front of him and was acting a bit tipsy, probably because he

wasn't used to drinking so much so fast. He was even cracking jokes with Grandma, which, all in all, made this one of the strangest evenings I had ever experienced. I was wishing Mom was here, things were getting so jolly, and then, like that, it was over.

"Time for you boys to get home," Dad said, meaning me and Destin, and while we groaned and protested, he wouldn't give in, and we had to leave. He said something one last time about my toe and Grandma's cooking skills, and as Destin and I went out through the back I got a last glimpse of Dad and Grandma and Inez and some of the regulars, sitting at the table laughing up a storm and Dad was chugging his fourth beer as someone counted down.

I felt great. I was tight with my dad and we'd had a great time tonight. He'd teased me like a regular kid and I'd taken it and given it back, just as good. We were on our way to being the way I'd always wanted to be. I was just a little bit worried about all the drinking he was doing. I'd never seen Dad booze it up like that before. Still . . . he was joking and clowning around with Grandma, so it would be fine, I decided.

"Night," I said to Destin, as he turned to go to his house and me to mine. He waved and grinned and was gone.

It was such a nice night and I felt so terrific, I decided I'd put up my tent and sleep out in the backyard.

In less than fifteen minutes, I had it up and was crawling inside. All kinds of thoughts whirled around

inside my head for the longest time, happy thoughts, and then I began to settle down and was almost asleep when the flap was thrown open and there was Destin, peeping in.

"Go away," I said. "I'm trying to sleep." I was also cold. I hadn't gone into the house for a blanket when it got chilly and was just sleeping on the tarp. I had my shirt off, using that for a pillow. As long as I didn't move around, it wasn't too cold or uncomfortable, just a slight night chill.

"I can't," he said. "I already went there. My dad's still drunk. He's been at it three days straight." He stood there a minute, uncertainty in the way he was standing. "Corey, let me stay with you tonight. Please?"

Any other time, I wouldn't have hesitated. I remembered him laughing at me back at the cafe though and felt just a tiny bit vengeful.

"Go on home. I don't want to have to go in the house and get blankets. Your old man's too drunk to do anything if he's been drinking that much."

He just stood there, holding up the flap. I couldn't see his face, but I knew it had a forlorn look on it. "I can't. He told me I couldn't. Said I wasn't even his kid. He called Mom a whore." This wasn't the first time Fembo had done that, called Delores a whore, and it wasn't the first time he wouldn't let Destin in the house. I decided to let him stay, but I wanted to give him some misery first, on account of the grief he'd given me back at the cafe.

"Leave me alone, Destin."

"C'mon, Corey."

I kicked at him and he jumped back but then stepped into the doorway again, still holding the flap.

"Okay, Corey. I'm sorry about your damned toe. I'm sorry I razzed you about the nurse. I did tell them how much guts you had when you stabbed it though."

That was true. He had, later in the evening.

He cleared his throat and held the flap up higher. "Your dad even said the same thing, about how you tried to pull it out yourself and everything. Hey, your dad was pretty neat tonight, wasn't he?"

That did it.

"Oh, all right," I said. "Hurry up and come in. It's cold. Shut that flap." And. "I'm not going in to get any blankets. Mom and Doc and probably Grandpa are all asleep. I'd wake 'em if I went in."

He walked in, bending over to clear the opening, and let the flap drop behind him.

"Don't you have any blankets or pillows?"

"Jeeze-Louise, don't you listen? What do you think this is, the Dow Hotel? It's not that cold. If you get too cold, hike on over to your own house. I told you I'm not gonna go in the house this late Shut up and go to sleep. I thought you were a tough guy."

"Okay, okay," he said. "Don't be so touchy. This is all right, I guess." It was tarry-black with the flap down, so I couldn't see him, but I could tell from the sounds that he was doing as I had done, taking his shirt off

for service as a pillow.

Moving around sounds, twitching, body-scratching sounds, told me he was settling in, and then I started to fall asleep for the second time. I was just on the abyss of unconsciousness when a new sound introduced itself. At first, I couldn't figure out what it was and then it came to me that what I was hearing was Destin weeping and trying not to be overheard, like with his face buried in his hands or something.

"You hurt?" I said after a few uncomfortable seconds, in a hoarse whisper, knowing he wasn't but giving him a graceful way out of it.

"No."

For a minute the tent was quiet, and then, suddenly, he was on my side, flopping his arm around me and sobbing his heart out. I was so startled, I didn't know how to react, so I just lay there, listening while his sobs gathered in intensity, growing deeper and deeper, the most heart- wrenching sound I ever hope to hear. They sounded like . . . they sounded like me when I'd found out Grandpa had cancer and I thought he was going to die.

I turned over and pulled him in to me and held him tight, his head buried in my chest, just like my mom had held me yesterday. We lay like that for a while, my mind kind of suspended as far as thinking goes, and then I said,

"Your dad?"

I felt his head nod and he said something but it

wasn't too clear, muffled-like. He had his face stuck in
my chest, breathing hot air, making me kinda sweaty.
I just sorta lay there, rocking him a little like a mother
rocks her baby, and then he just started talking, chok-
ing his words out, punctuated by sobs, as if the pres-
sure that had held them in was so great it was
uncontrollably spewing them out like a Gatling gun.

"I . . . hate . . . my . . . dad. He beat . . . my . . . my
mom again . . . I . . . want . . . I want . . . to . . . kill . . .
I want to kill him." All this, mixed with sniffling back
phlegm and hiccuping and bawling. He was on a talk-
ing tear now and couldn't quit. It was the strangest
thing, lying there cradling him in my arms and listen-
ing to his pain, and embarrassing too, in a way, but it
would have been stranger and more embarrassing to
let go of him. He just needed me to do this.

"My . . . mom's . . . lying on . . . the bed . . . and . . .
and . . . she was . . . unconscious. I . . . I tried . . . I tried
. . . to . . . hit him . . . but . . . he . . . he hit me instead.
I ran over here . . . I was . . . so s-scared . . . she's hurt."
He stopped, hiccupped, and I was just about to ask if
we should call the cops or tell someone, when the tent
flap whipped open; it sounded like a rifle shot, and a
bright light was in our eyes. We both sat up, hearts
racing.

"Son of a bitch. Will you just look at this. Two little
queers."

It was Dad.

"Get your asses out of there, you little perverts!" I

could smell the beer on him. I scrambled up, scuttling out of the tent on my hands and knees like a crab.

"Dad, it's not what you think. Destin . . ."

Crack!

His open hand caught me in the face, knocking me back on my heels. Momentarily in a daze, forgetting what had gone on just before, I wondered what I'd done. I stared up at him in amazement. He was kicking the tent and Destin was still in there, yelling terror-stricken little yelps, and then, somehow, he found the opening as the tent was collapsing and came out, the same way I had, sideways on hands and knees. My father launched his boot and caught him in the ribs while he was still down on all fours and he went half a foot in the air and then back down with a whoosh. It took the air out of him and he froze there, gasping as he tried to recover his breath and then Dad stepped toward him again and drew back his leg. He was so drunk he could scarcely stand. This time, I reacted, hurling myself at his leg and grabbing it with both hands. It threw him off-balance and he twisted and fell heavily to the ground.

"Destin! Run!"

Destin stared blankly at me, saw me holding my dad's leg, and his eyes seemed to be all whites. He shot forward like a track sprinter.

"You better run, you little faggot! I'm calling your father. I better never catch you around here again!"

I continued to hold fast to his leg, wondering why I

felt so calm. I knew I was in serious trouble, grabbing him like that, but it didn't matter. I didn't let go; I was afraid to, but it was a different kind of fear, somehow removed physically from me. I felt that as long as I held on to his leg, nothing could happen.

"Let go, ya little queer," he thundered. He simply stood up and kind of shook his leg and he was free, that easily. I lay there, looking up, not knowing what to expect or what to do. He made the decision for me.

"Get your ass up to your bedroom. I'll deal with you tomorrow. Right now, I'm calling Destin's father."

I stood there, not moving, knowing that doing nothing, not walking toward the house, constituted defiance, disobedience. I had to, though.

"Dad, Destin's not queer. He was just . . ."

"Bed. Now." He doubled up his fist and I saw his eyes. I lowered my head and began to walk toward the back door. All the way there, I hated my cowardice, hated that it was more important to save my own skin than my friend's reputation. I still didn't feel fear, not the kind of fear I normally would have. I don't know why I didn't go back and confront him. I just didn't, even though I knew I should. He snarled something else at my back, but I couldn't hear what it was.

Straight into the house and straight through the kitchen and living room and straight up to my room I went, and climbed in bed with my jeans still on. My toe was bleeding freely again; at least it felt like it was, throbbing and aching, but I didn't look to confirm

my guess. I closed my eyes and tried not to think about anything, to make my mind blank. I could hear Dad come in the back door and stumble around in the kitchen and I knew he was dialing the phone. I couldn't stand it. I went over to the register and opened it. He was on the phone and what he was saying I couldn't make out, but once I heard the word "queer" and I knew what he was doing and who he was talking to. I hoped Destin hadn't gone home but was hiding out somewhere else.

And then, something came over me. Courage. I don't know where it came from, but I stood up and walked out of my bedroom, down the stairs and through the living room. I could have gone out the front door and he might not have seen me, but something was going on inside me and I went out through the kitchen and the back door instead.

When I walked past him, he was still on the phone talking, and he looked at me wild-eyed, as if he couldn't believe what he was seeing.

"Where the hell you think you're going?" he said, holding the phone away from his ear.

"To find Destin."

"You come back here, you little sonofabitch." His arm raised and he stepped toward me.

"Don't you touch me. If you touch me, I'll kill you."

I said this in a monotone, the only emotion I was feeling perhaps one of amazement at the words that left my mouth. Inside, I felt neither angry nor scared

nor anything at all, just matter-of-fact and calm. He hesitated and I stopped, waiting, my hand on the door.

"Corey. Robert." We both jumped. It was Grandpa, standing in the darkened doorway leading to the living room. He must have come from his bedroom.

What happened next, I'll never know. I opened the door and was gone, cutting across the back yard to the alley, trying to figure out where Destin would have gone. The grass was wet with dew and felt good on my bare feet.

His house, I decided. I'd try his house first. I hoped he wouldn't have gone there, but I didn't know where else to look.

I was still more than a block away when I knew something had happened. Something terribly bad. Red lights swirled, lighting up the tops of palm trees, bouncing off white, stuccoed houses. I passed a 1950 green DeSoto and the red lights pulsating off it gave it an eerie quality, like some horror movie scene.

I ran the rest of the way. There were police everywhere. Most of them I knew. Neighbors were all standing about in their yards, arms folded, looking on and talking to each other with hands held over their mouths, heads tilted sideways to the one they were talking to so they could keep their eyes on the house where all the police were gathered.

A man came out of a house across the street, dressed in khakis and a white t-shirt, holding a bottle of beer. He looked all around, took a big swig of beer,

and went back inside. I could see the black and white flickering of his tv set from his front window, and, inanely, wondered if he was watching "The Honeymooners."

All this etched on my mind, while frantically I thought, Where's Destin? I saw someone I thought I knew and went up and tugged on his shirt sleeve.

"Mr. Brown." He was a policeman who came to the cafe at least twice a week. More than once, I had brought him an icy-cold bottle of Lone Star. He always seemed to like me, I thought.

"Mr. Brown, what's happened? Where's Destin? This is his house."

"What? Oh, hi, Corey. Listen, son, you better get on home. This here's not for kids. Someone's been murdered."

I wanted to sit down; I felt dizzy, disoriented.

"Destin? Is Destin . . ." I couldn't finish. The answer to the question I had to ask was too horrible to contemplate. Mr. Brown said something on his walkie-talkie, and somebody said something back he seemed to understand—to me it only sounded like a burst of static. Red lights from the three or four police cars gathered in the front of the house glistened and throbbed on the belt buckle of Mr. Brown's big Sam Browne belt. My mind was working funny. I saw the black felt on his hat shine in the light and wondered if he was required to polish it all the time. I'm sure that's what I was going to ask him, when he looked down

and said, "Destin? That's the name of the boy. You know him?" He looked over at another policeman just coming out of the house and writing on a clipboard. "Sam! Hey, Sam!" The other officer walked over, still writing.

"Sam, the boy's name was Destin, wasn't it?" My heart stopped completely.

The other officer nodded and walked on, his pencil still making notations.

"This Destin your friend?" I could only nod.

"He's okay, Corey. That what you want to know? His father's dead though."

"How? What . . .?"

"His wife stabbed him. About eleven thousand times, looks like. Say, I'm sorry—you shouldn't be hearing this. How 'bout I call your dad to come pick you up."

"Where's Destin?" Relief flooded over me, hearing he was all right, but where was he? What had they done with him?

"They took him out to the county. He's okay." The "county" meant the county home, the place where they kept old people and runaways too, sometimes. It was a catchall kind of place that housed anything from itinerants who were harmless, to old people too poor for a place of their own, and sometimes orphans, until they could adopt them out. In a pinch, they'd even been known to put a drunk or two there when the drunk tank was too full for any more.

"Corey, I got to get back to work, son. Listen, your

friend's all right. I saw them put him in the car my-
self. Wasn't even here when it happened. Came walk-
ing up right after the first cop got here. She—his
mother, phoned and turned herself in. Seems like a
nice woman. Pretty, anyway. From what I hear, sounds
pretty much like self-defense. Your friend's gonna be
all right. Just go on home and you can probably see
him sometime tomorrow. Now get out of here so I can
get to work."

I turned obediently and began to walk away. "And
tell your grandma Hank said hello. Be in this week for
some of that apple pie." I waved my hand over my head
to signify I'd heard him, but didn't turn around.

I had no recollection of how I got there, but I found
myself walking up the front walk and my mother was
there, sitting on the front porch, swinging. It was so
late the mosquitos had even gone to bed. She rose and
came part-way down the walk, meeting me.

"Destin's not queer, Mom," I said. "He's not." She
put her arms around me and I put mine around her.
We stood there on the walk, rocking back and forth.

"I know, baby," she said, her voice soft the way it
used to be.

We stood like that for awhile and then she led me
back up to the porch where we both sat on the swing.
She placed my head on her shoulder and we sat like
that, rocking gently, her feet leaving the ground each
time as she pushed. It seemed bright as day with the
moonlight. A chameleon scurried across the railing in

front of us and the sticky-sweet scent of oleanders was heavy in the air.

"He's dead," I said, meaning Destin's father.

"I know, son. I know." Her voice was as soft as an old flannel shirt. "We all are."

We sat like that till the sun came up and no one bothered us.

The Funeral

Things began to happen fast then. Very fast.

At the funeral, for a moment, I remembered saying something to Destin a long time ago about throwing handfuls of dirt on his coffin. This wasn't his funeral, it was his father's, but maybe that was why I thought of it, for when the eulogy was over, everyone was supposed to go up and throw a clump of dirt down on the box. I was with Destin, standing next to him, and when it was our turn to go up and throw our dirt, he walked right on by, not even looking down, and I did the same.

There wasn't much time to talk. He was leaving right after the funeral to go live with his Uncle Frank in Shreveport, and they wanted to leave right after the services. His uncle was a sugar farmer and needed

167

to get back to do something in the cane fields.

Destin's mom was in jail and would stand trial next week, Wednesday. The whole town buzzed about it, and it seemed to be a foregone conclusion that the trial was but a formality, that Delores would be set free, Fembo's death being a "justifiable homicide" in most everyone's opinion. Indeed, to hear most folks speak of it, the only question was why she hadn't done him in long before now.

If and when she gained her freedom, she was planning on joining Destin at her brother's, he having promised both of them a home for as long as they wanted it. He seemed to be a decent, if quiet, sort. He shook my hand as if I was an adult when we met just before the services began, and he said to come over and visit Destin any time I wanted.

It was great Destin was getting such a break—he was even going to get a horse, and you could see he was excited about going to Louisiana and living on a real ranch. Uncle Frank even raised Brahma bulls for rodeos. Half of me was happy and half was sad. I was going to miss Destin like crazy—I'd never had a friend like him. Everyone kept saying we'd see lots of each other, on holidays and in the summer, since Shreveport wasn't supposed to be that far from Freeport, but somehow I knew I was seeing the last of my friend.

Even Dad didn't open his mouth or give me dirty looks when I put my arm around Destin at the funeral. I was surprised he'd come, and nervous. He behaved

himself though, and even managed to murmur a few words to Delores. They'd allowed her to attend, a good indication that she probably wasn't in much danger of being sent to prison, although why she'd want to be at the funeral of the man she'd killed, I for sure couldn't figure out. Someone behind me said, "it was something, the way that woman loved that man," but I couldn't understand that. When he came to Destin, Dad tipped his hat but said nothing and Destin just stared straight ahead. I'd stood alongside Destin during the preaching and saw and observed everything.

They said we could have a half hour and then they would have to get going. Uncle Frank was also a part-time preacher, what they called a "jack-leg" preacher, and he had his Sunday sermon to get ready.

We walked away from the rest of the people. The cemetery was next to a swamp, and we walked down to where the water began, with the ostensible excuse of spotting an alligator. None were about, although Destin had claimed a trail of bubbles was one. I didn't tell him it was only a gas deposit. He was always the one to imagine incredible scenes from the ordinary. It was that innate ability that was making him anxious to leave Freeport and get to his uncle's ranch. I knew already he was visualizing himself as Lash LaRue, our favorite celluloid cowboy.

"Can't wait to get outta these shoes," I said.

"Yeah," he said. "Same here."

It got quiet again and we just kept walking, our

heads down, concentrating on where we stepped.

"Gonna miss you, buddy," was all I could come up with.

"Yeah." I could tell he was the same as me.

"Sounds like some ranch," I offered.

"Yeah. It is. I've been there a couple of times. It's really neat. He's got Brahmas."

"Really?" I'd only heard that a hundred times.

We both shuffled our feet, kicking at the grass. It was as if both of us knew our relationship had been forever altered, that never again would things be the same, that we had already started down two different forks in the path and that already we'd changed in our perception of the universe. Only three days had passed and we were already strangers. Already, Destin had a new life, a new future. He was going on, forward to some unknown frontier, and I was staying behind. It felt funny, like all of a sudden he was much older, knew things I had yet to learn, mysteries. It was unseen, unsaid, but it lay heavy between us, our friendship dissolving, even as we desperately wanted it to remain intact, the way it had been since the day we'd met.

"I've got something for you," he said, suddenly reaching into his pocket. We could see his aunt and uncle saying goodbye to the last of the departing mourners, looking over to where we were standing.

"Here." He handed me something, wadded up and slightly damp. I didn't have to unfold it to see that it was a bill, all crumpled up. A ten dollar bill, I could

see when I opened it up.

"What's this for?"

"Your dumb boat," he said. "I know you're short. Maybe this will help. Uncle Frank gave me twenty bucks, just for spending money. I don't need all that."

I got angry, although why, I'm not sure. It just made me mad. I started to give it back, but stuck it in my pocket instead. "Thanks," I said, my voice starting out normal, but breaking into a higher register the way it had been doing the last few months. I hated it when it did that. "I'll pay you back. When I come to visit you."

"Sure," he said. "Well, Corey, I gotta go. Let me know how your Grandpa does. You got my address?"

I nodded. It was sad; here we'd been friends for almost six years, brothers almost, and neither of us could find anything better to say to each other. We both turned to walk back to his aunt and uncle, and all of a sudden Destin screamed at the top of his lungs, "See? See there?" He was pointing to the swamp, to where the bubbles had emanated from. The snout of a small alligator was pushing up, making a v as it started to swim away.

"I told you!" he yelled, and I punched him on the arm, pleased at the frog that raised, and he punched back but missed me. We ran back to the cars and people and I felt good, in that instant. Sad that Destin was leaving, knowing maybe I'd never see him again, but happy for his good luck, too. Never again would his father get drunk and beat him or his mother. His Uncle

Frank and Aunt Maxine seemed like genuinely nice people who would take good care of Destin. It came to me as we were running for the cars why I'd become so upset a few minutes earlier. It wasn't only that my best friend was leaving me, it was that he had someone like his Uncle Frank and I didn't. I was jealous. Except—I had forgotten until I saw him leaning against the car, talking with Grandma and my folks— I had Grandpa. So it was all right.

Everybody piled in cars and I was the only one that didn't. I walked over to Destin's uncle's brand-new Ford, to say goodbye to him. He was sitting up in front with his uncle and his aunt sat alone in the back, talking to one of the women standing on the other side of the car.

"Bye, buddy," I said.

"Bye, Core," he said. "Happy trails, pardner." And then he stuck his hand out at me and I shook it. We had never shaken hands before. Neither of us said anything more and then his uncle said, "Everybody ready?" and they were waving and pulling away, oyster shells crunching beneath their tires.

I climbed in the car with Grandma and Grandpa. Mom and Dad and Doc were in Dad's cab, waiting on me, but I just went ahead and hopped in Grandma's car. Out of the corner of my eye I saw Dad shrug and tear out, spewing dirt clods and shells.

On the way home, I sat up front, between my grandparents. I had gotten in the back but Grandpa said to

come on up front and so I did. Grandma drove. She'd taken her Cadillac instead of one of the cabs. I was grateful for that. Seeing Dad's cab parked there had made me feel funny, like it was disrespectful somehow.

We turned out of the cemetery and Grandma turned on the powerful air conditioner, freezing the sweat on our faces. It felt delicious.

"Corey, we're sorry." Grandma. Both of them had said the same thing several times. What else could you say? I knew they were talking about the loss of my friend, not his father's death.

"Thanks," I said. What more was there to say in return?

"Remember when we all went dove hunting with Uncle Joe?" Grandpa said.

I remembered. It was when we had first moved to Texas, and I had just met Destin. We knew right away we were going to be buddies. We had all gone dovehunting in this huge field up north near Dallas; me, Grandpa, Dad, Destin, and Uncle Joe, Grandpa's brother, dead now. Uncle Joe was a big, fat man, full of laughter, cussing and jokes. I was maybe nine and scared to death of Uncle Joe, even though I'd been told he was the gentlest man alive. His size overwhelmed me.

We were sitting in the jeep Grandpa owned then, on this road that bordered the field. All along the road were dozens and dozens of other dove hunters in their

cars and trucks, waiting for the official start of the season. The sun was just breaking in the east, throwing fingers of sparks over the horizon, and there was a chill in the air that made you feel you would live forever and that there would never be a more perfect moment no matter how long that was. Hunters started climbing out of vehicles and going to stand along the edge of the field. There were hunters as far as you could see, in both directions.

"Too many damn hunters," Uncle Joe said, "and too few doves." I remember Grandpa chuckling. He was the only one who realized what Uncle Joe was about to do. Turned out, it was an every-year ritual, kind of a tradition with him.

He got out of the truck first and we all hopped out after him. I kept looking at my shotgun, a twenty gauge my dad had given me the week before. I was intensely proud of it, my first adult possession. Then, I noticed Uncle Joe was acting weird. He was making strange noises and walking funny, staggering-like, and I saw he had a bottle of Jim Beam whiskey, half-empty, in his hand. He lurched out from behind the Jeep in plain view of all the hunters near us and took a long swig from the bottle, burping loudly afterward. Then, he started waving his twelve-gauge around like a wildman and took another long swig.

"Lemme at 'em!" he roared. "Let's go get us some doves! There's some!" He lunged around and pointed directly in the direction of a group of hunters to our

left. I could see them backing up a step and looking at one another. "No, no, them's not doves," he said, correcting himself. "Them's hunters. Okay. Doves is out thataway." He pointed himself toward the open field, though not without seeming difficulty. He staggered out onto the edge of the field, maybe ten feet in front of us, and tipped the bottle, draining about half a fifth of Jim Beam in one continuous swallow. Wiping the tears from his eyes, he then dropped the bottle as if his coordination had failed him, and began fumbling in his hunting jacket for his shells. He got a handful out and broke his gun open and tried to insert them. He kept dropping them and then he'd get down on his hands and knees and look for them, stagger to his feet again; try once more to punch them in. He did this over and over, at least a half a dozen times, and finally he got the gun loaded. Shotgun shells he'd dropped, lay all about him. He was reeling like a bachelor party, and asking Grandpa in a loud whisper to fetch him "that other bottle from the truck".

Then, the strangest thing. All around us, car and truck doors began slamming and car and truck engines started up. On both sides of us, they began driving off, a mass exodus, and in five minutes we were completely isolated. The nearest hunters to us on either side were at least a hundred yards away, and even at that distance we could see them looking at us and talking, Uncle Joe the obvious topic. I guess my own eyes were big as dinner plates and I know Destin's were cause I

could see his. Dad had this worried frown on, and Grandpa, well, Grandpa was doubled over, laughing silently, or as silently as he was able, considering.

"Ah," said Uncle Joe, suddenly seeming to sober up. "Now then, there's just enough hunters." Destin was giggling so hard, tears ran down his cheeks. I still hadn't quite caught on to what had happened, but Destin had seen right away what Uncle Joe was up to. He went over to him and picked up the Jim Beam bottle where Uncle Joe had dropped it, put it to his nose and sniffed, and then lifted it to his mouth and took a glug. I almost fell down in surprise, thinking Uncle Joe or one of the other adults would backhand him, but no one said or did anything. He walked over to me, the bottle in his hand.

"Tea," he said, grinning. "It's just tea. Not enough sugar." Then, it finally dawned on me, and I joined the rest of them in hooting and slapping our thighs.

We got over a hundred doves between us, but Uncle Joe shot the most.

"Thanks, Grandpa," I said. Grandpa always somehow knew just the right thing to say.

We turned into the driveway at home. Grandma had to change into her white waitress uniform. It was almost the first time I had seen her out of it, saw her in a regular dress. She looked really pretty. Grandpa thought so, too. He gave her a hug and then a kiss

going up the steps into the house. I couldn't recall the last time I'd seen them do that, kiss in front of me. They didn't ever display outward affection for each other, but you knew they liked and respected one another. I thought of my own parents and was ashamed of the disloyal thought.

I went up to my own room to change into jeans and rid myself of my shoes. I came back downstairs. It must have been because I was barefoot that they didn't hear me. I was just outside their door, which was slightly ajar, when I heard Grandma say, "Well, I guess he did it. Her things are gone. I don't know, Toast. Is it the right thing?"

I don't know how I knew, but I just knew they were speaking about my mother. I stopped and listened.

"Nothing could be done, Lucille. She was just getting worse. I don't like this any more than you do, but he's her husband. He has the right."

"What're you talking about? Where's my mom? Aren't they on their way home?"

I was standing in their doorway. I'd pushed the door open. Grandma was in her slip, but I didn't even notice.

"Corey! You get out of here. I'm naked!"

I stood there. "Where's my mother? What's happened?"

Grandpa got up off the bed where he'd been sitting and came toward me. "Let's you and me get out of here," he said. "Let your grandmother finish dressing."

I let him lead me into the living room and sit me down at the couch. He sat beside me.

"Corey, your mom is sick. She's been sick a long time." He saw I was about to say something and held up his hand. I kept quiet. "She's not sick physically. It's more emotional. Do you understand?" I nodded my head that I did, but I disagreed. She just had to tone down her religious kick some. That's all that was wrong with her.

"Son, she's got what's called an obsession. Do you know what that is?" Well, of course I did. She likes something too much. At least more than most folks did. Was that a crime? Something to be put away for?

"There's nothing wrong with religion. You know that, don't you?" I still hadn't spoken or even nodded at the last few questions. He went on. "All of us need religion, I suppose. We all need God. Your mom's problem is that she needs Him a little too much. She's got things mixed up in her head. Your dad's taking her to Houston. To a doctor there who will help her. Do you understand now?"

"No. I want to see my mother."

The other night. The other night she had seemed to be like she used to be. She'd held me and rocked me and talked to me like when I was little and had fallen down and hurt myself. There wasn't anything wrong with her. She was fine. How could Dad do this to her? What doctor? What was wrong with the doctors *here*? These, and a dozen other questions went through my

head, but I only said, "I want to see my mother."

Grandpa looked at me and his eyes were sorrowing. "Son, you just can't do that. Just trust me when I say that what's been done has been done for her own good. She'll be back home before you know it. And she'll be well again. She'll be the way she used to be."

"I don't want her like she used to be!" I stood up, my hands balled into fists, verging on crying. "I want my mother now! There's nothing wrong with her!"

"Sugar Man." It was Grandma. She'd come out of their bedroom and stood there in her white uniform. Her hair was back in the net she always wore.

"I'm the one that had her sent to Houston, Corey. Your dad agreed, but it was me that decided. He just took her there. Your grandfather's right. She's not well." Grandma crossed the room. "She's seeing the best doctor there is. He'll make her well. Nobody's going to hurt her. I wouldn't let them. You shouldn't worry. There's nothing to worry about." My grandmother was firm, solid. There was no nonsense about her, standing there like a rock. It was what I needed.

"She's all right?"

"She's all right. She doesn't want you to worry. She'll be back home before you know it and she'll be all right. You're going to see the mother she used to be and then you'll see why we had to do this. Now," she turned and walked toward the kitchen and the back door. "You go swimming or something and just be a boy. Have some fun. It's summer vacation." She went out, on her way

to run her business.

Grandpa stood up. "Wait here, Corey. There's something I want to show you. I've been thinking about this for some time and I think now's the time I've been waiting for." He went into his bedroom and came out a minute later with something in his hand. It was black, whatever it was, some kind of object made of cloth, with holes in it like a hunting boot, and laces. It was the oddest looking thing I'd ever seen. It looked like an item of clothing, but not like anything I'd ever seen before.

"Here." There were two of the objects and now I was holding them. I was puzzled. I had never seen them before and they certainly didn't look like any great treasure, so why was Grandpa making such a holy deal out of this?

"They're my spatterdashers," he said.

Spatterdashers?

What a weird name! They looked like some kind of leggings. He didn't expect me to wear them, did he? I'd get laughed out of town!

"Most people call them 'spats.' Men—I—used to wear them, a long time ago. These are old, very old. They belonged first to my great grandfather—that would be your great, great, great grandfather. He got them in London when he was a young man. It wasn't long after that that he shipped out on a whaling ship and ended up in Texas where our family's been ever since. Great-grandpa gave them to my grandfather and

he in turn passed them down to my father. My father gave them to me. The day he died. I guess they're what you'd call an heirloom. They're way over two hundred years old. All the men in the family have worn them on important occasions, like when they got married. They weren't in style when your grandmother and I got married, but I wore them anyway. Under my trousers. No one saw them, but I still wore them. I wore them at my father's funeral, too."

He reached over and took one from me and ran his fingers over the material.

"We never had a son, Lucille and I. I was going to give them to your dad, but it never felt right, that idea. I was hoping someday it would. I don't think it ever will."

He handed it back.

"I've decided to give them to you."

I was completely asea. Why was he giving them to me? Now? What was the significance? I was never getting married, but if I was, I wouldn't even dream of wearing them! They'd lock me up!

"Let me tell you something about these spatterdashers, and I think you'll understand why I'm giving them to you.

"Before we had concrete and black-top roads, roads and streets were mostly just plain dirt, packed down hard. When it rained, there would be mud-holes, full of water. Then, a man usually only owned one suit, one good suit, at most. There weren't dry cleaners on

every corner like there is today." I felt like I was in school, in history class, but this was much more interesting, much more than Mr. Bormuth's dry lectures about the Spanish-American War. Interesting, yes, but even so, what was the significance? Grandpa's demeanor suggested strongly that there was an underlying meaning to what he was telling me, but if so, I just didn't get it. Not yet, anyway.

"To keep from getting your trousers ruined by a horse-drawn carriage or a motorcar splashing mud on you, these were invented. They named them 'spatterdashers' because that's exactly what they did; they prevented 'spatter' from 'dashing' you. Get it?"

Well, sure, I understood that, that was simple, but still the question persisted, what was the significance? What did this have to do with me?

"They also lent style to your appearance. They were elegant, and they protected you from mud and dirt." He paused as if trying to fit the right words to his thoughts.

"Every generation in our family, not unlike most families, has had to go through some hard and difficult times. I myself lived through the Great Depression and served in World War I, and I saw my own mother killed right before my eyes. She died of a rattlesnake bite. It was a horrible death to experience seeing, especially for a young boy.

"My grandfather had to have his arm amputated, after he got it caught in a mowing machine.

"Seems like each one of us men in the family has had something tragic or terrible happen to them, at some point in our lives.

"My great-grandfather, the original purchaser of these spatterdashers, was not only a bold and adventurous man, but a wise one as well. When he gave these to his son—my grandfather and your great-great-grandfather—it was right after his own wife had died of small pox, a horrible way to go in those days. He gave them to my grandpa with a little speech, the same speech each generation has given the next at the time when we pass these on. The same speech I'm about to give to you.

Corey, in and of themselves, these ancient artifacts of history, no matter how personal, are only that, artifacts. Curious, to be sure, and perhaps interesting, but that's not why he gave them to his son, and it's not why my grandfather gave them to my father and why he in turn passed them on to me. It's because they're a symbol of something important. To each of us that they've been given to, they've come to represent something precious.

"Perhaps in your case, it will be your father. Or rather, your relationship with your father. I may not be aware of everything you're going through with him, but I know enough, I think. I know that you want his love more than anything else in the world, and . . . I know that you feel you won't ever receive it. That, I think, is a pretty sad state of affairs."

I was listening for sure now, scarcely drawing a breath. He continued.

"I knew a man like your father once. His problem was drinking. That was his excuse. Your father's excuse is that he's frustrated, unhappy. His problem is that he can't relate to people. His understanding of relationships was short-circuited somewhere along the line, so that he sees in terms of categories, neatly packaged categories. If you don't fit into the box like he expects you to, he'll do what he can to make you fit the box, and if that doesn't work, then I'm afraid you're shit out of luck, as far as expecting him to love you. These are hard words, Corey, but I'm just being honest and saying what I feel to be true. The funny thing is, as far as Robert's concerned, I understand. As much as any man can understand another. I don't think you do, not yet anyway. You will, someday, but I don't think you see him as he is just yet."

He shifted his weight on the couch a bit and moved closer. I saw a spasm of pain cross his face when he moved.

"I think you need these spatterdashers now. Grandfather had these given to him when he was twelve, and when he was twenty, he lost his arm. That loss could have made him feel like less of a man but it didn't. He always said it was because of these spatterdashers his father had given him. That's what he told my father and what my father told me. Each of us has something meaningful attached to these spats—there's a

lot of family history contained in these pieces of cloth.

"As I said, they're a symbol. It's because they're a symbol that makes them important. Important to me and the others in our family who have possessed them, and I hope, one day they'll be important to you.

"This is what they mean to me. Spatterdashers can prevent spatter from dashing you. The physical kind of mud and dirt they can protect against. There's another kind of dirt in your life they can't guard against though, except through the psychic energy and meaning they contain.

"The dirt others throw your way.

"The way others treat you.

"We can design a protective item for trousers, but it's a different matter to make a spatterdasher for the human heart. There's only one way to do that, and it's not accomplished with a bit of material and some stays. It's done from something inside. It's a memory, or a knowledge, that as long as there is one person in the world that loves you and that you love back, as long as there's one person in the world that accepts you for the special way you are, no matter what that is, then no matter what dirt anyone else throws on you, it can never ever truly soil us inside.

"That's a spatterdasher for the heart.

"That's what these spatterdashers represent, what I intend for them to represent as I present them to you. I wish I could give you something better, but then, I doubt if I could give you a finer gift than these, as

long as you come to understand fully what they mean."

His eyes were boring into mine, piercing to my very soul. I swallowed and nodded but couldn't say a word.

"You're a fine boy, Corey, and someday you'll become a fine man. You'll do great and wonderful things, I can see that. I have a feeling your mark will be made with words, perhaps as a teacher, perhaps as a writer. Who knows? But you're bound for something special, that I can tell you.

"But, whatever it is that you choose to do, and whatever it is that you become, you'll always have your father. Your father will be with you all your life, whether he's alive or not. We aren't able to chose our parents; we have to take what's given. But, we are human beings and therefore have the dignity of a soul, and we are blessed with the intelligence to understand the immutability of certain things; fathers and mothers and even grandfathers being certain of those things."

I listened, transfixed, understanding some of what he was saying, while much of it remained cryptic and mystic.

"Some day, before you can resolve your relationship with your father, you'll have to know that your father may never change from the way he is, no matter what you do. You'll have to understand that whatever you do won't matter at all. We are the way we are, each of us, each locked into our own way of being. Some of us are in our own special prisons, while some

of us are fortunate enough to find the key that frees us
from the darkness. Your father may never find that
key. It's up to you not to allow that to force you into
your own prison.

"Try to think of your father as someone who has
lost his way. Do your best to help him find it, if you
can, but don't make the mistake of getting lost with
him. No matter how much it hurts. Destin's father was
in a prison too. He ended up being killed because of it,
and maybe that wasn't such a bad thing, because it
may have freed Destin.

"I see you in a kind of prison as well. And I don't
want your father to have to die to release you. If you
can grasp what I'm telling you, in here," he put his
hand over his chest, "then you'll always be free." I
hadn't taken my eyes from his, and I saw enormous
pain etched there, whether physical or not, I couldn't
say.

"What I'm trying to tell you is tough, Corey, be-
cause it may seem like I'm telling you to turn against
your own father. I'm not, not really. I'm just asking
you to understand him. And yourself. When he's pun-
ishing you, he's not after you; it's himself he's lashing.
He sees something in you that he's denied himself and
he can't stomach it. He's jealous. He's human. He's frus-
trated. You can't do anything about that. You can't help
him. But you have to try. I hope you realize this some-
day soon. The day you do is the day you cross over the
line from being a boy to being a man. A free man. It's a

hard way to become an adult, but it's the way you're stuck with. You don't have much of a choice, I don't think.

"I'm giving you these," he pointed to the spatterdashers I held on my lap, "as a symbol. The highest form of intellectual thought for us poor humans is through symbols. In themselves, these are nothing but pieces of cloth. Their worth is negligible, a few dollars at best. As a symbol, they may be priceless.

"Someday," he paused, and though he had been staring at me the whole time he had been speaking, his eyes seemed to become bluer, more electric than ever I had seen them. "Someday, there'll come a time when your heart is breaking. I don't think that day has come yet. When it does, remember this gift and what it stands for. They only represent something you already know. That you're loved, in the deepest, truest sense of the meaning, and that you have worth and dignity of your own. No one can take that from you, son, no matter what they do or say, as long as you know that I, or your grandmother, or your mother, or Destin, or anyone else, loves you. For being you and for no other reason.

"What we have just done, Corey, has been to create a symbol between us. When the time comes that you'll need it, you'll know it. That's the time to strap on your spats, so to speak.

"There's just one other thing," he said. "When

things get tough enough in life, sometimes we think the best way out is to just end it. I'm talking about suicide. You're an intelligent person, so I'm not going to tell you any garbage that such action is always wrong, when a case can be made in its favor, under certain circumstances. Can you, for instance, imagine Socrates to have had any other choice, morally, other than to end his life by his own hand? Of course not!

"A lot of times, people my age are amazed when a young person such as yourself takes their own life. The reason we are astounded is that we know that however bad things look at the present, one thing is for sure; the condition will change. That is what life is, a series of ups and downs. And, I believe that is why young people sometimes make bad decisions and end their lives. They don't realize that however bad things are at the present, at some point they will begin to get better. Conversely, if things are peachy, then you can make book that bad times will come along as well. But, that too, will end. That's one of those things that separate children from adults. Adults realize that life isn't static, while a child's idea of his future is that it is but a continuation of the condition he's in presently. If things are harsh now, then the rest of his life will be the same bitterness, forever and ever. That just isn't true, but children cannot grasp that. Not in their heart.

"I'm telling you this, Corey, because I worry about you. I know this has been a tough year for you and I'm afraid you might consider something drastic. Maybe I

shouldn't even bring it up, but hiding from things never solved a problem. Maybe suicide is something you would've never considered in a million years—I hope that's the case—but if it does, try and understand that no matter how bad you feel and how dire the future looks, it will get better. I swear to you it will get better. Just tough it out and you'll see."

He got up and walked away from the couch so quickly I didn't realize he was leaving until he'd gone through his bedroom door. A minute later, he re-emerged and had his yellow hard hat on.

"Got to go to work, boy," he said. He crossed over to me and squatted down on his knees so our eyes were on an even level.

"Something else, Corey, on suicide, and then I promise not to ever bring it up again, unless you want me to.

"When I was a kid, and someone, my dad or mom, did something that pissed me off or hurt me, I had a thought or two about jumping off a bridge or something, to make them sorry. I want to point out something about that theory. Do you remember Doc's dog Spunky?"

Spunky had been Doc's dog since the week she was born, and had been part of our family for almost eight years, until he got hit by a car in front of the house. I think I had cried as much as Doc when we buried him.

"Yes."

"Okay. Well, do you remember Spunky had one blue

eye and one brown one?"

"Sure."

"Okay. Which eye was the blue one?"

For the life of me, I couldn't remember. It had only been two years since Spunky was laid to rest, but I couldn't remember which eye was blue and which brown.

"The left?"

"Good guess, Corey, but you're wrong. It was the right one."

Of course. Now, I remembered. Grandpa was right.

"Do you know what the lesson in that was?"

I didn't.

"You loved Spunky, didn't you?"

"Well, sure. He was a great dog. Even if he was Doc's."

"Okay, then. You loved Spunky a lot and yet, only two years after he died, you couldn't remember which eye was blue. I remember the day he died and we buried him in the back yard, you and Doc and your mom, too, all of you cried like it was the end of the world, and Doc even got a fever she was so upset. But, guess what? I bet if you were to ask Doc the same question, she would guess wrong, too. The point is, if you were to take your life to 'teach someone a lesson', well, Corey, we'd never forget you and yes, we'd be sorry you'd died, and yes, probably the person you were seeking revenge on would feel a tremendous amount of guilt, but, our lives would go on. And, no matter how much we loved

you and no matter how much we missed you, your
memory would begin to fade, and every year would
find us missing you a little less and remembering you
a little less clearly. Don't misunderstand—if you died
for any reason, we'd always remember and love you.
But, it's only human for those emotions to fade. The
degree of hurt felt initially will wane. But . . . you'd be
dead. Do you see where revenge is a useless reason for
suicide? It's pretty dumb, isn't it?"

I nodded. What he was saying made a lot of sense.
I was just trying to deal with the fact that I'd be for-
gotten in time when I died. But it was true. I would
be. I didn't know if I was ready for all these lessons I
was receiving. My heart ached and yet I felt okay, good
even, as if I was being accepted into some secret club,
and in a way I was. I was becoming privy to adult
themes and the knowledge was sometimes painful to
acquire, I could see.

"Well, that's about enough gloom and doom for one
day, don'tcha think, boy?" He winked and grinned at
me, and stood up. "Got to get to work, son," he said. He
stood there, legs spread wide, hands braced on hips.
He was the most heroic figure I had ever seen. I was
bursting inside, unable to name the emotions I was
going through.

"Oh, yeah," he said, heading for the front door. "I've
got to go to Houston this weekend to get radiated," he
spread out the word "radiated," poking fun at it, and
winked as he pronounced it, "and maybe the weekend

after that, too, but the very next weekend, plan on go-
ing tarpon fishing. You and me." He opened the door
and was gone.

Tarpon fishing! I had given up forever on that! We
were going to go after all! A horrible thought struck
mc. That was the weekend of Dad's birthday. What if I
hadn't finished the boat by then? Then, I relaxed, re-
membering the money Destin had given me. I only
needed a little more than ten bucks and I'd have
enough. It'd be finished. We could use the boat! Dad
could come, too. That is, if I got my butt busy and got
it done. I had to. Ten bucks, that's all I needed. I ran
out back to get a burlap bag. If I filled it, that would be
almost five dollars. I only had to fill it twice and I'd be
home free.

I found two bottles right behind the shed in the
alley. A good omen.

*I startcd to takc the padlock off, when he shoved me
aside and did it himself. He threw the lock on the
ground and tore open the door, going in ahead of me.*

*He found the light switch and flicked it on. There it
was, his almost-finished birthday present. The first
thing you saw, you couldn't miss it, was the nameboard.*

This was not the way I'd imagined this.

Thief!

It wasn't a good omen. I didn't even get half a bag filled. Only a dollar and six cents worth. Twenty-eight bottles. I still needed nine dollars. It was Thursday. Dad's birthday was just under two and a half weeks away. I not only had to earn the money, I had to have time to cut, sand, and fit the seats, as well as give them several coats of varnish. That could take a week, week and a half, two weeks maybe. Time was running out.

When I went to bed I set the alarm for six o'clock. Tomorrow, I would take the lawn mower and find some mowing jobs.

I tried to get to sleep but I kept thinking about Destin, wondering what he was doing, if he missed me like I did him. I was happy for him, for escaping his

situation, but sad for me. I'd lost the best friend I'd ever had. I knew we'd talked about me going over to visit him, but that was like a lot of things. It would never happen. I wondered if he'd remember me in a year or so, or if he'd be too caught up in his exciting new life to think twice about an old pal in Texas. I was still thinking about all the things we'd done together when I drifted off to sleep. Maybe I cried a little bit.

Dad still hadn't returned from Houston by the time I hit the sack. I hadn't seen him, at least.

Next morning, I fixed myself two pieces of toast and had a glass of milk. The house was quieter than usual. There was a note on the kitchen counter telling me Doc was over at her girlfriend's house for the week since Mom was gone. It was written in Grandma's hand. Grandpa was home; I could hear him snoring through the open doorway to his room, and Dad must have come home sometime in the middle of the night, but was already gone to work. I'd seen his suit laying on his bed when I came downstairs. Grandma always left at five to do the books and deep-fry fresh dough-nuts for the breakfast crowd. Her and Dad ran on less sleep than anyone I'd ever known.

I cleaned my plate and glass and went outside. Halfway to the shed to pick up the lawnmower, it started. The rain. There wasn't a cloud in the sky, or so it seemed, and all of a sudden, you couldn't see your hand in front of you. Texas weather. Instantly, it was dark, the sky crayoned in with black and gray. A

norther. It would be here all day. Already, it was turn-
ing chilly. I tried to keep my spirits from sinking as I
walked to the shed. Nobody would want their grass
cut in this weather, as if I could anyway. All that grew
around here was saltgrass and it was tough enough to
cut dry, impossible when it was wet.

I went ahead anyway and pushed the mower out
of the shed. Just as I got it out, the left front wheel fell
off. I picked it up and inspected it. It was chock-full of
rust. Maybe it could be fixed but it was for sure I didn't
know how. I didn't have a clue what to do or where to
even start. I thought we'd have to buy a whole new
wheel. I had a feeling too that somehow this would be
my fault.

My spirits were lower than a mealworm. I thought
about the spatterdashers Grandpa had given me and
what he'd said. This obviously wasn't the bad time he
had talked about, but curiously, it made me feel bet-
ter, thinking about our talk yesterday.

I put the mower away and got a burlap bag out of
the shed. My clothes were soaked through and I had
goose bumps on my arms as the temperature plum-
meted, but it didn't matter. I should have checked the
radio for hurricane warnings like you were supposed
to when the weather changed like that, but I didn't. I
had to make some money.

All day I walked all over town, picking up empties
in back yards and alleys. By noon, I had a whole bag
filled and was feeling pretty chipper. The rain kept

coming down, clearing up every so often for five or ten
minutes and then starting up again. I was freezing,
but didn't consider quitting. At Weingarten's, the girl
counted out three dollars and eighteen cents. I had
broken my back lugging that bag, and for a lousy three
dollars and eighteen cents! Still, I was only six dollars
from my goal, and the feel of the money in my pocket
gave me renewed hope. Mentally, I calculated how
much longer I'd have to go on looking for bottles. Two
more bags ought to do it. Today was pretty much shot—
I doubted if another unclaimed bottle remained in the
whole of town, with the thorough combing I'd just given
it. Tomorrow or the next day would be another story
though.

And then, just a block from the store, I stuck my
hand in my pocket to feel my money again and all I
found was a hole! The money was gone! Worse, the ten
from Destin and the dollar I'd made yesterday had been
in that pocket as well.

Disbelieving, I poked through my other pockets,
hoping I'd just forgotten where I'd put it. Nothing. I
even took my billfold out, hoping I'd put the money
there, but all that was in there was the picture of Jane
Russell from her movie "The Outlaw," the one I hadn't
been allowed to see. I'd paid Destin a quarter for the
picture. He'd gotten it from some magazine his dad
had.

I wheeled and retraced my steps to Weingarten's,
searching in every direction around me as I walked,

like a magpie looking for bright trinkets. No money appeared. Then, I spotted some, a few coins, just outside the store's entrance. A quarter, two pennies, and a dime. No bills.

And there was no chance that the money might be lying at home, on my dresser. I distinctly remembered taking all of it with me. Not an hour before, I had taken it out and recounted it.

I had to face it. Either the bills had blown away or someone had found them. Either way, they were gone.

I sat down, my back to a building, and tried to think. I was even farther behind than when I'd started that morning. It suddenly began to look impossible. There was no way I was going to get enough money in time to finish the boat.

I got up and walked home, trailing my sack behind me. Once, I passed an alley and saw two empty Barq's bottles. I started toward them, to pick them up, and then just walked past them. What was the use? Four cents wouldn't help. There weren't enough pop bottles in the universe to help. Not enough time. I realized that even if I got jobs mowing lawns, it wouldn't be enough. I charged two dollars a lawn, and one good-sized lawn would take me half a day. Four bucks a day. I couldn't mow on Sundays; nobody mowed their lawns on Sunday. Not in our Baptist town. We'd go fishing, but we couldn't cut our grass. We'd drink beer and have barbecues outdoors, but nobody'd paint their front porch. I never could understand that.

I threw the sack into the shed and went into the house. In my room, I picked up a book and tried to read it. The words made as much sense as Egyptian hieroglyphics. The title said *Robinson Crusoe*. One of my favorites. Unable to concentrate, I put it down and went back downstairs.

Grandpa was coming out of his bedroom. He didn't have his yellow safety hat on, or his khakis, or his steel-toed shoes he wore to keep his toes from being crushed. He had on none of those things, his work garb, but instead was dressed in a brown suit and atop his head was perched a snap-brim hat, the one he saved for church. The hat made me think of the spats for some odd reason, lying upstairs in my room in my top drawer. A vision of them strapped to Grandpa's trousers popped into my head.

"Aren't you going to work, Grandpa?"

He'd aged ten years in a week, I suddenly realized. I noticed wrinkles that hadn't been there just days before, but more than that, he just didn't look right, not like Grandpa. He was all yellow, his skin had this cast to it, and I could see his stringy, tough jaw muscles working as if he was fighting against pain.

"You all right, Grandpa?"

His mouth grinned, but it was evident it took effort.

"I'm fine, Corey. Fine as can be. I'm a little tired and it hurts some is all. I'm okay, boy."

I could see he wasn't; it was plain from the pinched

furrows of his forehead, but I didn't dispute him.

"Where you going?"

He crooked his finger at me and we went on into the living room. He sat down in the green easy chair, the one Grandma'd bought on Magazine Street in New Orleans, at the antique store, and I sat on the couch.

"Houston. Grandma's gonna drive me. She should be along any minute."

He didn't look like my grandpa, in a suit, even though I had seen him dressed in one before. Not today, somehow. He was supposed to be in khakis, getting ready to go to work, not to some hospital where they were going to do something to him they kept saying would help him but which I knew in the back of my mind would do something horrible to him instead.

"Wanna wear my spatterdashers?" I grinned at him

He laughed aloud. "Thanks, no, Corey. Those're yours. I'd look kinda foolish wearing them in 1954. They're a bit old-fashioned. Besides, I've got my 'mental' spatts. The best kind."

"I thought you didn't go to Houston till tomorrow."

"Well, I've been having kind of a rough time. Thought I might go up early. Check out the nurses, y'know?" He gave me a conspiratorial wink.

He was hurting bad. It was plain as old maids.

"You want an aspirin, Grandpa? I'll get some for you."

He looked sideways at me. "No thanks. I'm a little beyond aspirin. Does it show that much?"

I went over and put my arms around him and squeezed. I was as surprised as he probably was at what I did and I was also surprised at how slight he felt. He'd lost weight. He hugged me back and then gave me a little push away. His voice had a catch in it.

"Can't fool you, can I?"

"Guess not."

"Well, you're right. There's a lot of pain. Comes and goes."

I knew he had started getting shots for it—I had seen him in the bathroom, sticking the needle in his own arm.

"Can't you take a shot?"

"Doesn't seem to have the kick it once did," he said. "That's one reason I'm going up to Houston early. Get some stronger stuff."

"And chase the nurses." I tried to make a joke.

"And chase the nurses," he said, smiling. Outside, a horn tooted three times.

"Grandma," he said. "Gotta go. See ya. And listen, Corey, don't worry. We're still going fishing in a couple of weeks."

"Oh, Grandpa," I said, my voice loud. I crossed the room and put my arms around him for the second time. "I don't care about any stupid tarpon. We can go whenever you feel like it. We don't have to go at all. It's okay."

"I'll feel like it."

He opened the door and went out. I could see

Grandma at the wheel of her cab. She saw me in the doorway and waved. I waved back.

"Grandpa!" He was halfway to the car. I ran out, caught up to him.

"Grandpa, I got a problem. I need me some money. Can you make me a loan? I'll pay you back. In a month. It's important. Really important."

"Corey, I don't want anything. I don't want you to go buying presents for me."

"It's not that, Grandpa. It's something else."

"Are you in some kind of trouble?"

"No, Grandpa."

"How much you need."

"Twenty dollars. Maybe twenty-two."

"Twenty dollars! You sure you're not in some kind of trouble? That's a lot of money."

"No sir. I just need it for something." I tried not to let my face show it, but inside I was sending out mental pleas for him to help me out. "It's something for Dad." I hadn't wanted to say that much, but I did.

He stared at me. "For your dad, you say?" The horn sounded again out front. Grandma wasn't noted for her patience. "And you can't say what it's for, eh?"

"No, Grandpa. It's kind of a surprise. For his birthday."

"Not for me, huh?"

I nodded.

"Well, okay then. It better not be anything for me." He took out his wallet, opened it, and snorted. "Well,

hell. Damn." He was peering inside, and I could see there was no money there.

"Corey, I forgot. I haven't cashed my check yet. Are you in a big hurry? Can I get it cashed and give it to you on Sunday when I get back?"

"Sure, Grandpa. That'll be great." I would still have enough time. Barely. I'd have to be lucky in locating all the materials and I'd have to work like crazy, but I could do it.

Grandma honked again, a long blast that meant business, and Grandpa stuck out his hand, an odd thing, and I shook it before I could react otherwise. We'd never done that. I was starting to shake a lot of hands lately. He went through the front door and I watched him go down the walk and climb into the cab. He and Grandma waved and they were gone.

Back in my room, I picked up the book I'd been trying to read earlier. *Robinson Crusoe*. I opened it at random and it fell open to the part when Crusoe first meets Friday. I laughed as I read the familiar words.

Grandpa didn't come home on schedule. Sunday morning came and neither he or Grandma had returned. And we didn't go fishing on Saturday, Dad and I. He was in the kitchen when I got up, but he didn't mention it and I didn't bring it up. I had pretty much figured the trip was off. He didn't even say anything about taking Mom to Houston. He said hello, looking

out the back window, and said the grass would need
another cutting in a day or two if it rained, and then
he was gone, to work I suppose.

Saturday, I just fooled around, reading and stuff
like that and hit the sack early, around nine. For some
reason, I was extremely tired and sleepy. The next
morning, I was up with the red-winged blackbirds in
the back yard, expecting Grandpa to come in my room
any second, but when it reached ten o'clock and he
still hadn't shown up and I could tell by the lack of
sounds in the house no one was there but me, I grabbed
my basketball and went over to the junior high to shoot
some buckets. I really missed Destin. It wasn't the
same without him, doing just everyday things. Destin
would have shot hoops with me, the whole time mock-
ing me and the game, calling it a "sissy, Yankee game."
He was a true Texan. In his mind, the only true sports
were football and baseball. Having lived the few years
in Indiana, I always defended basketball as the pur-
est of all athletic pursuits and we had some dandy ar-
guments, sometimes resulting in shoving matches.

He wasn't the only one in town who thought bas-
ketball a sport for girls. There wasn't a player on the
court, although I could see a large group of boys in the
field adjacent, lining up and throwing the football.
Ninety-two degrees according to the radio, and there
they were, tackling one another among the sandburs.
I felt somewhat foolish, shooting the ball, paranoid that
they were staring at me and wondering who the fruit-

cake was with the round ball.

It got too hot to shoot, so I went home and laid on the couch in the front room and busied myself watching a chameleon scurry about on the front porch railing, catching flies.

Dad came home in the afternoon. To change clothes and grab a shower, he said in passing. He seemed not to want conversation, which was okay by me. I hadn't seen him or Doc since the funeral, except for his brief run-ins to fetch something from the house. Doc must still be at her friends. No great loss there to society. Mine, anyway.

I went to the bathroom door and asked, "Is Grandpa coming home today?"

He kept his lathered face in the mirror, but I saw his eyes glance sideways at me.

"No. Lucille phoned this morning and said they want to keep him another day. Maybe more. He's getting radiation. To make him all better." He said it like he was talking to a six-year-old.

"Dad, Grandpa has cancer. He might die." I don't know why I had to say that. Except that Dad was acting like Grandpa had just caught a bad cold or something minor and would be over it in a week.

He came out of the bathroom, razor in hand, face lather frothed on his face like a mad dog, and he spat out his words.

"Damn you, don't say that. Toast is going to be just fine. A little radiation and he'll be a new man. I can't

believe you! You've already got him dead and buried! I
don't want to hear that kind of talk ever again!" He
turned on his heel and went back to the sink, this time
slamming the door behind him.

The outburst stunned me. I knew he admired and
respected Grandpa, probably more than anyone except
for his own father, who'd died before Doc and I were
born. Dad seemed to alternately love and hate him,
giving us a mixed notion of what that grandfather was
like.

But to deny Grandpa's illness! I didn't understand,
nor did I comprehend his vehemence in denying it. It
was as if he couldn't accept the fact that Grandpa would
ever die. This was a side of Dad I hadn't seen before,
and it seemed a weakness. I didn't know if I was ready
for a weakness in my father. That was the one thing
that had always been constant about him, no matter
what. He was always strong.

"Corey."

He'd opened the door and stood there, wiping bits
of lather with a towel, clad only in boxer shorts and t-
shirt. I could smell the lather from where I stood.

"Yessir?"

"Corey, I . . . I'm sorry. About Destin and his father.
I know he's not a queer. I know you aren't either. If
you want, you can go visit him later this summer."

As if embarrassed, he turned to the mirror and
started feeling his face with his fingers and scraping
at it with his razor, signifying that was the end of our

conversation.

"Okay, Dad," I said, in a low voice.

I went out and sat back on the couch. It faced away from the bathroom. Away from his bedroom as well. I heard his noises as he ran water in the sink, rinsing his face I guessed. Then, in his bedroom, pulling drawers out and shutting them. Steps behind me, walking to the kitchen. I wasn't sure, but I thought I heard his "good-bye" just before the kitchen screen door squeaked open and then slammed shut. His car started up and some gravel struck the side of the house as he pulled out. I just kept staring out the front window. No cars passed by, nor did I see anyone walking on the sidewalk. A blackbird flew by once, in a looping arc. Headed for the catalpa tree, I figured. Get him a nice, juicy worm. We had a female, full of worms this time of year. They made great fish bait. You turned them inside out.

"Don't eat all my bait!" I yelled from where I sat. The bird made me smile. Funny that fish and birds had the same taste in food.

"Corey." My heart bounced up around my throat somewhere.

It was Inez. She had come in the back.

"Hi, Inez. What are you doing here?"

"Your dad asked me to come and do some wash. He was out of things. Guess he don't know how to turn on the washer." She grinned her toothy grin, but I could see she was a little ticked, too. "Where you bin, boy?"

"Right here."

"No, 'bout an hour ago."

"Oh. Out. Playing basketball."

"Well, Oscar Robertson, your grandpappy called and wanted to talk to you. I told your dad. He didn't know where you were, thought maybe you'd gone fishin'." Dad hadn't said a word about Grandpa asking for me. Only that Grandma'd called that morning. I wondered if he'd just forgotten. Probably.

"What'd he want?"

"Didn't say. Just said if you wuz to come home to tell you not to get lost. He's gonna call back in awhile, see if he can catch you. I'm leavin' now. Tell your dad his shirts is on the line. Tell him he can iron them hisself. This is Sunday. He oughta know better than to call me on Sunday. Yankees!"

With that, she left. No car started up. Inez didn't drive, had never learned how. She'd walked the ten blocks from the cafe, from her trailer behind it. Dad must have forgotten she was there. He could have given her a ride back. No wonder she was hot. She must have seen him when he left. It was only five minutes ago. I was mad myself. Why hadn't he told me Grandpa had called?

I sat by the phone and watched it, not moving, not even to go to the bathroom. Forty-five minutes later, it rang.

"Grandpa!" I yelled, before I even knew who was on the other end.

It was him.

"Hey, Corey. I got hung up here longer than I thought I would, so I thought I'd call and let you know I won't be home until tomorrow at the earliest. I remembered that loan you wanted. It sounded kinda important. It's for something you need right away?"

"Oh, Grandpa, yes. But it can wait till tomorrow. Till you get back."

"Well, that's why I'm calling, son. I think I'll be back tomorrow, but it's not for certain. These sadists may want to keep me longer. So I got to thinking."

"Huh?"

"In my room, in my closet, is a sock. Clear in the back, in the far left corner, up against the wall. Might be stuff piled up on it. I've got a bunch of silver dollars in there. I'm pretty sure there's enough for what you need. Go ahead and get what you want. They're not collector's items or anything. Just ordinary silver dollars. I can get more at the bank."

"You sure, Grandpa?"

"Sure, I'm sure. Take whatever you need. If you're not sure how much you need, take extra."

"Thanks, Grandpa. Thanks a lot!"

"And Corey?"

"Yessir?"

"Start thinking about that tarpon you're going to hook. I'm feeling much better already."

I hung up, tingling. Now I could finish the boat. Hey, we could take it on our fishing trip! Me and Dad and Grandpa. It all laid out in my mind. I could see

Dad's face when I opened the door to the shed and he saw the nameplate. "Bob-A-Long." It wouldn't dawn on him at first what it was or what was going on. I savored the mental image, seeing his face, puzzled at first, then with the light of understanding spreading over it, and after, the love and pride that would pour into his eyes. I didn't expect he would turn and hug me or anything that corny, but I knew the boat would fix everything that was wrong between us. He would see what I had done, see I had achieved something difficult and mechanical, something he could respect, something made with my own two hands, just for him. I anticipated the pleasure of answering his technical questions, talking to him man to man.

I stood there by the phone, my hand still on the dead receiver, and a host of images swept over me. I was dreaming up all sorts of things that finishing that boat meant to me. Dad would see the effort and ability I'd invested and realize at that moment just how much I loved him, and then he would be sorry he had acted the way he had these past few years; he'd see that if I could do something so entirely foreign to my nature then so could he; he had the power to do anything he wanted. He'd realize, through my example, that he could quit working for Grandma, take up flying, get Mom out of the hospital, and move back to Indiana, put our family back together. I would hate to leave Texas; I would have to leave Grandma and Grandpa; I would even sort of hate to leave Mrs. Clopys who was

moving up to the next grade with her class, but we could come back, on lots of vacations; Dad could fly us back whenever we wanted, but most of all he would be happy again, and we would be a regular family. Mom would be the mom she used to be, the one I barely remembered. Her voice would stay the way it had the other night, and we'd do things together. I'd even try to get along with Doc!

A million other things along the same order went zipping through my mind, and then I laughed. I sure was putting a lot into just one boat! But it wasn't foolish, I insisted to myself. The boat would be a symbol to us all, just as Grandpa's spatterdashers were a symbol to him and me.

The lumberyard wasn't open on Sundays, so I couldn't buy the pine boards I needed, but I couldn't wait. I ran to Grandpa's room and to his closet. I couldn't find the sock! Panic overcame me. I tossed shoes and bags of old clothes around, not caring I was making a mess, searching everywhere. What color was it? Why hadn't I thought to ask what color it was?

And then I found it. It was in the right-hand corner. Grandpa had gotten it mixed up. It was a gray sock. It would have matched his spats. I grabbed the sock and took it out and dumped the contents out on the bed. It seemed like there were hundreds of the shiny disks, but I suppose it was closer to fifty or sixty. Carefully, I counted out twenty of the heavy silver dollars. Remembering what Grandpa had said, I took out

two more. If I didn't need it, I'd put it back.

I put the rest back in the sock, tied a knot in the middle and took it back to the closet where I replaced it exactly where I'd found it. I walked back to the bed and began putting the coins in my pockets, stuffing handfuls into each one. I had already checked to be sure there were no holes in these jeans! Just as I got the last one crammed in, loving the way they felt, weighing me down, something, a noise, made me turn around. Dad! He was standing in the doorway, leaning up against the door jamb.

"Regular little Jesse James, aren't ya?"

My heart started going crazy and I couldn't breathe.

"Grandpa said I could have them," I said, knowing somehow that he wasn't going to believe a word I said. He had to though—the birthday surprise and all it meant hung on his believing me.

"Call him up and ask him," I went on. If he talked to Grandpa, Grandpa'd tell him it was okay, and everything would be fine.

"Toast is in Houston in the hospital. He's sick. I'm not going to call him up and tell him his grandson is a thief, is robbing him while he lays in a hospital bed half- dead. He thinks the world of you. I'm not going to make him sicker than he already is. If he's to get well, he doesn't need to know about you. No, boy-o, this is between you and me."

He grabbed me by the arm. I tried to slip away, but he was too quick and got my shirt, pinching my bicep

with his fingers, hurting me.

"Put the money back," he ordered. "Put it on the bed. I'll take care of it later."

I did what he said. I emptied my pockets, piling the money back on the bed, trying to figure a way out of this. Every cell in my body was alive with fear. I had never seen a look on his face like there was now, not even at his angriest. It was like the face of God, the face conjured up by the fire and brimstone preacher my mom sometimes made us go to.

I couldn't; I just couldn't tell him the truth. I'd worked months for this surprise. I couldn't show him until it was finished. I was about to get a whipping, I knew. I'd take it, but I still wouldn't tell him, no matter how much it hurt. I made up my mind. A beating was just physical. I'd had bad ones and survived. I'd get over it. He'd realize what he'd done when I showed him the boat on his birthday, and then he'd be sorry. It'd make it just that much sweeter, I kept telling myself. Just endure this, I told myself. In the end, everything would work out okay. I took a last look at the bed and the money lying there. Somehow, I'd get it back. When Grandpa got home. I'd swear him to secrecy. I'd have him tell Dad he'd given me permission to take the money, but I'd make him swear not to tell him why. That wasn't even a problem—Grandpa didn't know why I'd wanted the money anyway, other than it was something for Dad's birthday.

We went downstairs, him jerking and yanking me

the whole way, out through the kitchen, out the back
door and down the path to the shed, inside it, and the
door slammed shut behind us, and he locked it. That
scared me the most.

"Bend, boy."

I grabbed the edge of the work bench and did as he
said.

Whomp!

His belt whistled through the air and across my
back. My back! I thought of George, the snake. It was
happening again, the same way. My stomach rolled,
then tightened up.

Crack! I felt the skin break and knew I would be
bleeding, but oddly, it didn't hurt. I don't know why
my eyes watered.

KaWhap!

"What were you stealing that money for?"

"Nothing."

Ka-Whomp!

"Don't give me your lies. What were you going to
spend it on, you little faggot?"

"Nothing, Dad. I . . ."

Wramp!

"I can keep this up all day. I will until you tell me
the truth. We're not leaving here until I have the truth."

Sssss-crack!

I started to cry. I couldn't help it. Now it hurt, hurt
like nothing I'd ever experienced. It wasn't just the
belt that made me cry, though.

Ka-rack!

"Save your bawlin.'" Whap! "What were you stealing for?"

Whap.

"For you."

He stopped. I was standing still, but it took every bit of strength I possessed. I felt my shirt on my back, sticking to my skin. It was funny—when he quit, it didn't hurt that much.

"You little chickenshit." Wramp. "You sniveling punk. I knew you were a little queer. You and your faggot friend. Now, you're gonna get a good whippin'. If you hadn't lied to me, that woulda been it." I turned around, slow, only because it hurt to move, even a little. He had his arm raised for the next lash. I could see the brown leather glisten and realized it was my blood that was making it shiny.

"It's the truth, Daddy." I was trying to talk between snot running down my nose and hot tears blinding me I don't know why I called him "Daddy"—it was like I was a little boy again, and I hated the weakness I felt. I wiped my sleeve across my face, which only smeared the mess worse.

"It's the truth. I took it for your birthday. Grandpa said it was okay. I swear it. I'll show you. Just please don't hit me any more. Please."

He quit hitting me and all I could think of was those spatterdashers Grandpa had given me and what they meant. As long as I could hold on to that, I could stand

the pain. I knew that someone loved me even if it wasn't my father, and that made this bearable.

"Show me," he said.

We rode there in his cab. I felt like an old man, my body beaten and bruised and bleeding. I wasn't allowed to change my shirt or wash my face. When we drove past the docks, I lowered my head. I knew most of the men who worked there. I didn't know how bad I was bleeding or how gruesome I looked, but my whole shirt was starting to stick to my back, and I had to lean forward during the ride. I hated having to ride in front with him, that close.

At the shed, he parked in front, the car facing the door. I got the key out of my wallet, my fingers stiff and shaking and uncooperative, and then fumbled with the lock. At last I got it open. Neither of us spoke.

I started to take the padlock off, when he shoved he aside and to the ground and did it himself. He threw the lock on the ground and ripped open the door, and entered. This was not the way I'd imagined this, I thought, and then I pulled myself up and followed him in. I think there was still some kind of faint hope burning inside me. A tiny, impossible flicker.

He found the light switch and flicked it on. There it was, his almost-finished birthday present. The first thing you saw, you couldn't miss it, was the nameboard.

The Bob-A-Long.

The mahogany glistened and shone. He said not a word, but strode to the rear of the shed, like he'd seen something he wanted. It was a crowbar. A big one.

He came back to where I stood and glared at me for a long, long moment. My mind was blank. There was something I should have said, something I could do to make a difference, but in that terrible moment I was speechless, had lost the power to communicate. He shook his head, slowly, from side to side, his face twisted and black and fierce. Then, before it dawned on me what he had in mind, he stepped over to the boat and began to strike it with the crowbar, heavy, crushing blows that splintered the wood, and sent splinters and chips flying, methodically, carefully, over and over and over, until there wasn't a single usable board left in one piece. He saved the nameboard for last, laying aside his crowbar and picking up the gleaming mahogany in his hands. He threw it as hard as he could against the far wall and it struck with a terrible thud and then the room was quiet.

I was paralyzed. I could only watch him. My eyes were dry, and what had been on my face, blood and mucous and tears, had dried, stretching the skin taut across my cheekbones so that I must have looked like a death's-head. My back was in flames, a raw hunk of meat, aching, and I was unable to move. I couldn't help it I did the craziest thing. I smiled.

I got the biggest, widest, goofiest grin on my face, and then I said, "Happy birthday, Daddy."

He grabbed my arm and propelled me out of the shed, lifting me off my feet. He didn't bother locking the door, just kicked it shut.

"I don't want your goddamned stolen money present! If I find you used any more stolen money to do what you did, you're gonna think this was a day at the beach!"

The crunching of oyster shells beneath our tires was the only sound to break the silence as we left, and the hum of the air conditioner the only other thing heard on the ride home. I wanted to roll my window down for air. All I could smell was the scent of his shaving cream and it made my stomach roll until I thought I would lose control, but I held it in, not daring to even breath, and then we were slamming to a stop in front of the house and I opened my door and got out, moving slowly. He didn't give me a chance to close the door once I was out, but tore off, the door closing itself with the force of the acceleration.

I dragged myself to the bathroom, showered, the water stinging like someone was pouring acid over my flesh, but it felt good, too, cleansing in more than a physical sense. I toweled off, gingerly, wincing when the rough cotton touched my back, and went up and climbed into my bed, naked, and was asleep almost immediately.

It was mid-afternoon and hotter than a fever.

The Death of Tarpons

*H*ere in the marshes the
water was shallow, at the most four or five fathoms
deep, and on the average, about waist-high. Long,
bleached fingers of sand, sparsely covered with tough,
slender salt-grass lay maze-like, swelling here and there
to a height of a foot or so and then gradually receding
back into the water, providing a natural dike system
that kept the movement of the sea to a more tranquil
pitch than that of the booming surf farther out. Fish-
ing country, miniature, cigar-shaped islands and doz-
ens of channels and tiny bays dotting the landscape as
far as the eye could take in, until the beach proper and
the waiting sea appeared. Far off, in the opposite di-
rection, lay cypress swamps, and beyond that, north
and east, pine forests, and beyond that; civilization.

219

Pencil-legged kingfishers, the geeks of the animal kingdom, and delicate sandpipers angled slowly and gracefully across the bays, secure in the calmness of the water where they searched for food. With each imperious, regal, and halting step, they majestically and methodically worked the bottom — searching, cunning eyes alert for the sudden movement of tiny, steel-gray mullet or baby blue crabs, which they speared with swift, iron beaks.

Far overhead, seagulls floated over the whole scene, silent curlicues against the huge, vapid canvas of the firmament. Silent, except when every now and then, one would flash-drop with a kree-kree-kree, and plummet into the lapping waters below, curved wings folded for aerodynamics, close to the breast, and emerge, bright sparks of sea showering, a silver flash of color in a curved, cruel, impersonal beak.

Sandfiddlers scuttled sideways in the sand, their one ridiculously-large claw poised nervously in readiness for the unexpected, danger or food, whatever presented itself, a bird of prey, or the larger, fiercer blue crab, or, more happily, a dead fish tossed aside by the waves. Everywhere in the marsh, life hunted the opportunity of death, steadily, relentlessly, matter-of-factly, as the white, formless, Texas sun mounted in the sky, forever chasing the dead star that kept just ahead of it on the other side of the planet.

An ancient, hump-backed tarpon cruised through the salt liquid of his world, his huge tail barely switch-

ing from side to side as he hunted, eyes piercing through the shadows for schools of fish. Incredibly strong, but slowed by his years, he was unable to catch the sleek, swift mullet of his youth, still yet able to overtake the slower sheepshead and red snapper, and it was on them mostly that he now fed.

Behind him, at a respectful distance, trailed a smaller version of himself, possibly even one of his own progeny. The younger tarpon was an aberration. Tarpon are not normally a social fish; they prefer to hunt and live in solitude, but this particular youngster had been wounded by an alligator when he had wandered too far up a coastal bayou, and was so lacerated by the reptile's teeth that he was unable to hunt as he had before. By good fortune, he had come upon the old tarpon days before, just after the ancient warrior had had the good luck to destroy a small school of yellowfin tuna. The younger fish discovered that by hanging back just far enough, he could pick up morsels the elder fish had missed or not wanted. His prehistoric brain had just enough intelligence to tell him this was a good thing, and so he had adapted, laying to just off the old tarpon's stern, feeding on his leftovers and regaining his strength. From time to time, as he was aware of the upstart, the old tarpon would wheel and make a run at him, but the older fish was too slow to catch the younger on a short run. After a while he didn't seem to care so much that he was being shadowed and used. The younger tarpon was now almost fully recovered from

his wounds, but still swam behind the other, enjoying the ease a symbiotic relationship provided.

The old tarpon himself was close to death, and he knew it in the way animals know these things, through a slowing in the blood and a calling from somewhere up ahead, but he wasn't yet ready to concede and roll over just yet. A slightly-luminescent greenish mold covered his back and was spreading its way toward his belly and up toward his massive head. When it reached and finally covered his gills, he would suffocate, a slow, laborious death from which there was no escape, a victim of the mysterious slime that appeared now and then in these waters, one of the by-products of civilization and its attendant gift of pollution. Younger fish usually escaped it, the mold confining its spread to the older of the species, almost as if it were a judgment against them for having lived too long. Or, maybe it was a plague of mercy, ending an existence that had turned undignified.

All paths eventually converge at one point or junction, and the tarpon's path too, would meet with another's, his fate to be sealed therein and the golden circle of his life completed. As he slowly worked his way up and down the narrow bayous and frequent bays, he was minute by minute, mile by mile, drawing nearer to the point of convergence. Time and space were diminishing, like the two hands of a watch reaching toward each other until finally, they are as one for one full, impregnating second, embracing for one full tick of the

clock, in climax as it were. So the tarpon and his future would meet.

Far away, even now, a boat of singular significance, carrying two people, a boy and an old man, moved in the whiteness of the same Texas sun toward a bay not far from where the tarpon hunted and lazed in the warm salt water of a no-name bay just off Bryan Beach.

The boat thumped and humped against the waves of the sea as its motor sang a ragged roar of song and the old man steered into the sea's furrows, strangely akin to what a farmer does across his landlocked fields, humming a tune with no words and older than his oldest forebear. The young boy sat in the bow, race-memory genes recognizing the song, and smiled a strange smile, a smile without mirth or warmth, feeling the sun and salt breeze move across his face like the soft caress of a large, invisible mother's hand.

It was a small boat to be traversing the waters it found itself in, in the open sea just off the breakwater, but the old man at the throttle seemed to be confident of his ability to pilot their way, and the young boy seemed to trust the old man.

Long, swelling waves plumped against the sides of the craft and curious gulls swerved far overhead as the boat knifed ahead on its unwavering course.

An impartial observer, even one of the seagulls circling far overhead, with unlimited access of observation into the contents of the boat, would have noticed almost nothing untoward about the dinghy. Fishing

rods, pieces of tarp, tackle boxes, two fishermen, nets and a cooler holding probably soft drinks and maybe beer, and certainly a sandwich or two, much the same as any other boat that had passed this way in the last forty years or so, save one thing. Something the boy held tightly in his hands. Should a curious gull pass close enough and use his exceptional powers of sight, he would note the boy's arms to be purplish, bruised, and that alone would perhaps cause him to brake with wings flung wide, fighting to stop his downward flight, but what was in the boy's hands would no doubt force such an inquisitive seagull even closer, and such a bird would be able to see that what the lad held was black and gray and made apparently of cloth, and could be laced up, although it wasn't.

The seagull wouldn't know what the object was of course, but a human would, provided he were old enough, or had learned enough in the study of antiques. What the boy was clutching so tightly was a pair of spats. That was a slang term for spatterdashers, and they had been a present to him from the old man who steered the craft. He was the boy's grandfather. Just at the point where the seagull would be getting as close as possible, to see, the boy would lay down the objects, stuffing them under his seat, and pick up a piece of shrimp from the bait box, and fling it to the winged observer, a reward for the inquisitive gull.

The old man would yell at the boy then, scolding him for drawing scavengers to the boat.

"Hey, Grandpa!" I had to shout to get his attention above the crash and hiss of the waves as they struck the bottom of our moving boat.

"Are we 'bout there?"

Grandpa put his tanned, wrinkled hand to his eyes to shade out the sun and looked far ahead and to his left. The seagull I had thrown a shrimp to banked and soared back into the sky, high, high, until it disappeared.

"Over there, Corey. Way over there where those islands are. Good tarpon country." I saw his smile. "Never caught a tarpon, didja? You wait."

I smiled myself and reached over and touched my fishing rod for luck. Grandpa turned and spat into the wind.

I was amazed to even be here. After Dad had driven me back home, I had showered and gone straight to bed, I suppose in a state of shock. I hadn't let myself think about what had happened; I couldn't. It hurt too bad. It was more hurt than I was capable of handling, just yet. I could feel it inside me, a black chunk of anger, and sorrow, and fear, and I kept it there by refusing to think about it. Sooner or later, I would have to deal with it, but now wasn't the time. Something had slipped a cog, inside, and I couldn't face what everything meant, just yet. Soon enough.

It was dark in my room and dark outside and
Grandpa was shaking me awake. Come on, he whis-
pered. Be quiet and don't wake anyone. I'm not sup-
posed to be here.

I obeyed, not fully awake, slipping out of bed and
standing, clearing my head. We're going fishing, he
said in the same whisper. Wear something comfort-
able and bring a light jacket.

He had parked in the alley so as not to wake any-
one. I had forgotten to note what time the clock on the
nightstand read, but I estimated it to be around four
in the morning. He had Grandma's taxi. I wondered
why he had her car and not his own, but I didn't ask.

We drove over to a friend of his, Smiley's, and he
just went up and banged on Smiley's door, four o'clock
in the morning or no, and I kept behind in the car like
he'd told me to. Smiley wasn't too fired up about being
wakened, I could tell, even without hearing what
Grandpa and he were saying, but then he seemed to
calm right down and I saw him shake his head up and
down, agreeing to something. He was. His wife, whose
name I had forgotten, appeared in the doorway for a
brief moment, her hair in pink curlers and wearing
the awfulest pink nightgown I'd ever seen, and then
she disappeared back into the house.

Grandpa and Smiley went around to the back of
the house and then reappeared, Grandpa driving

Smiley's old Nash Rambler with his boat hooked on
back. He was loaning us his boat and fishing gear.

It was all so strange and alien and so unlike
Grandpa, but still I kept my peace. I had thoughts of
my own to mull over, or rather, not to mull over. Still,
something wasn't right. Grandpa would let me in on it
when he was ready.

That had all happened a couple of hours earlier.

I touched my fishing rod again. Luck. It was
Smiley's South Bend bait caster, but for today, it was
mine. We'd picked up bait and Dr. Peppers and Jax
beer and sandwiches and ice and were all set.

We turned from the open sea and entered a wide
channel. After about ten minutes, cruising at about
five knots, the channel suddenly opened into a large,
bay-like area with other channels emptying into it like
green aortas into a giant heart. Little islands, spits of
sand actually, long and narrow, were here and there,
everywhere in the bay. Grandpa pointed the bow at
the largest.

Running the boat ashore onto it, we jumped out
into knee-deep water and hauled the craft up onto the
sand and grass, then reached in and gathered up our
borrowed fishing gear, laying it down in the sand and
assembling the gear and baiting hooks.

It was another world we had entered. Birdlife of
all kinds and colors flew by or fed within a stone's

throw. Electricity and automobiles were a thousand light-years away. Monstrous fish leaped temptingly in the waters just yards away, landing with pregnant splashes as they fed on their smaller cousins. The morning sun sparkled in tiny pinpoints on the gently rippling waters, skiffing up as light breezes blew this way and that, and muted bird-calls tickled our ears as our senses drank in the savage beauty that was all around us. I felt I could never see another person or a town again the rest of my life and be perfectly happy.

Grandpa baited up with a small squid and told me to use one of the shrimp.

"See what they're bitin'," he said, wading out until the water was just past his knees. His feet must have been more tender than mine. He winced as he walked, and then I realized that it couldn't have been the cool sand beneath the water that pained him. I followed him out and flung the heavy weight of my line a little to the right of where Grandpa had cast his.

"Pull your rod tip up and then slack off and reel in," he suggested. He used his own rod to show me, using exaggerated gestures. "Keep doing that but don't do it too fast or you'll spook 'em."

We angled together, side by side, like two Dodge City marshals working Main Street, for more than an hour without a bite. Another hour slipped by and the sun rose higher. The first freckles appeared on my face. I couldn't see them but knew they were there from past experience Also, Grandpa said, "You didn't dry off

good, Corey, your last shower. You're getting rust spots."
It was an old joke of his and I always laughed. After
awhile, he went back to the boat and stuck on a hat he
had left there. Still another hour passed with no bites.

After a long time, we kicked up a conversation. I
had my shirt off by then, and my bruises were visible.
Grandpa didn't say anything. I knew he was waiting
until I chose to bring it up. I wasn't ready to.

"How'd Houston go? Are you gonna be all right,
Grandpa?"

He kept his eyes on his line, pulling the rod to him
deliberately, and then reeling in the slack, doing this
several times in the space of a full minute.

"I'm not going to get well, Corey."

A terrible silence ensued, almost heavy with a
physical, tangible weight that pressed down, making
me feel as if I had been transported to an identical
world somewhere else, but one with a totally different
system of gravity, where my weight had soared to over
a ton.

"That's what I found out yesterday, Corey. They give
me a few months, at best. Three, maybe. Maybe less."

I sneaked a peek at him. Far in the distance, a
blue heron flew, his long, stiff legs straight out behind
him. He was flying straight for Grandpa's head and
would have struck him if it had been a one-dimensional
universe. I waited until the heron's outstretched beak
struck Grandpa's head and then passed by before I
spoke.

"You scared?"

He didn't answer immediately.

"Sometimes I am, and sometimes I'm not. Most times I don't want to live much longer. Don't see the point. There's a lot of pain, Corey."

Both of us were using each other's names now, almost as if extreme politeness were required.

"I don't like pain either, Grandpa. If I had pain all the time, I wouldn't like it either."

He looked at me like he was studying something in me, his head cocked like a sparrow hearing something foreign or dangerous.

"You're in pain, Corey. Maybe a worse kind than I have. There's a difference, though. Remember our talk the other day?"

I wasn't sure which conversation he meant, but I nodded like I did.

"The kind of pain you have may stay with you a long time, Corey, but it will get easier, and not only that—there's going to be some good times for you and they're not that far off. Remember what I said about children and suicide? That a child's idea of the future is that it's just going to be more of the same condition, same feelings he's experiencing at that moment? If the feeling is one of hurt, the child assumes the rest of his life is to be nothing but a continuation of that condition. If the feelings are happy, the child sees nothing but joy down the road."

I nodded.

"Neither are reality. I know we talked about this, but I think it's important for you to understand this. Life is a series of ups and downs, ups and downs. One of the things that allows you to cross over from being a child to becoming an adult is when you can grasp that concept. How about it? Do you see what I'm talking about?"

"I think so, Grandpa."

"I hope so, Corey. I have the strangest feeling you're going to need that knowledge in the very near future. I know where you got those bruises and cuts."

"You do?"

"I can guess. Your father, right? He beat you?"

This was going to be a conversation of honesty. It was the only kind possible with Grandpa, but it made me uneasy. Skirting the edges of truth seemed preferable, more comfortable. No, it didn't. That was a dumb thought. I'd learned better.

The truth hurt, sure, but it was a clean hurt, and then it was over. Lying about things, especially lying to yourself, kept the hurt alive and festering.

"What'd you do? What made him that mad?"

What did I do? I made him a birthday present.

"He thought I stole something. Money."

"The money I lent you?"

"Yes."

He sighed. He had just reeled in again. He reached back with his casting arm until the tip of his rod almost touched the water behind him, and then he flung

it out with a mighty pitch. His bait went out a long way, much farther than he had cast it before. He jerked back on the rod tip, reeled in the slack, let it lay for a second, and then repeated the whole procedure.

The tears just started rolling. Hot, fiery tears that coursed down my cheeks and into the water. I was adding my own salt to the water, I thought, then right after; am I going crazy? I feel this pain and yet I make jokes? I began to talk. I told Grandpa everything, all of it. I saw he had stopped cranking his reel. He looked out to where his bait lay, as if intent upon it, but I knew he was hanging on to every word I spoke.

"It wasn't the beating that was bad. It hurt, I guess, but what hurt the most was knowing . . . knowing. I don't know . . . just knowing that he was never going to love me." As I said this, my voice dropped lower and lower, a small voice to little more than a whisper, and I realized as soon as I said it, that that was what I had been keeping inside, hidden even from myself. The truth. The truth that had been there all along, the truth that I had always been afraid to bring out into the light, a truth that was so awful, so crushing that I'd been sure it would devastate me, annihilate and utterly destroy me.

But it didn't. It hadn't!

On the heels of the bittering sorrow, deep, wrenching sorrow, followed an elation, acerbic, joyful elation, sweet in the center and sharp and biting and stinging on the edges, but an ecstasy all the same.

"No? How's that?"

"It was what you said about them. About them being a symbol and what the symbol was."

"And what's that?"

"People that love you. Love me." I said it so low, I didn't know if he'd heard me. "Like you. And Grandma." My voice raised, got louder. "And Mom. Maybe even Doc."

"Destin."

"Yeah. And Destin. There's others. Lots of others.

He reeled in his line. His bait was gone, stolen. He reached into his pocket and pulled out a clear plastic bag. In it were several other squid. He took one out and rebaited. He glanced at me and then threw out his line.

"You're going to be all right, son. I think you're going to be all right. I have to be sure." He was talking to himself more than to me, it seemed, but the way he said the last sentence I knew he wanted an answer to something. "What else, Corey?"

"Dad isn't going to change," I said, surprised at what I was saying, knowing as I spoke that these were my true feelings. I went on, but it was as if someone else had taken over my voice and was using it. "It isn't my fault he doesn't like me. I act the same around you and Grandma. And Mom and Doc. And none of you hate me." I went on talking, and as I spoke, I felt something growing inside me, a new kind of knowledge about myself. It was the same kind of feeling almost

The worst was over.

And I had survived.

I had survived the surety that my father didn't love me, never had. Never would. It was crushing, oh—it was the most debilitating blow ever I had absorbed, but I hadn't folded, hadn't died, hadn't even broken one tiny bone! Not physical pain or death; that was unimportant; I hadn't died inside. I was alive and I was hurting and I was okay. I had to tell Grandpa something.

"Grandpa, while he was hitting me, all I could think of was the present you gave me. The spatterdashers." I looked into his eyes for the first time since I'd begun. "Silly, huh?" I had stopped crying sometime in there and my eyes were dry. I threw out my line again. It went out farther than it ever had. Grandpa hadn't touched his reel since I'd begun talking. Now, he did, reeling in sharply for a minute and then letting the bait fall back to the bottom.

"No, Corey, it isn't silly. I think that's what I gave them to you for. I had a feeling the time was drawing near. How do you feel about things now?"

"Just . . . better, Grandpa. Nothing stupendous, I guess. I just feel better. I'm all right now." I was, too. The ache was still there; it hadn't gone away, but for some reason, I knew I had passed a crisis of some sort and done all right. I was going to be okay. I kinda liked myself right then, felt pride in myself.

"It wasn't the spats exactly, Grandpa."

that I'd had when I first understood algebra, or when I first kept my two-wheeler up by myself. Before, I could do the problems, but it was only through memorizing the process; all of a sudden there was a moment when I knew how the goddamned stuff worked. The same way when I didn't fall off of my bike. Suddenly, I knew how to ride, not just the principle or the mechanics, but the balance, the feel. The exultation that there would be no more skinned knees, no more disapproving remarks from my father who was teaching me how to ride, and best of all; freedom. I had my own transportation, my bike. I could go anywhere I wanted, places I couldn't reach on foot. It was odd; I remembered just then the feeling I'd had when I made my first wobbly ride on my repainted red Schwinn, and I was having the same rush of emotion now, only sweeter, better.

"I can stay up, Grandpa," I said, and then blushed thinking he must think I was talking like an idiot. "My spatterdashers are you, Grandpa. And Grandma. And Mom and Destin and Doc. And people I haven't even met yet."

I was crying again, but it was a weeping of joy, and the tears tasted sweet, not salty. I felt transported, a sense of ultimate freedom and independence. And a sense of loss. I could go on now, deal with my father, but things had changed, forever, irrevocably, between us. It didn't matter what he did from now on. It wasn't my fault he couldn't see me the way I was. Others could.

Only my father hadn't been able to know me. He never would. I could see that now. That was what I had always hoped for; that a moment would come when he would see me for me, when he would know how I loved him, openly, without reservation, without qualification; just loved him for being my dad and nothing else. His "love" for me, I saw, if love was what it was, had always been subject to terms. He'd love me if I was this, or if I behaved that way, or if I had these interests. Never just because. Maybe at one time; right after I was born maybe. Or even in my early years, when my personality hadn't yet emerged, when it was unclear what kind of person I'd be. When I'd started being me, he'd lost interest, become disappointed. I didn't fit his idea of a son; therefore, I was not a son, not the son he wanted. He'd never understand the kind of love I had for him. The kind of love that didn't require him to be a certain kind of father, act in a prescribed way.

And it wasn't really the move to Texas that made him the way he was. It wasn't the loss of what he wanted from life. It wasn't even my Mom, with her religious fanaticism. I could see now that Mom hadn't turned to religion; she had turned away from him. It was her way of being able to live with him. He had showed her the same brand of love he had me. She hadn't measured up to what he wanted or expected either. When she saw that, she was devastated. Maybe she had never been able to articulate her despair; maybe she had never seen her relationship clearly, but

in her heart she must have known where she stood. Her religion had become her savior, her spatterdashers.

It's the wrong way, Mom, I wanted to say. You chose the wrong way. All of a sudden, I needed to talk to her. I needed to explain to her. That I understood. I needed to tell her that she didn't need her religion. Not the religion she had. She just needed to know she was all right. That I loved her. And Grandma and Grandpa and Doc did. And others. Plenty of others.

Dad was the outcast, I'd tell her. He didn't drink, but he was as big an alcoholic as Destin's father had been. He and Fembo were a lot alike. There was one difference. I didn't have to wait until he was dead to be free. Not any more.

I think at that moment, crazy as it sounds, I loved my father more than I ever had in my life. For I could see him. And I could see me. I saw him for what he was, a blind, frustrated, hurting man who was incapable of any feeling for anyone save himself. I didn't ever expect him to love me back. It was okay, though. I had the right kind of love that wasn't contingent upon anything. I could consciously decide to love him regardless. And I did.

Some of this I explained to Grandpa. Not all of it; some of it was private. But enough for him to know that I was all right. And that from now on I would always be all right.

For a long space, we were both quiet, reeling in and casting out, rebaiting our hooks when we had to,

each wrapped up in his own reverie.

"You know, Corey, you asked if I was afraid to die. Well, I was, plenty scared, but now I'm not. It wasn't death itself I was afraid of, I don't think, but I felt like I was leaving you unprotected, alone and in danger. I don't know, exactly, I was worried. About you. There's nothing to worry about any longer. You're going to be fine. I told you once before; I see great and wonderful things for you. I see them even more clearly now. You're a fine young boy, and soon you're going to be a fine man. I gave you my spats, but you gave me something equally good. The peace to die. What I was put on this earth to accomplish has been accomplished."

He reached into his pocket and took out the plastic bag again. I had just reeled in and my hook was bare as well.

"Here. Try one of these. I've got a hunch that squid's the answer." He spat on the slimy gray blob and handed it to me. I did the same—for luck—before impaling it on my hook.

At this moment, as if on cue, the old tarpon swam into the bay from a side channel, still looking for a slow sheepshead or a wounded sea trout. Behind him, twenty yards off his port stern, followed a smaller tarpon.

He hadn't been able to catch anything all morning, the old tarpon. The mold on his back glistened dully as he broke water almost on top of the young boy's bait, and then he spied the squid and gulped it down

with one instinctive motion, slower than he would have a few years back, but still with incredible swiftness. To his rear, the younger tarpon saw a meal for himself, a small squid about four inches in diameter, lying on the sand bottom. He didn't see the faint outline of the steel leader attached to it, like some alien kind of antennae.

"You got one, Corey!" Grandpa's yell reached me at the same time as the shock of the fish's strike, and I heaved back like he'd coached me, with all my might, feeling the crunch of steel hook meeting solid bone, and then the tarpon's strength swept through the line and into my arms, as he lunged against the sharp pain that burst in his jaw.

I knew instantly it was a tarpon, even without having ever hooked one. I had replayed this scene so many times in my head, it was like watching an old familiar movie.

"Ummmmph!" grunted Grandpa, and I saw his own rod bend, to the breaking point it seemed, and then I was too busy playing my own line to watch him, other than to make sure we didn't foul our lines.

Up, out of the water, exactly as he had in my dream, leapt the great fish, gleaming silver and green in the scorching Texas sun, and the sound was of a giant sucking noise, and then a subsequent, immediate slap, a cannon ball striking the water, sending a geyser ten

feet straight up, and then the tarpon was sounding, down five full fathoms, into the very sand it seemed.

"I can't budge him!" I yelled.

"Wait him out!" yelled back Grandpa. "I've got my own problems!"

Indeed, he had. His tarpon, for tarpon it was as well, was smaller, but what a leaper. Up and down, jumping and twisting in the sunlight, he leaped three times in rapid succession before making a long, straight run. I just kept the line taut against the monster on my line and watched Grandpa play his smaller one.

"I got 'im, now," he said, singing the words. "He's too young, doesn't know how to shake a hook. Thinks it's all brute strength." And just then, his line went slack.

"I'll be a son of a gun," he said, respect in his voice. "That sucker sure fooled me. He came back on the line and lost it! For a fish that wasn't too smart, he sure got educated in a hurry!" He laughed, and I felt relief that he wasn't too disappointed. He sloshed his way to my side.

"That was a beauty, Grandpa," I said, in admiration.

"Yeah, it was, wasn't it? But look at the one you got. I never seen one bigger. Don't lose him. I'll help you."

I resisted the urge to horse the tarpon toward me.

"That's what he wants," said Grandpa, uncannily reading my thought. "You do that and he'll be laughing at you six miles away. This one's no rookie. Maybe

he taught the other one. This isn't the first time this one's been hooked. You've got to outsmart him, you want to catch him."

Long minutes passed, ten and then fifteen and then it was drawing close to a half an hour, and still the tarpon didn't budge. I kept the pressure on, praying I didn't have any weak places in my fishing line. Mentally, I urged my protagonist to move, even though my heart was thumping double-time in anticipation of what I'd do, wondering if I'd be up to holding him. What would he do? Then he stirred. I felt him, just before, gathering himself for a Herculean effort. I'd outwaited him and he'd used the time to gauge me as a foe. I knew he could tell he was stronger than me, that I was but a boy. I started to hand my rod to my grandfather, panic-stricken, amazed that I had managed to hold onto him this long; it was crass impertinence on my part. Grandpa pushed the rod back at me, refusing to take it, making me deal with the huge fish.

Then, quicker than I could think, the tarpon was coming, coming, hurling himself through the water, toward the surface. He was like a crazed Brahma bull I had foolishly thrown a rope around. I glanced around, wild-eyed, thinking for a second that I must be crazy to stand here in the same water as this animal—he was coming to kill me and there was no place to go— and then I knew that wasn't likely, or even possible, or was it? There was no way I could ever hope to land this leviathan. Closer and closer to the top he came,

and more and more fearful my heart beat, and then he broke through, smashed through, shooting into the ether like he was a blue marlin, and not a tarpon at all, and the force and fury of his great leap was more than I could bear or handle. I dropped my rod, but Grandpa got to it before I could, reaching swiftly into the water and thrusting it back at me, my hands reaching and clutching only by instinct and not the wish of the boy whose hands they were. Everything happened in slow motion, seconds were minutes, and I had the rod back in my shaking hands just as he struck the water. It had seemed as though he would remain suspended forever, shaking his shaggy head to and fro ferociously, a mad, angry, furious shaking, like a yellow street cur shaking a freshly caught rat. Never had a fish jumped so high. Never had a fish been that huge. When he smote the water, the sound and splash was that of a meteor dropping out of the heavens. He was sixty-five yards away and drops of water struck us where we stood.

"Jesus Christ!" I breathed, unaware that I was cussing in front of my grandfather.

"That's some fish," was his own response. "I never!"

It was all I could manage to hang on as the marvelous monster headed toward the mouth of the bay and the open waters of the Gulf. There was something different, though. He was still strong, still all I could handle, but with a different feel.

"He's got air!" shouted Grandpa. "He's done for now.

He shouldn't of jumped. Now you can horse him in."

And I did.

The tarpon fought, flinging his tail and head about valiantly, even more; once or twice I thought him perilously close to shaking loose, but I hung on, even through a last jump, but now his strength was waning rapidly, this jump a pale imitation of the other, and what should have been a long, hard battle became instead a rout.

Five minutes later, Grandpa reached down with his gaff as I reeled toward the sandbar where the boat was beached, and together we pulled the monstrous fish up into the shallow water, all the fight gone out of him.

"How we gonna get him in the boat, Grandpa? He must go a hundred eighty pounds!"

"More like a hundred and forty," he said, "and we don't get him in the boat. What for? He's no good to eat. We have to let him go. He'd swamp our boat. Take some of his scales. That'll show everyone how big he was."

Suddenly, he bent down and lifted the tarpon's head out of the water and began dragging it up onto the sand, next to the boat.

"What're you doing, Grandpa? Aren't you going to let him go? What's wrong?"

He finished pulling the tarpon all the way up until the fish was clear of the water. He pointed. "Look there, Corey. See that slimy stuff on his back?"

I nodded, not understanding.

"That's a mold, son. When a fish gets that, he's a goner. Nothing you can do to save them. It's a death sentence. In a day or so, he's going to begin suffocating. Might take one day, might take a week, but he's gonna die, sure as shootin' And, it'll be one hell of a way t'go."

He pushed at the tarpon's great heaving belly with his toe. "We'll just leave him here. He'll be dead in a little while. Lot better'n dying that other way. This is more merciful by far."

He picked up his fishing tackle and mine and placed it in the boat, and began pushing it out into the water. I watched for a second and then asked, "Why don't you hit him in the head then? Isn't that faster? More humane?"

He came back to stand beside me and looked down at the tarpon, whose sides were heaving, almost as if he were breathing. "Looks like it, doesn't it?" He wiped the sweat from his brow with his forearm.

"I don't think so though, Corey. See, he's like he's drowning now. A long time ago, I almost drowned, over to Garner State Park, and believe it or not, it was easy, peaceful-like. I never forgot it. It was like going to sleep. I remember knowing I was dying and afterwards everybody said I was fighting like gangbusters, but I don't remember it that way at all. It was just so damned peaceful. I remember thinking the whole time I was under, that, well, here I am, Toast, dying, and it's calm;

it's not bad at all. Not like I'd ever thought dying would be. It was a hundred years ago, when I was in the Boy Scouts, but I can remember every single detail just like it happened an hour ago."

He paused in his reverie for a moment, his eyes far away at a place only he had ever visited, and then he said,

"I always kinda thought that would be the best way to go, happen it was your time. No, Corey, I think this is the way for that old tarpon to die. This way, he dies easy, with dignity, slain by warriors like himself."

He gave a bitter snort.

"Far as smacking him on the head and putting him out of his misery, well sir, I've done that to fish before, a lot, and now that I think about it, I guess I never did think about it too much—I just always did it cause that's what my pappy taught me to do. The theory was that that was more humane. I don't think so, though. I been hit on the head myself, more times than I would have asked to have been, and every single time it hurt like holy hell. No sir, I think we'll just let this old boy kinda drown out here in the air."

"See," he nodded toward the heaving body of the tarpon. "He looks at peace, don't he? He's thinking what a glorious life he's had and he's glad he doesn't have to fight any more. He's dying and he knows it. He welcomes it. He gets a chance to kinda go over his life, remember the highlights, the good times, and then he's gonna go to sleep."

He grabbed the gunnel of the boat. "Let's get out of here, Corey. Time we was heading home."

In ten minutes, we were back in the open sea, the sun at our backs, and the wind jacking up a little. I was glad Grandpa had made me take a jacket. I got into it. I sat in my place in the bow and thought on what had happened this day. This was a day like you always expect birthdays to be, memorable and auspicious, but they never are. This one was. Only, in a way, this had been my birthday. I was sure not the same kid I was yesterday. A lot had happened and I was changed.

I started to say something to Grandpa, but saw his eyes and decided against it. He was somewhere, but it wasn't in the boat. Then, his eyes seemed to catch focus, and he looked up, blinking as if he wasn't sure where he was at first, as if he'd just dropped in from another planet or something. His guard must have been momentarily down for I saw pain in his eyes, intense pain. He opened his mouth and spoke, something that was strange at the time and only later made much sense.

"Whatever happens, Corey, I know you'll understand, won't you?"

I shook my head, lost as to his meaning, only I felt I had to pretend I knew what he was talking about, and it was the funniest thing—at the exact moment I nodded, I felt a bond pass between us that was the strongest thing I'd ever felt in my life. It was physical,

that feeling.

"I wouldn't ever put you in a situation I thought would hurt you. You know that, don't you?"

Of course I did. I told him I did.

"Good. I thought so. You know, Corey, that tarpon was a lucky old bird. He had a good life, I bet, and some great times, but when it was time to go he just went. Animals know a lot more than humans sometimes, I think. I kinda like that tarpon. I don't think he much liked living the way he was, with that mold all over him and everything. He got lucky. He got to go out the right way, not wallowing in the shallow water, half in and half out, crabs eating him alive."

Grandpa'd slipped back into his reverie. He had addressed me, and he was even looking at me as he talked, but I could tell he didn't even know I was there, not really. He seemed like he was summing up something or making some kind of decision. I think even at that time I knew what it was he was deciding, but I didn't want to think about it, forced myself not to think about it.

I grew edgy as he talked, began to hate the way his words sounded—ominous—why, I don't know. It was the way he was saying the words as much as the words themselves, like he was in church or something, like he was some kind of elder deacon or something. I didn't say anything to him, couldn't say anything to him. I wasn't there to speak, only to listen. Something had hold of both of us and all I could do was hold onto the

sides of the boat and listen to him as he spoke. The wind kicked up even more, and gray furze that wasn't really clouds, just raggedy bits of dirty rags, moved between the sun and our boat, making the sun fuzzy and indistinct. The wind chilled and whipped from first this direction then that, then another. I hunched up inside my jacket, shivering, but it wasn't the weather that chilled me as much as it was my grandfather.

It smelled like a norther.

"Y'know, dying's no worsen being born. We don't really know what's coming each time, but the first one turns out okay and I don't see no reason to not believe that so will the second. Dying, I mean." He mused to himself a minute, and then whatever was on his mind left him, and he was back to being Grandpa.

"You ought to have your life jacket on," he said. I shrugged, and put it on. It was an odd request, I thought—we hardly ever wore life jackets—then dismissed it.

We were just coming into sight of Bryan Beach and the waves were rougher near where it got shallower, although it was still deep here. There was a bad undertow at Bryan Beach. We weren't allowed to swim out far when we came here.

He must have been daydreaming, because somehow the boat got turned out to sea and then at cross angles to the waves. That's dangerous, I started to say, but just as I opened my mouth to speak, the boat struck a giant roller and the sea rushed up and over us, blind-

ing me for a minute and requiring all of my strength
just to hold on. Blindly, I went down on my knees and
reached for the seat before me and clutched it. The
motor quit and the boat swung around with the cur-
rent. We were all right.

Only I was alone in the boat.

There was no sign of Grandpa.

"Grandpa!" I screamed. He was nowhere, vanished.
I scrambled to the stern to where he'd been sitting.
Get the motor going, find him, my mind urged. I
reached his seat and stood up, a foolhardy, dangerous
thing to do. Grandpa would be mad, he sees me, I
thought, my mind confused. I looked everywhere for
him.

Then, I saw him. He was just beside the boat, only
a foot beneath the skin of the water's surface. I
watched, paralyzed, as his head came up, broke wa-
ter, and then sank again. He was caught in the under-
tow. Dimly, I could hear the roar of the surf and, I
thought, voices, and realized we were drifting toward
shore. Hang on, Grandpa, my mind pleaded. I'm not
sure if I said the same thing aloud or not. I think I did
but I don't know.

Ketchup bottles, I thought. Inanely, the image of
the last day of school, while I was watching the clock
so anxiously, drifted up. Would I have watched that
clock so desperately had I known what the summer
held in store, I wondered, and then washed the im-
ages clean.

With a lunatic's wild eyes, I looked about for the life preserver. It was right by my foot. I reached down and grabbed it, and then my fingers slipped and it fell. The boat lurched, enough to cause me to stumble, and all the time I'm looking down at the spot where Grandpa had gone down and then back to the preserver. I reached down and found it by feel, never taking my eyes from the water.

Where was he! I had the life preserver in my hand, ready to throw. There! I saw him just beneath the water. He was coming up for the second time. I clutched the preserver with a fish hawk's grip, ready to spring into action.

He came up, fast, and it was the weirdest thing; I thought of the tarpon and his tremendous leap, and then his head broke the plane of the water and popped free, then started sliding back and this time he began to tread water, not making a sound, not choking or sputtering or yelling or anything. There was just this pause, everything, the whole world just stopped, the wind quit, the waves froze, nothing breathed; it was the space of the click of a camera shutter, but it lasted as long as I wanted to hold it. I have never before or since encountered anything like that moment, although those who have been involved in wars, in shooting wars, where the bullets were whizzing about them, over their heads, next to them, say a similar thing happens to them, where time slows down and then just stops, and that's the way this was. I knew what was

happening and I knew it was only a brief part of a second but I had the power to hold onto it for as long as I liked. It was my decision to make to let time start up again when I desired; as long as I retained my concentration, the moment would last. Then, something happened, I blinked, and for a second forgot where I was and what was happening and as slowly as everything had been before it all began accelerating now to catch up, to get the universe back on track.

A wave crashed into the side of the boat and I drew my arm back to heave the preserver; he was two feet away, I could reach out and touch him with my hand if I chose to, and he started to slip back down in the water. Just before he went under, he seemed to stop once more, suspended, as if he himself were a drop of ketchup in that empty bottle, and our eyes met and locked. It must have been for only the narrowest of seconds and time didn't slow as before, but it seemed forever, and I reached down with my arm and he shook his head the tiniest, imperceptible bit, side to side, a trace of a smile on his lips. And then he was gone.

He was gone.

He didn't come back up. I don't remember exactly what happened next; I still had the life preserver in my hand, and I sat down I guess; I must have; the next thing I can remember clearly was the boat bumping up against the shore, in the shallows, and some people were running and yelling, and I watched as one of them, a young man in red trunks, ran out into the

surf and began swimming.

I'm afraid I didn't pay much attention to what went on next. I let them do what they wanted. They asked me some questions and I answered them, but I don't recall what the questions were or what I said in reply. Except, that before I would leave the boat I had to get something from under my seat on the bow end. Someone lifted me out of the boat and I think somebody else pulled it up on the sand, and then a blanket was around me, a woman tucking it tight, and people were talking, waving their hands, and asking more questions, but I wasn't there.

I had had time to throw it, I thought. Why hadn't I thrown it?

I started to cry, but just for a minute, and then I knew Grandpa wouldn't want that, so I stopped. A man and a woman got me up and helped me walk to a truck parked up on the beach. I was thinking: They're not tourists or Yankees; they knew enough to park away from the tide.

They were parked in almost the same exact spot we had when we'd gone floundering, a long, long time ago, it seemed now. Destin would have said they weren't Yankees, I thought, and I smiled and laughed out loud. That was when I realized I wasn't alone, but in a truck squeezed in between the man and woman who'd helped me up from the boat, and the woman had her arm around me, and was looking at me with a strange look when I laughed. It felt good. They were

strangers; I had never seen them before, but they seemed nice and the truck was warm, and I told them where I lived and also my phone number and the first place they had a phone we stopped and the woman got out and went in and came out a little while later and you could see she had been crying although she was trying very hard not to let us, me and the man I guess was her husband, see that she had been, as she climbed back into the passenger side.

Then, we were on our street and in front of our house and they were helping me out as if I was an invalid or coming home from the hospital.

We started up the walk to the front door, and then there was my family, Dad coming out of the door first, and Grandma, crying, her face red and wrinkled, and behind her, Inez, holding the door open, and then Doc popped out from under her arm and they all met us halfway up the walk.

"Corey."

It was my dad saying my name. He was standing in front of me and his eyes were funny. I started to tell him that, and he said,

"Corey, your grandmother told me about the money. She told me your grandfather loaned it to you. I honestly thought you'd stolen it. Corey . . . I'm sorry."

I looked at him very carefully. We were almost even in height, I noticed in amazement. This must be the summer for my growth spurt. No wonder my legs hurt all the time. And yes. He was sorry. It was in his eyes.

It didn't matter.

"That's not important, not now," I said, knowing he wouldn't know what I was talking about. Pain was in his eyes, but not the same pain mine held. His hurt was for himself, for the breaking of his own selfish, twisted code, not for me. He had me placed in that camp where he had placed nearly everyone, among the legion whose only aim in life was to thwart him and his own happiness. That was how he viewed others, how he viewed life. How he judged all other's actions. His was a bleak outlook—him against poor, misguided, weak humanity. The rest of the world cheated both at cards and at life itself, played unfairly. This was his terrible belief, and he would not stoop to their level, that was his other belief. That was all his apology meant to him—that he had accused and sentenced his son under the same judicial system the rest of the world adhered to. Not his more honorable system. His regret was that he had punished me unfairly, for a crime I hadn't committed. His regret was for the pain that caused him, for the violation of his sense of honor, not for any anguish I had suffered.

I stepped up closer to him. What I wanted to say wasn't for anyone else's ears.

"I don't care, Dad. I don't really think you're sorry at all. Not for what you should be sorry for. I don't think you're sorry at all for what you did to me. I don't think that kind of sorry is in you.

"I love you, Dad," I said, looking him straight in

the eyes. "I do love you—I can't help that—but I don't care if you fall off the edge of the earth. I will tell you this. Don't ever mess with me again. I won't have it." A different look came over him, one I recognized and knew well. A look of anger, and yes, hatred, but as much as it frightened me, and it did, I ignored it and continued to stare into his eyes, my expression the same.

I became aware of something in my hands. Something I had insisted on getting from the boat and was still clutching tightly. Something I had held onto, all the way home. I held them up, stared at them, started to do the craziest thing; hand them to my father. The most insane thought overcame me. I wanted to say, "Here, Dad. These were Grandpa's. He wanted you to have them. He told me that. They're an heirloom, passed from father to son. They wore them a long time ago. They're a symbol. I'll tell you about them."

That's the crazy thing I wanted to say. I didn't though. I couldn't. I didn't utter a word. There were to be no more lies between us. Not from me. There was to be nothing between us from this time. No more pretending to be the son he wanted. Just me. I was going to just be me, from now on. "There's just one more thing, Dad. I'm going to talk to my grandmother and then we're going to see if my Mom can come home. Don't try to stop us."

I hadn't even known myself that I was going to say that to him. His eyes blazed up for a minute and I knew he was going to strike me, hit me like he'd never

hit me before, and then something happened, something passed between us, as we looked at each other; they went opaque, his eyes, as if he were looking out of a frosted shower door, and there was something else I'd never seen there before, a hint, just a hint, but there, nonetheless, of fear, and it puzzled me, and more than that, gave me a feeling of power, a feeling that was uncomfortable. I knew in that instant that he was no longer a person to fear. To mistrust, possibly, but never again to fear.

Our business was over.

I pushed past him and went to my grandmother. Doc was standing beside her, her arm clutched around Grandma's leg. She looked cute and vulnerable and not nearly as bratty as I always thought of her. She was just a little girl with a tooth out in front. How could you dislike someone who looked like that?

Grandma was openly crying, not trying to hide the tears that rivered down her cheeks. Behind her, Inez still stood in the doorway, and water coursed down her dark skin as well.

I went up to Grandma and Doc and put my arms around them and reached behind them and took hold of Inez' sleeve and pulled her to us as well and all four of us hugged and cried, that is, they cried, not I, not out loud, but quietly, and then I said to my grandmother,

"Grandpa's dead, Grandma." I buried my face in her neck and felt her arm hold me tight, my own tears

finally flowing, washing and beginning the long heal-
ing process I needed.

"But we caught a tarpon, Grandma. We caught the
biggest damn tarpon you ever saw. I want to tell you
about it. You shoulda seen Grandpa."

We went into the house, all of us except one.

My father left soon after that, for good, hopefully
to find the life he felt he'd been cheated from. I bear
him no ill will. I've only been thankful he left quietly
and quickly, and even though he's been gone many
many years, from time to time I get this uneasy feel-
ing that he's about to reenter my life, and that is my
worst nightmare. That's all it is though—a night-
mare—and I know how to deal with it, defuse it. Mom
came back home to Freeport—I was away in Indiana
most of the time at Aunt Pat and Uncle Charles's—
but Doc and Mom and Inez and I talked on the phone
often and I came home for a month or so most sum-
mers until I graduated from high school, and then only
rarely as I was accepted at Indiana University and
began my studies. Doc, in our many phone conversa-
tions and letters, kept me informed. When Mom came
home, Doc said, she seemed for awhile to hardly even
think about religion, didn't go to church, read her Bible,
nothing, and then one afternoon my senior year I came
home from school and there was a message to call my
sister. She was trying hard not to cry, I could tell, as

she described the scene she'd walked in on the day before. Mom lying in bed, the covers pulled up, yellow tissues all around her, her eyes red-rimmed and the big black Bible open. She scarcely noticed or acknowledged Doc. It was Mom as we'd always known her, except for that brief interlude. I talked to Doc, calmed her down, and it was from that day that we lost Mom completely, which as it turned out, was strangely okay with all of us, even Doc, who I could tell had made a quantum leap in maturity. Mom was happy—we realized that—and we were practically raised. I myself was a thousand miles away most of the year, and what little rearing there was left to do with Doc, Inez finished up, undoubtedly doing a better job than Mom could have. Inez was a saint. She took care of Mom as well and there has to be a special place in heaven for that woman.

My mother left the travail and trouble the rest of us suffered in and entered another universe, purer and sweeter than the one we were obliged to exist in. She never hurt a single living creature on the face of this earth and she never told a lie or committed a visible sin, to my knowledge, and while she didn't get her allotted three score and ten years her beloved Bible promised, I took that to mean that God was making up to her in Heaven what He had denied her in earthly life. She left us in her sleep, looking twenty years younger, and to a person, all who knew her pronounced her a saint and the holiest woman they had ever known. The

funeral was lovely and felt like a sanctified event, which most times they don't, and Dad had the good grace not to show up for it, even though he was officially notified. He was out west somewhere, working not as a pilot but at an aircraft factory, helping build engines or something. Doc knew where to get in touch with him, which made me suspect she had corresponded with him before, but I didn't say anything, as, after all it was none of my business. We'd always had different fathers.

There was a strange man at the back of the church and for a moment I thought it to be him, but then the man was gone and I didn't get a closer look. There was something in the way the man held his head that reminded me of my father, an arrogance in the tilt of his head only he could have achieved at such a time, but then it was most probably my imagination working overtime.

Now it seems, from all that time since Grandpa's death, from when we all scattered as a family—me to go up north, Dad out west, Mom to the bosom of her God, first figuratively, and then literally—Doc growing up and marrying, then the rest of my life, going to college and beginning the decades of putting together a family and a career and a life, and then this cancer thing, and it just seems like all that's happened in between never really happened at all or it happened to someone else. I feel like I'm still just fourteen and the part of my life up to that time, that summer when I

built the boat for my father—that part of my life takes up an excessive amount of memory, even though the remainder up to now is nearly double that amount of time.

What should have been prologue seems to have been the main body of my life sometimes, and what has happened since seems more distant than that summer. That summer seems near, even now.

I mean, the salt air from the Gulf smells exactly the same as it did then.

Where were my answers? They were there all right. All the answers I required had been provided. They were just not the ones I'd expected. Another lesson of life. The lessons of life were wearying. Perhaps that was the real answer. When you wearied enough, you laid down and pulled the covers over you and you went to sleep.

I turned on the local radio station and naturally, they were playing country music. I was startled to notice the sky had grown dark. How I had done it, I don't know, but I had driven from Bryan Beach back to town and here I was getting ready to drive over the levee that kept the Brazos River from flooding the town, the moon rising just over it.

I drove up and over the levee, the white oyster shells shining luminously in the moonlight, and drove down until I was once again at the shed I'd been at earlier in the day. I don't know why I'd come back here, but I had. Once here, I had no desire to enter the shed

again. There was nothing in it for me. I just sat in the car and turned off the engine, but kept the radio on, and stared at the shed. The DJ must have been an oldies fan, cause a song from my childhood was on.

"... *yore che-e-ay-tin' heart*," it was going, "*will tay-yull on y-ou.*"

I had gotten what I came back for. Grandpa's legacy. The spatterdashers. Not the spatterdashers themselves, but what they meant.

And to decide what to do with the rest of my life. To go on with it or not. Grandpa hadn't. When I first decided to return, I knew now, I had expected to discover permission to do the same as he had. End my own life. After all, he had, and it had been the right thing to do. We even had the same disease.

But I'd remembered it wrong. I'd been thinking that Grandpa had said suicide was all right. He hadn't, though. What he'd said, was that it was all right for *him*. He hadn't said it was all right for anyone else, including me. What he had said, that I had forgotten, was that a child takes his own life because he thinks the rest of his life will be exactly the same as it is at the present time. An adult realizes that life is a cycle. The good times are followed by bad times and the bad times, in turn, run into better things. That is life and those are its seasons and that is one of the great secrets of life. Grandpa took his own life because there was absolutely no chance of any more good times or ways to make a contribution. No chance at all. Not

only that; he was presented with an opportunity to go out in an honorable way, purely by chance. Maybe he had a premonition that that was what he was going to do; perhaps that was why he had asked me to put on my life jacket; but I never will believe that he had his suicide in mind when first we began our fishing trip. It was just something that came along, a door that opened, and he went through.

There were no such doors in my life right now. There might be at some point, but none existed now. There was still the chance of life, the doctors had said so, a slim chance to be sure, but a real one, nonetheless. And, as long as that chance existed, it wasn't right to put an end to my existence. Besides, there was a piece of unfinished business I had left to do.

The spatterdashers.

I had forgotten them for years, until my own crisis came up.

There was a chain to be continued.

My own son.

Hell, my own grandson.

I had things to tell them, things I should have told them a long time ago but never had. They knew nothing of their ancestors. Of Toast. Of their other forebears. I had been too busy with my own life. Escaping from my own life.

I started up the car engine. If I drove straight through, I could be back home in less than a day.

But first, I had to make a call.

"Hello," I said, into the receiver at the first pay phone I came to. "This is Grandpa, Bobby. Tell your dad I'm on my way back home from Texas and tell him to cancel whatever plans he has for this weekend. I'm going to take both of y'all fishing. No arguments."

Highway 288, the sign read. The air conditioning felt good on my face. I turned up the music. Patsy Cline. God, I'd forgotten how good she could sing!

I listened to that station as long as I could and when it faded out, I found another just like it.

Later on, before I got out of Texas, I'd stop and have me a sandwich and a longneck. An ice-cold Jax, sweat on the bottle, drink it in a bar where you could hear the air conditioner when it went on, feel its icy breath hit the back of your neck.

I wondered if they still made Jax beer.